House Industries

LETTERING MANUAL

KEN BARBER

WATSON·GUPTILL
CALIFORNIA | NEW YORK

CONTENTS

FOREWORD

BY JIMMY KIMMEL

My love affair with lettering began at an age when most boys are busy throwing rocks at garbage trucks. Every night I could be found in my bedroom hunched over a desk, listening to a portable black-and-white TV while working on whatever project I'd cooked up: comic books, caricatures, logos for companies that didn't exist, textbook covers, T-shirts, even membership cards for those lucky enough to be invited to join my plastic baseball league, the Indoor Wiffle Ball Association of America.

Every logo, every new superhero (the standout being Muscle Man, who wore a crown to let good and bad guys alike know he was the King of Superheroes) I drew had his or her own emblem and customized print style. Every hand-drawn birthday card and unflattering caricature of teachers, family, or friends had its own unique set of letters.

I often consulted the *Speedball Textbook: For Pen and Brush Lettering*. I don't know how this little booklet of alphabets found its way into our house, but in the pre-internet era, it was my most-referenced reference. I still have it, and page through it occasionally. The smell brings back memories of meticulously copying the letters within, learning calligraphy and techniques I didn't even know were techniques.

I take photos of logos and signs wherever I go, storing them in a file I call "stuff I like." Over time, my enthusiasm for typography began to attract other enthusiasts. About ten years ago, my friend JJ Abrams (we buy each other pens) asked me if I'd heard of House Industries. I hadn't, but I looked them up immediately and, before long, was begging them to design a new logo for my show. They designed the logo for Jimmy Kimmel Live, and when I opened a comedy club in Las Vegas, they designed the logo for the club. If I ever get a tattoo, I'll ask them to design that too.

House Industries is a special company. I love their style, I relish being a part of their process, and I am in awe of their talent and body of work. The fact that you are reading this leads me to assume that you agree. Welcome to our strange little fan club. Send me some pens and we'll see where it goes.

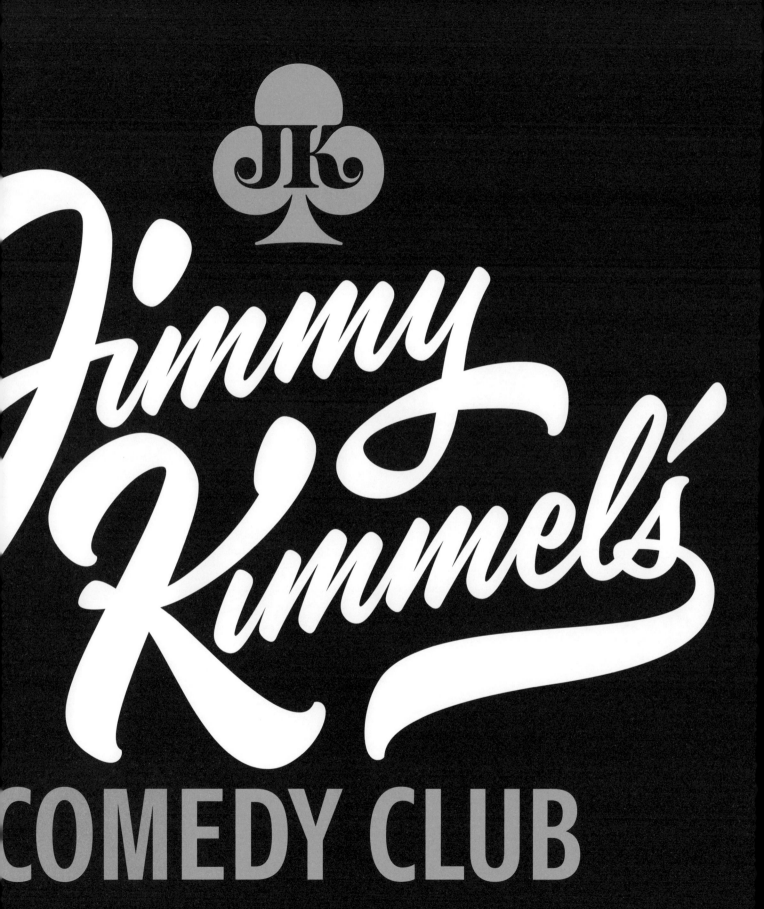

PREFACE

When House Industries opened its doors in 1993, letterforms were not in the crosshairs of our original business plan. The idea was to build a little design studio with a visual point of view that we could call our own. The loose goal: have fun creating artwork and get the viewers to experience something new but slightly familiar. In an effort to mutate our jobs into a hobby, we'd work with likeminded friends and scheme with co-conspirators to help us pull it off. But not so fast...

Our idealistic business construct was immediately challenged by the financial reality that inserts the business end of commercial into art. Commercial art by definition naturally leans toward the comfort of the status quo. And in so doing, it blankets an industry with a cloud of conformity and risk aversion that often dictates which ideas get expressed in mainstream culture and how. Sure, our clients dug the idea of commissioning original artwork, but when our creative ambition irritated comfort zones (and maybe sales forecasts), courage faded.

The answer to our commercial frustration came in the form of a muse that held the key components of communication: letterforms.

Letters have always been the starting point. Characters combine to make words that create ideas and build connections and new ways of thinking. And whether it was drawing a custom logo or using early digital font technology to experiment with forms, we reached for the alphabet as our favorite instrument to harmonize a relationship between art and commerce.

Embracing the letter reminded us what we love about creating art. We grew up in the golden era of product marketing where letters and logos sold ideas with a perception that was often more memorable than the products themselves. Inspired to draw from childhood influences and emulate our design and illustration heroes, we learned from what we liked and pushed the boundaries of our work while trying not to embarrass ourselves.

The side effect of this process was the development of a "style." But as much as I enjoyed creating said style, I often found my groove slipping into the rut of boredom that would eventually force me to push our style further. Luckily for us, nothing kills boredom like exploring different aesthetic points of view and honing technical chops. And nobody embraced this harder than Ken Barber.

It was 1995 and Ken moved from New York to my couch in Delaware. We were trying to make sense of designing for clients while also carving out time for self-initiated projects where we distilled hand lettering into fonts. Ken's natural ability to render the anatomy

of any letterform in graphite or a bézier curve could add a disciplined elegance or defiant playfulness to whatever happened to be on the drawing board. We toyed with what are usually the non-negotiable aspects of letterforms, and defied how the Romans and scribes trained our eyes to perceive the alphabet. And like all the cool stuff we considered art, it was fun to create and insert the subversive.

Following our instincts became the foundation and process for House Industries lettering and design. We learned a choreographed dance of cultural input and self-taught technique that added a musicality to the letters we released into the wild of contemporary culture. Following our design bliss led us to supportive patrons and a creative community that appreciates our influences and encourages us to keep pushing the craft.

A typical House lettering project goes something like this. An idea, more often a concept, is entertained and researched while esoteric tangents are welcomed and explored. This is then followed by general bullshittery and discussion ad nauseam. Then after all the cerebral sweat and an extended lunch, Ken and I might do some rough thumbnail sketches.

My thumbnails lean toward the rough side, while Ken's sketches are often ready for publication or framing on the first go. This

is followed by some chin stroking that evolves into a free math, history, or physics lesson from Professor Barber. After the lecture, I then grab a pencil and say, "Yup, you're probably right. But let's try it like this and see how bad it sucks." Humoring my vision, Ken takes another pass, and in the process, blends some warm imperfection with his technical perfection and brings it to life. It's hard to describe, and remarkable to behold.

Which brings me to what a unique honor and privilege it has been to plot, laugh, and ultimately create artwork with Mr. Barber. Throw a little black powder on our visual landscape and the fingerprints left by House Industries—from blue chip companies to start-ups—are all over the place. These fingerprints remind us to continue both embracing and pushing against the enigma that is commercial art.

In the pages that follow, Ken has distilled his wit, wisdom, and a seductive flirtation with the Platonic forms of the alphabet. I hope it leads you to create an inspired version of what lettering can be.

When I was a kid, before my family took a road trip my dad would become obsessed with packing the trunk of the car. He could have just thrown everything in the back, but to his mind, the packing must be done efficiently, and he took it as a personal challenge to figure out the best way possible. He typically started by assembling all of the luggage on the driveway, and assessing each piece by its size, shape, weight, and importance—among other considerations: Could it be folded, deflated, bent, twisted, or otherwise contorted if needed? How accessible would an essential item be in the event of an emergency? Would the contents spoil before we reached our destination?

As he began to plug the various pieces into the evolving puzzle of the trunk, my dad would periodically stop and rearrange things to improve the fit. Gradually, the solution became clear as he put the main pieces into place, before filling any remaining gaps with the smaller, more trivial items. Mind you, the contents of every suitcase, toiletry bag, and insulated cooler were packed with just as much thought and care. It all seemed a little excessive at the time, so I didn't fully appreciate how closely I stood to greatness: the man was a maestro. Little did I know how much those moments would eventually impact me.

In a way, this book is also about organizing things. Shapes are assembled to form letters, letters are combined to make words, and words are arranged to create a message. The size, shape, weight, and ultimate arrangement of each element ultimately affect how effectively the job gets done. The role of words is often more than simply an informative one: words can also entertain, influence, and incite. Yet, the message is only half of the equation: the logos, advertisements, and headlines that compete for our attention every day depend on well-made letters to attract and persuade us. Hand-drawn words, in particular, can elicit emotion, provoke action, and even challenge opinion—apart from simply promoting an idea or selling a product. (Though they're pretty good at that, too.)

The Latin alphabet has remained largely unchanged for centuries, but that hasn't prevented people from taking it down a few aesthetic detours along the way. Shifts in trends, technology, fashion, and thinking have all affected the appearance of our letters. Over time, different attitudes and ideas have become associated with certain styles. Consequently, collective notions and expectations have emerged about letterforms and their uses. For example, delicate flourished scripts are thought to exemplify elegance and sophistication, while bold, blocky faces embody strength and simplicity. This is testimony to the fact that the alphabet can provide a voice to words beyond literal communication. The key to making engaging lettering is tapping into these commonly held ideas to connect with people.

At House Industries, our design approach has been built on the practice of exploiting the versatility of the alphabet by injecting our work with a heavy dose of custom letterforms. We discovered that the secret to creating successful lettering is to pay equal attention to both the message and the means by which you express it. In other words, *how* you say something is just as important as *what* you're saying. This book illustrates how we at House Industries have capitalized on the distinct advantages of lettering to develop a unique brand of visual storytelling, and how you can develop your own approach to creating and executing letterforms in various design settings.

In Part 1: Lettering Basics, I lay the foundation for solid lettering practice. I introduce the various ways to make letters, emphasize the benefits of drawing, explain sources of inspiration, illustrate the anatomy of letterforms, cover basic tools, and outline the method of lettering by reinterpreting standard models.

I take a closer look at the nuts and bolts in Part 2: Lettering Technique. In this section, I delve extensively into the fundamentals that govern the creation of good lettering. You will learn how to sketch effectively, construct letterforms properly, compose layouts, pair complementary letter styles, proof artwork, and dodge common lettering pitfalls.

The rubber really meets the road in Part 3: Lettering Models, where I'll get you acquainted with the common letter styles that serve as the basis for lettering, including examples of the House Industries working process that ultimately demonstrate how to put the precepts of this book into practice.

The *House Industries Lettering Manual* not only provides you with the fundamentals of letter-making, it also uncovers all of the tips, tricks, and techniques that we have stockpiled over the course of twenty-five years in business. Throughout the book you'll find bonus sections, including instructive skill-building exercises, informative sidebars, and case studies detailing the thinking behind many real-world projects. Whether you're new to drawing letters or a grizzled vet, you'll profit from the detailed strategies outlined in these pages. In addition to attaining a firm foundation of sound lettering principles and practices, you will gain insight into the unique perspective on inspiration, craftsmanship, creativity, and personal style that continues to feed our unending fascination with the alphabet.

Unfortunately, we can't guarantee that your trunk-packing skills will improve—*that* is a true art.

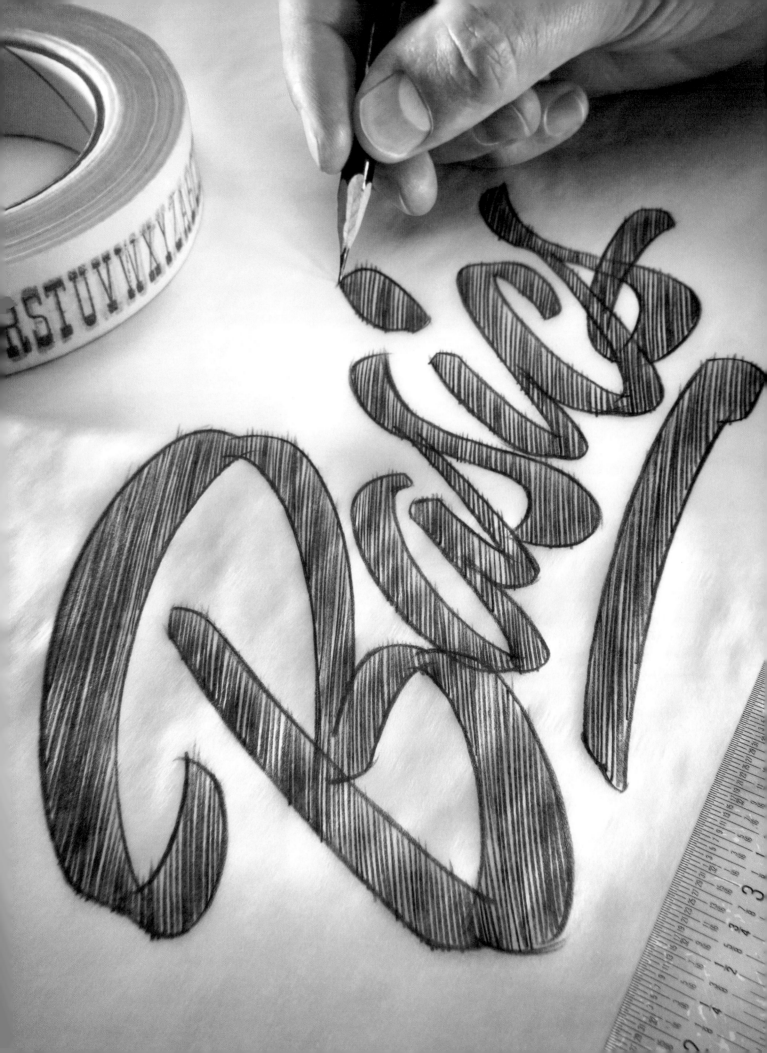

1

LETTERING BASICS

Like all creative disciplines, the practice of lettering relies on solid technique. But there's more to it than just good draftsmanship. Carefully crafted letterforms should be guided by sound decision making, which only comes after gaining a firm grasp of the fundamentals. This section lays the groundwork for lettering, beginning with the various letter-making methods and the unique advantages that drawing has over different production means. Next, I'll discuss the many roles lettering plays, as well as the conceptual, aesthetic, and technical demands it must answer. The anatomy of letterforms and common lingo are also covered, along with the basic tools you need before getting down to business. Most important, I'll explain the method of modifying common letter styles as a basis for lettering, which lays the cornerstone of the approach outlined throughout the rest of the book. All right, let's get to it.

READ THIS BOOK

Once while conducting a workshop, I referred to an old lettering handbook to point out how the author had illustrated mistakes commonly made by novices. A student exclaimed, "Oh! That's what you're *not* supposed to do. That book makes so much more sense now!" It turns out that despite poring over the contents of the book countless times, he had never bothered to actually read it.

I can't say I blamed him. For years, I had studied magazines, instruction books, and design manuals, studiously copying the examples without giving a thought to what the authors had to say or the logic behind the lettering they were trying to impart. Fortunately for me, I finally surrendered and began reading the books that, up until that point, had served primarily as visual reference and "inspiration." That's when my lettering education changed.

While there's no replacement for personal guidance from a seasoned mentor, instruction books are often the most practical introduction to the field for many budding letterers. With that in mind, I ask that you please *read* this book. It doesn't have to be from cover to cover. You don't even have to start from the beginning (although, that would be nice). I can't promise that the book will be terribly entertaining, but it does contain a quarter-century's worth of the kind of insights and experience I wish I had had the sense to glean from those old how-to books years ago.

LETTER-MAKING METHODS

There are various methods for making letters, so it's helpful to have an understanding of the most common ones. Letter-making can be categorized in different ways, but generally speaking, there are three primary means: writing, typography, and lettering. Despite the prevailing tendency for people to use these words interchangeably, these designations are understood in a very specific manner among professionals. At the risk of sounding like a didactic jerk, if letterers are in the business of communicating, they should strive to do it as clearly and effectively as possible. Using these terms properly is a good place to start.

▼

Take it from advertising vet Barry Katz Sr.: to make your lettering really swing, get acquainted with the wealth of info in this book. There's more to it than a few pretty pictures.

Writing
Typography
Lettering

WRITING

The primary parts of written letterforms are made with a single pass of the writing instrument. Oftentimes, a group of letters or even an entire word can be created in one go. This means that each word is one of a kind—even skilled calligraphers can't replicate their own efforts exactly. The tool may be a brush, or a pen, or even a stick used to scrawl a message on the beach; if the main components of the letter are made in a single movement, it's writing. (While mastering the art of writing is not a requirement for lettering or typeface design, a solid foundation of written letters goes a long way when it comes to understanding the historical basis for the formation of the Latin alphabet. But more on that later.)

TYPOGRAPHY

Typographic letters, on the other hand, are prefabricated forms that have been engineered for systematic composition and reproduction. Because they're part of a mechanical process, they can be exactly duplicated. However, since typographic letters must work in nearly any

conceivable combination, they usually favor predictability over personality. While embellished fonts for use at large sizes can be rather eccentric, comparatively restrained text faces (like the one you're reading right now) avoid drawing attention to themselves. They are instead chiefly concerned with communicating the content of the copy in a clear and readable manner. As we'll soon see, the custom-made forms that comprise lettering have no hang-ups about hogging the spotlight for themselves.

LETTERING

Lettering, the subject of this book, is composed of forms whose primary parts have been built up by multiple strokes of a drawing tool. Letters shaped by this method are the result of a cumulative process, whether they are rendered with pencil, vectorized in points and lines, painted on a sign, or incised in stone. Whatever the production method may be, lettering is essentially drawing. As you'll soon learn, the specific means by which it is formed gives lettering its distinct benefits.

SIDEBAR
BUILD A LETTERING MORGUE

As I started paying more attention to lettering, my go-to references were popular magazines from the mid-twentieth century. The ad captions and editorial headlines in those fusty pages spanned the entire spectrum of styles. Before I knew it, I started spotting letterforms everywhere: welded into decorative ironwork, embroidered on linen napkins, or chiseled in stone. Gradually, I began hoarding loads of samples: hand-drawn book jackets and posters, vintage packaging, and snapshots of weathered billboards. It wasn't until later that I learned I was unknowingly assembling a *morgue*, a collection of old images that might trigger new ideas down the line.

If you're already a fan of lettering, chances are you've started stockpiling images of your personal favorites. Maybe you've taken a photo of an old motel sign or clipped an attractive newspaper headline. If you haven't gotten into the habit yet, it's never too late to start. You might be surprised to find interesting specimens in everyday places; manhole covers, building cornerstones, and cemeteries are loaded with excellent examples.

As you add new entries to your morgue, observe how the letters are formed. Are their shapes or arrangement dictated by a specific production process? Take neon tubing, for example; its limitations can make for some pretty unusual forms. Maybe you detect a genre of lettering prevalent in a certain setting? Gravestones often favor different styles according to the time period in which they were carved. You might even notice some surprising connections, like the relationship between cross-stitched monograms and 8-bit video game graphics; the environments couldn't be more different, yet both needlework and pixels use a grid-like foundation, making letterforms in each medium look more similar than you might have guessed.

The secret to curating a useful storehouse of resource material is being discriminating about which pieces make the cut. If you save every photo or paper scrap, you'll end up with a bloated folder of digital files or clippings that's impossible to navigate. When considering potential additions, I look for letters with unusual proportions, contours, or other notable traits. Signatures and handwriting samples are some of my favorites because they suggest novel ways to join cursive forms or construct letters. Your morgue doesn't have to be limited to outside sources, however; recycle some of your own rejected proposals or unused sketches. A well-cataloged archive of imagery and ideas can be called upon when needed, or combined with other interests, input, and discoveries to inspire new pieces of lettering.

Remember, the purpose of building a morgue isn't to duplicate its contents recklessly. Copying material can be a useful exercise for students to gain a practical hands-on understanding, but doing the same for a published job would be unethical and reflect poorly on your professional reputation.

In the long run, inspirational sources won't replace the discoveries that are made by getting down to work. Sure, the items in your morgue might spark an idea, but they should serve merely as a catalyst when it's time to start sketching. The drawing process itself offers the best learning opportunities. Every time I begin working through a problem, I'm reminded of how flexible letterforms are and what they're capable of expressing. I'm also often surprised by the many things that the alphabet still has to teach me.

USES AND ADVANTAGES OF LETTERING

The versatile nature of lettering and its unique production process make it useful for a broad range of applications. Whether it's a simple monogram or a complex corporate signature, lettering can lend personality to a logo by capturing the essence of a person, product, company, or brand. Labels and packaging for consumer goods can benefit from eye-catching letters to indicate quality, familiarity, or tradition. Hand-lettering can also grab the attention of readers via magazine editorials and advertisements, or through large-scale promotional pieces like posters, billboards, and murals. No matter what the application, lettering has the power to suggest various attributes, from value and simplicity to luxury and craftsmanship.

Because hand-lettering is created for a specific purpose, the style and layout of the letterforms can be tailored to suit any given application. This allows the artist unparalleled freedom in determining the letters' appearance and arrangement. Hand-drawn letterforms can be molded to fit an inflexible layout, or stylized to capture just the right emotion. Lettering can also exhibit depths of warmth and character not possible with run-of-the-mill fonts. With the emphasis placed on the look and feeling of the letterforms, a piece of lettering can be thought of as a "word image." The aspect of editing inherent to the drawing process means that letters can be uniquely fashioned to elicit precisely the desired mood—this is perhaps the most notable advantage of lettering. Consequently, the content and the means to express it are one and the same. When it comes to lettering, the style *is* the content.

Although lettering does require time and effort to master, hand-drawn letterforms don't rely on a particular writing tool to directly shape their appearance, as calligraphy does.

And once an artist becomes familiar with a range of letter styles and understands how to modify them, there's no need to hunt down just the right font for the job, either. (However, House Industries can help out in that department if a looming deadline means you're short on time.)

But there are plenty of other good reasons for designers to study lettering. The practice presents a hands-on opportunity to learn about the principles that guide the creation of well-crafted letterforms. Revamping common letter styles (a popular method that I'll introduce shortly) reveals the individual merits of each genre, while offering a historical perspective on the lettering process. This not only helps to make abstract ideas more concrete and tangible, but it also provides an experience that is both practical and relevant. Drawing letters also helps you sharpen indispensable skills like attention to detail, patience, and craftsmanship—values that are hallmarks of all good design. Finally, you'll get an appreciation for good letterforms, however they're made. Even if you don't instantly become an expert letterer (spoiler alert: no one ever does), applying lettering principles will make you a better designer—no doubt about it.

In a 1986 video interview Archie Boston conducted for a project called *20 Outstanding Los Angeles Designers*, design legend Saul Bass offered this advice to students: "Learn to draw. If you don't, you're going to live your life...trying to compensate for that." That's because drawing (and therefore, lettering) is design thinking in action. Working by hand is a physical extension of the problem-solving process, and one of the quickest ways to realize an idea. In essence, design (whether it's graphic design, illustration, photography, or architecture) requires the

arrangement of elements to achieve some purpose. (Okay, I may have cribbed that definition from Charles Eames, but it applies here, too.) Lettering demands that the designer deals with universal concepts and spatial organization in a direct way. Furthermore, because the practice requires balancing constituent factors like scale, composition, foreground and background elements, and so on, lettering is itself a microcosm of the design process.

These designs were produced as a series of die-cut tags for women's jeans by Express Ltd. The lettering was painstakingly drawn to work within the figures' different silhouettes. It would take an immense amount of wrangling, not to mention a lot of hair pulling, to adapt existing fonts to fit these unique and challenging layouts.

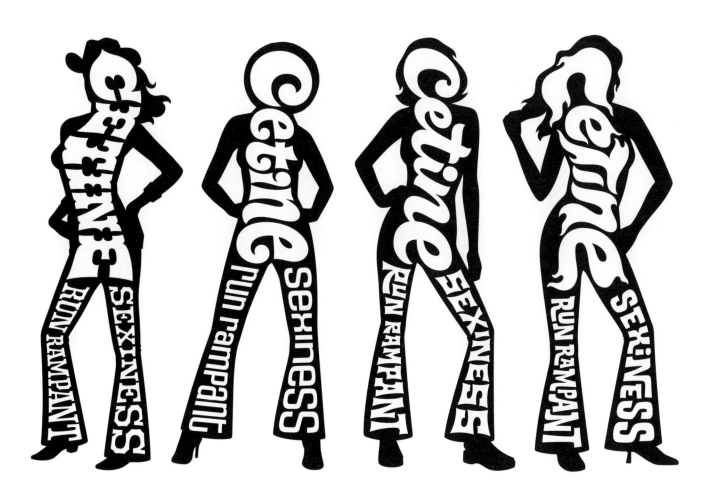

CASE STUDY

HOUSE INDUSTRIES'
LOVE HEARTS

One of the biggest advantages to lettering—and perhaps the most compelling reason to use it—is that the shapes and composition of letterforms can influence the tenor and power of a message. In fact, sometimes the essence of the words can be understood even when their literal meaning is not. Take House Industries' Love Hearts products, which communicate the profound sentiment in an array of languages.

The project was born from a request by the revered French glassworks Baccarat—famous for its fine crystal—who invited us to design a special Valentine's Day tumbler for their Roppongi store in Tokyo. Unfortunately, the affection we held for our initial proposal, a lush piece of floridly embellished script lettering, went unrequited by our partners in Japan. Undeterred, we fanned the flames of our preliminary idea, and eventually added eleven more pieces in various languages to create a line of House Industries products including posters, children's blocks, and tea towels.

Drawing familiar letterforms can be challenging enough, but even more difficult when they belong to a foreign alphabet. Fortunately, with the invaluable aid of several native speakers, we managed to dodge a number of potentially embarrassing grammatical blunders, not least of which were a couple of unintended near insults and obscenities. In order to create variety throughout the dozen translations, I picked a different letter style for each. For German, I drew a soft and curvy blackletter, a form of Gothic writing long associated with the region. The French design utilizes a decorative yet playful script, while the Italian version stars a daring and uncommon all-cap version. Japanese, Arabic, and Hebrew all riff on traditional forms, whereas other less obvious associations were represented in assorted letter styles needed to fill a few aesthetic gaps in the set.

In order to wrangle the stylistic diversity of lettering, a universal heart-shaped cartouche was introduced to provide a constant and recognizable silhouette. While the graphic device visually unified the various pieces, squeezing letters into such an uncompromising shape presented its own heartaches. In order to avoid distracting negative spaces produced by ill-fitting letterforms, a number of techniques were employed. Meandering flourishes were threaded through some layouts to occupy otherwise awkward open areas. In other instances, interlocking letters were tucked into each other to economize on space, or scaled to reach difficult spots.

Marshaling all of these demands across a broad collection required a slew of attempts, many of which were unsuccessful. However, the final selection features expressive letterforms which themselves are just as much an emotive element as the sentiment behind them.

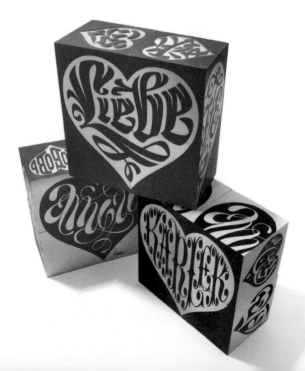

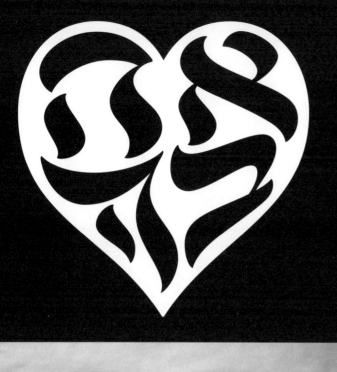
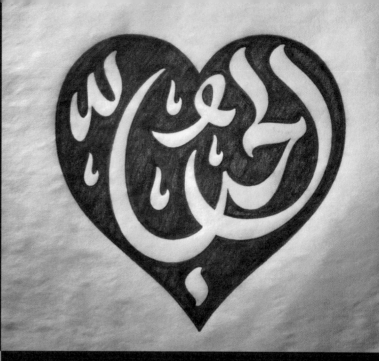
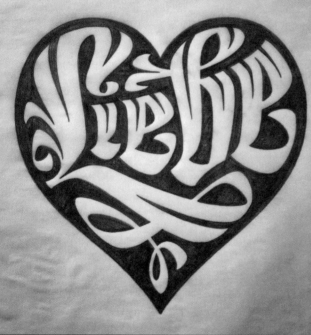
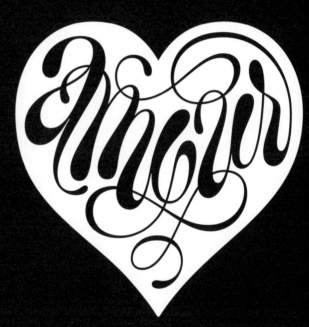
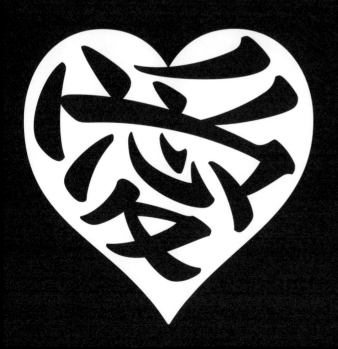
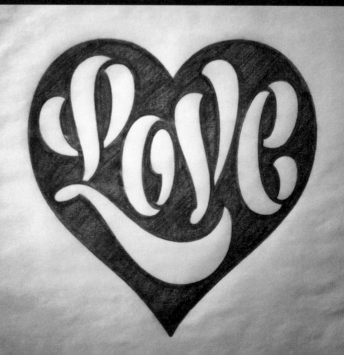

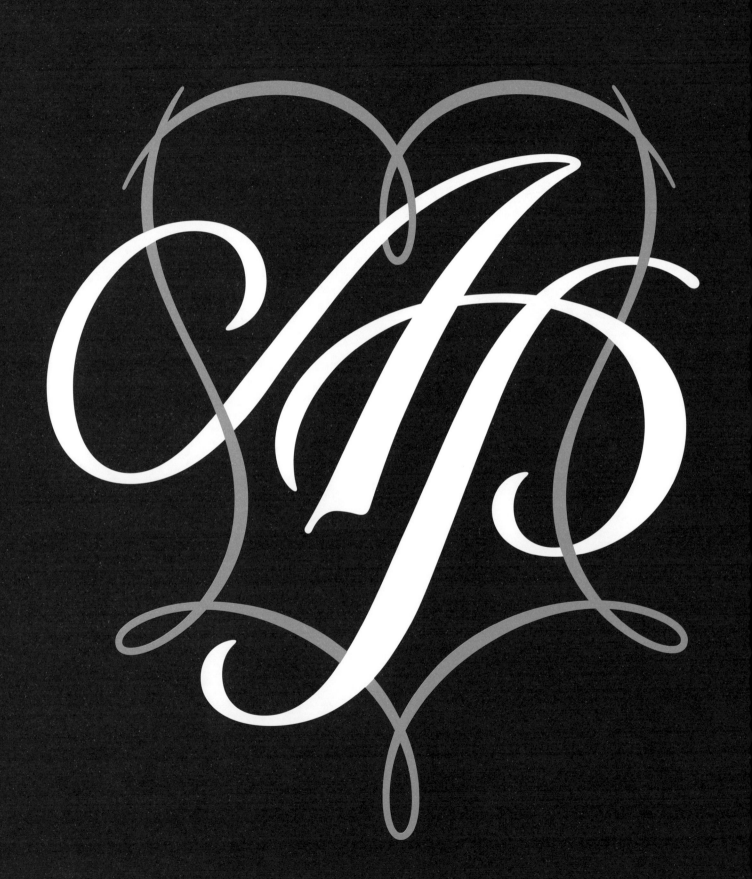

REQUIREMENTS OF SUCCESSFUL LETTERING

Although lettering requires cultivating some creative ability, it's usually not a purely artistic endeavor concerned solely with personal expression. Lettering created for a specific situation—be it advertising, logos, or other letter-based design applications—has a job to do, and there are certain requirements that come along with the territory. With this in mind, lettering typically has three general functions: conceptual, aesthetic, and practical.

1 CONCEPTUAL

2 AESTHETIC

3 PRACTICAL

Conceptual: This monogram was designed for British luxury lingerie retailer Agent Provocateur. The elegant script style lends sophistication to the mark, while the surrounding filigree creates a seal that calls to mind the image of a corset, hinting at the kinds of items offered by the brand.

CONCEPTUAL

The aim of each piece of lettering depends on its intended use and ultimate application, which differ from project to project. In some cases, letters must inform; in others, the goal is to entertain, or motivate. A logo, for example, must embody the person, product, company, organization, event, brand, or idea that it represents. Similarly, successful editorial or advertising lettering should relate to the subject matter in some meaningful way. Conceptual decisions are often informed by cultural forces, so it's the letterer's job to anticipate consumers' expectations when it comes to letter style, composition, and other elements. For example, juvenile lettering on a funeral parlor sign might fail to set the right tone, just as an elegant script on a monster-truck rally poster could likewise miss the mark. Ultimately, stylistic treatment of the letterforms will be determined by varying needs—your first job is to find out what those needs are.

AESTHETIC

Regardless of its purpose, ideally lettering should be visually distinctive and memorable. This is especially true of logos, which must vie for consumers' attention in a competitive marketplace. Labels, posters, and other product lettering must be similarly engaging. If an existing typeface fits the bill, then there's no need to draw custom letters. (If that typeface is from House Industries, all the better!) Keep in mind, however, that off-the-shelf fonts are available to anyone who plunks down the cash for a license to use them, and they lack the hand-tailored look that only lettering can convey.

PRACTICAL

Each lettering project comes with its own technical requirements. A brand mark, for example, usually has to function at small sizes and in a range of environments. Consequently, it may need to be robust enough to be read at a few pixels high, or perhaps withstand the constraints of embroidery or some other restrictive production process. Overly fussy designs and those with delicate details don't hold up well under poor conditions. Billboard lettering and editorial design, on the other hand, are guided by a different set of considerations and generally enjoy more latitude when it comes to complexity of form and composition. The letterer must take all of these factors into account to ensure that there aren't any surprises before putting pencil to paper.

While not every piece performs each one of these functions, the most successful lettering usually exhibits all three, personifying a particular message in a stylistically distinct way while taking its ultimate application into account. Although personal taste plays a role, these factors allow a piece of lettering to be evaluated with some degree of objectivity. Even beautifully drawn letterforms can't save a piece if it doesn't embody a given idea, isn't visually noteworthy, or fails to meet technical demands.

Now that you understand what lettering is, the distinct advantages that it offers, and how to evaluate successful examples, let's look at one of the most common approaches to drawing letterforms, which is the primary lettering process detailed throughout this book.

Aesthetic: Cinghiale is a bicycle touring company that conducts trips throughout Italy. This lettering employs several distinguishing devices to create a logo with unmistakable personality. The broken stenciled forms provide a sense of rhythm, in addition to the punctuating elements above the g and pair of i's. Finally, a swash visually extends from the initial C and intersects with the lower part of the g, creating an underlying foundation while carrying the viewer's eye through the logo.

Practical: Bizarre, an alternative culture "lad mag" published in the UK, wanted a refreshed look that matched the footprint of the previous nameplate while remaining simple, legible, and easy on the eyes. The mark also needed to work at small sizes in outline (as show here), and with the initial B isolated to close the end of magazine articles. Ultimately, these requirements determined the direction of the project.

Cinghiale

BIZARRE

THE LETTERING PROCESS

I was twelve years old when I first heard *speed metal*. The intensity of the music instantly grabbed my attention, especially the throbbing guitar riffs that regularly got stuck in my head. But what really sucked me in were the blistering guitar solos that punctuated each track. The best ones teetered on the edge of veering out of control, yet managed enough restraint to keep my interest. By the time I started playing in punk bands of my own, I realized that my guitar heroes—however uninhibited they sounded—weren't pulling notes out of thin air: they were cleverly improvising the same basic music scales that I was learning. I got a similar impression when I initially encountered the work of experienced letterers, who mysteriously seemed to possess an inconceivable amount of intuition. I soon discovered, however, that skilled lettering artists typically riff on a handful of standards in much the same way as my favorite bands.

In this book, you'll learn how to create lettering by analyzing and modifying common letter styles, many of which are derived from familiar typographic models. Sure, there are other approaches to lettering (like using handwriting as a starting point, for example), but many hand-drawn letters are essentially interpretations of distinct categories, examples of which you might even recognize from your font menu, such as Caslon or Bodoni. (Don't worry if these typefaces aren't ringing any bells—that's what this book is for.) Using established models as a basis, letterers alter one, or several, defining characteristics—like weight or width—to produce new pieces of lettering. This time-tested technique has been used by commercial letterers for decades, and is the process behind much of the work that we see today.

Although some lettering may emphasize the conveyance of an overall image or emotion in favor of more practical concerns, generally speaking a wordmark isn't doing its job if consumers can't tell what it says. Although *legibility* and *readability* are often used interchangeably, I use them to differentiate between two related yet distinct concepts.

Legibility refers to whether or not a logo or other form of lettering can be read and understood. If some letters can't be deciphered and obscure the content of the message, then the lettering is not *legible*. The style or execution may make a piece of lettering tough to decode, but so can poor print conditions and other restrictions.

Readability refers to how *quickly* a piece of lettering can be read and understood. It's generally acceptable if a piece of editorial lettering requires a moment or two to parse its meaning; a magazine has a captive audience once a reader begins paging through it. However, the same lettering on a scrolling sign may not fare so well since readers need sufficient time to process it. If the lettering can't be grasped immediately, it's not *readable*.

Take note that not all lettering must be readable, or even legible. Lord & Taylor's iconic scrawl comes to mind as an example of how an illegible mark can gain broad recognition through persistent use. This takes time, of course, and cannot be built directly into lettering. Other genres of lettering are unapologetically not interested in legibility and practical production concerns. Take the style of lettering commonly associated with *black metal* music, for instance. Band logos of this underground subgenre of intensely aggressive heavy metal are more preoccupied with expressing an abrasive attitude, or creating an otherworldly atmosphere. They're notoriously impossible to read, and the most chaotic ones look as if they've been conjured from the dark abyss itself.

▶▶

The bottom two pieces of lettering sacrifice a small degree of readability in favor of creating a strong visual impact. The top two wordmarks, on the other hand, completely forfeit legibility, but gain a moodiness that would be tough to capture otherwise.

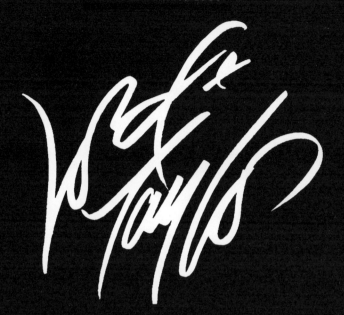

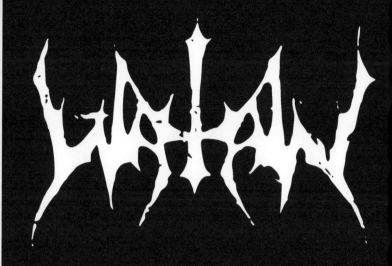

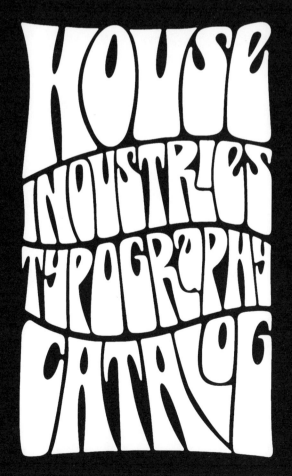

HOUSE INDUSTRIES TYPOGRAPHY CATALOG

Learn from what you like And apply it to what you do

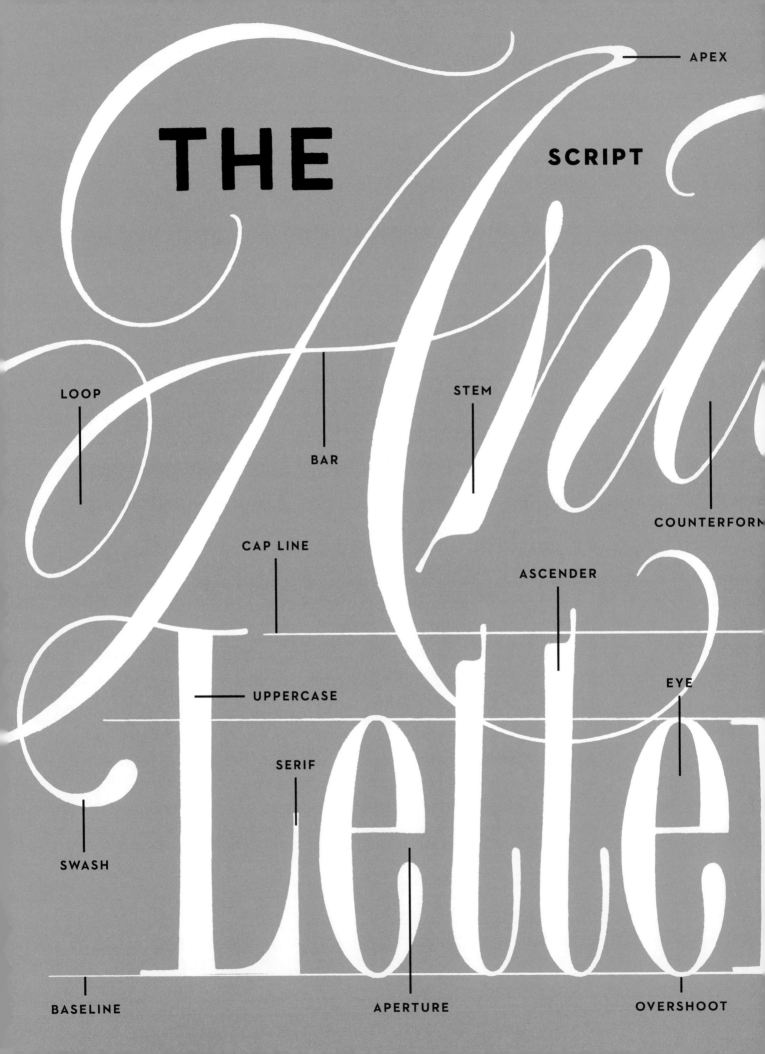

THE

SCRIPT

APEX

LOOP

BAR

STEM

COUNTERFORM

CAP LINE

ASCENDER

UPPERCASE

EYE

SERIF

SWASH

BASELINE

APERTURE

OVERSHOOT

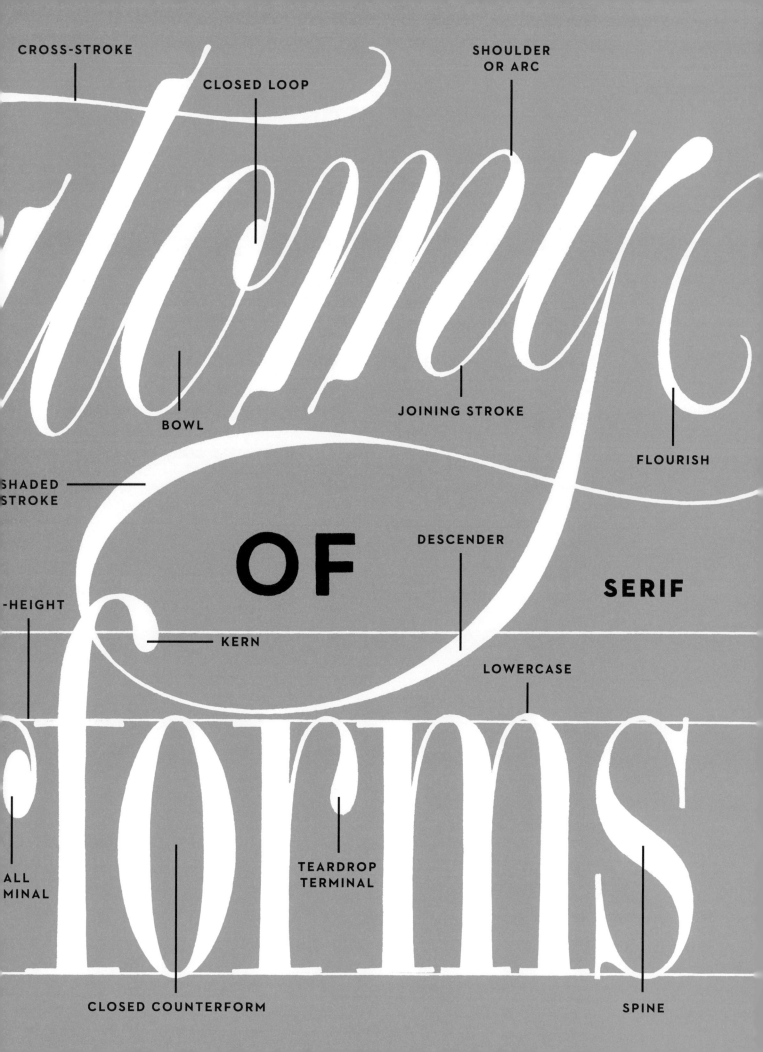

CROSS-STROKE

CLOSED LOOP

SHOULDER OR ARC

BOWL

JOINING STROKE

FLOURISH

SHADED STROKE

OF

DESCENDER

SERIF

-HEIGHT

KERN

LOWERCASE

ALL MINAL

CLOSED COUNTERFORM

TEARDROP TERMINAL

SPINE

THE ANATOMY OF LETTERFORMS

Before getting acquainted with different letter styles, it's helpful to know a few of the terms used to describe letterforms and their components. Sure, you could probably get by using "doohickey" or "thingamajig" to describe any strange or unfamiliar parts, but if you want to communicate clearly and effectively, it's best to sound like you know what you're talking about. Not only does this go a long way when working with fellow professionals, but it also helps reassure clients that the cash they coughed up to hire you was money well spent.

The illustration on the previous pages introduces the jargon associated with lettering, diagrams letterform anatomy, and demonstrates how various letters in a group are systematically treated. Keep in mind that certain features might not be relevant to particular styles. For example, components that characterize Serif letterforms will not apply to Sans Serif ones, while some categories, like Blackletter and Brush Script, exhibit qualities that are unique

to their respective styles. What is important is to examine the various traits of the letters and to observe how they are implemented throughout that alphabet.

In order to understand this better, it might be helpful to consider letterforms as siblings. While they all share the same "DNA," and therefore look related to one another, each letterform is an individual with particular quirks. Some letters may share certain qualities, such as a similar shape, while others may not. In other words, letters should look like they belong to the same family, while remaining distinct as unique members. The same is true of the various categories of letter styles that I'll introduce in the next section; some will share more of the same characteristics than others.

Most of the terminology used here and throughout this book is standard in the typography and lettering trades. You may encounter a few differences in your adventures with letters, but these should give you a good head start.

LETTERING MODELS

Getting acquainted with different letter styles is indispensable for lettering artists. Beginning with a model as a foundation, letterers can alter various aspects of the letters' appearance to suit a given situation. Many such models are related to typefaces like Clarendon or Futura, which are already familiar to most font users. These examples epitomize common categories of type classification—in this case Ionic and Geometric Sans Serif, respectively. (It's okay if you don't recognize these; they'll be introduced soon.) By studying traditional sources, you learn the essential qualities of each style, as well as the potential pros and cons of their use. Once you become acquainted with a model, there is little need to consult the actual reference itself: you will have already internalized it, along with the logic behind its creation, and can tailor hand-drawn variations of it for any conceivable application. (This strategy of using standard models as a basis for lettering is thoroughly explained in Parts 2 and 3 of this book.)

Type classification, however, is an inexact science with no single industry-wide standard. Here's an example of how confusing typographic taxonomy can be: in one well-known naming system, "Lineale" is the name given to Sans Serif, which the French sometimes call "Antique," not to be confused with Slab Serif, which also goes under that title in English, unless it's referred to as Egyptian. Gothic has been used to refer to Blackletter, but can also mean Sans Serif in America; in Germany Sans Serif is called Grotesk, and in Great Britain, Grotesque. Got it? Good.

You've probably caught on that there is no one scheme that can accommodate all typefaces. And while it's not imperative to get a degree in type history, having a general outline of related styles offers a compass to help navigate the vast sea of letterforms. With that in mind, the following list is by no means comprehensive—as the nerdiest of type aficionados will undoubtedly attest. There are countless subcategories, spin-offs, and stylistic diversions, but these are some of the most common. (In Part 3, I'll zero in on a handful of House Industries favorites, especially those letter styles whose qualities make them superior candidates for modification and therefore most relevant to lettering artists. Consult Recommended Reading on page 194 for books that geek out on the nitty-gritty of type history.)

Keep in mind that letter styles are understood in certain ways among different cultures. Therefore, populations have varying expectations in regard to the appropriateness of a letter style in a given role. That means a style that makes sense in one context is not guaranteed to work in another. For example, in looking for an appropriate style for a baseball team, many Americans would immediately conjure in their minds a heavy outlined script punctuated with a bold sweeping underline (called a paraph, in case you're taking notes). For cultures that don't share an affinity for America's national pastime, the result is not as predictable. So, it's important to consider all of the baggage we attach to letterforms.

INSCRIPTIONAL

These letter styles—also referred to as Incised, Glyphic, or Lapidary—are evocative of the square capitals that ancient Romans chiseled into stone monuments, which explains their Latin name: *capitalis monumentalis*. (Sounds pretty epic, huh? And, no, I did not make that up.) Although the oldest examples of Inscriptional styles were entirely composed of uppercase letters, later models that riff on the theme incorporate lowercase. Some Inscriptional forms have triangle-shaped serifs, sometimes leading Latin (see page 22) to be grouped in this category.

Blackletter

Sometimes referred to as Gothic, this genre has a number of subcategories and is often lumped in with other calligraphic forms that originated from broad-edged pen writing. For our purposes, Blackletter is characterized by angular "broken" strokes and the dense texture that gives the style its name. These are the kind of letters found in medieval manuscripts that were originally handwritten by scribes, before the introduction of moveable type in Western Europe during the fifteenth century put a whole bunch of monks out of business.

Old Style

Among the first roman typefaces, Old Style (also called Aldine and Garalde, the latter a portmanteau of the names of type designers Claude Garamond and Aldus Manutius) includes early examples dating to the fifteenth century. Hand-lettered Caslon—a typeface developed in the early 1700s—was pretty common in advertising during the first half of the twentieth century. Old Style is often broken into a handful of separate categories, but this catchall suffices for our purposes. The model that I reference in Part 3 (page 134) borrows from Transitional type, which bridged the gap between Old Style and the later Modern style.

Chancery Italic

As you might have guessed from the name, this style of handwriting originated in Italy. The cursive variety was chiefly developed by papal scribes during the fifteenth and sixteenth centuries, and is also referred to as Chancery. Although widely used in legal papers, business documents, and written correspondence, more elegant examples were often embellished with decorative strokes. Italic also influenced early sloped typefaces bearing the same name.

Modern

This ambiguously titled class, referred to by other mysterious-sounding descriptors such as "Neoclassical" and "Didone" (a mash-up of two exemplary typefaces, Didot and Bodoni), emerged around 1800. The vertical axis, uniform proportions, distinct *contrast* (degree of variation between the thickness of strokes), and simple serif structure of Modern letters make them particularly easy to modify and thus remarkably adaptable to all sorts of lettering applications. This versatility makes Modern among the most popular hand-lettered styles, not to mention one of my personal favorites.

Slab Serif

As you might have guessed, this class gets its name from the heavy serifs that are characteristic of its profile. You may run into examples with names like Square Serif, Antique, or Egyptian. There's usually very little noticeable contrast in the thickness of its strokes, and no bracketing (smooth transitions where the stems and serifs meet). Like Fat Face, this style was popularized in nineteenth-century handbill and poster design. Ionic, Tuscan, and Latin frequently fall under the Slab Serif umbrella, but their distinctive traits deserve individual consideration.

Fat Face

Think of Fat Face as a supercharged Modern. It was created for use in nineteenth-century advertising and has all the hallmarks of its predecessor, with one glaring difference: its thick strokes are heavy as hell! Fat Face is just begging for a hand-lettered overhaul, making it particularly fun to explore just how far the style's already exaggerated features can be pushed. (And, yes, Fat Face is a technical typographic term.)

Ionic

Clarendon is probably the best-known typeface in this style. In fact, the whole category sometimes goes under that name. Ionic typefaces, another brainchild of mid-nineteenth-century font foundries, were initially used for emphasis in book text, though large sizes also made the rounds. The sturdy, no-nonsense style has moderate contrast and bracketed serifs. This is a House Industries go-to for serious—and sometimes not-so-serious—lettering.

Latin

Some Latin letters fall under the Inscriptional category, but many are closer to Slab Serif in appearance. Whatever the case may be, there's no arguing the flexibility of the style. Latin can be robust and stern, or light and playful. Either way, its wedge-shaped serifs make Latin loads of fun to draw.

REVERSE-CONTRAST

Popularized in the nineteenth century, letter styles in this category were commonly used on posters, handbills, and other publicity pieces of the time. In the United States, they continue to be associated with circus and Wild West themes. High-contrast versions include Italienne, while French Clarendon is a popular moderate-contrast alternative. Like the name implies, the stress exhibited in these letters is opposite from the norm. In other words, the horizontal strokes are heavy while vertical ones are light.

TUSCAN

The letterforms under this category have split, or bifurcated, serifs. In fact, the serif construction can be fairly elaborate. (Is "trifurcated" a word?) Like me, Tuscan can fluctuate in weight and, in some cases, exhibit an inverse of thick and thin strokes, as discussed under Reverse-Contrast above. Cool, huh?

MISCELLANEOUS

This isn't so much a category of classification as it is a convenient way to corral a random assortment of oddballs, effects, hybrids, and one-offs that don't fit neatly elsewhere. It's a yard sale of unrelated miscellany that includes interlocking, stencil, decorative, and other novelty styles.

Casual Script

This is a broad category composed of connecting scripts that are warm, friendly, and playful. Though decidedly informal, many examples can trace their roots to Roundhand. Different takes on the style can vary in weight, slope, and scale, but they always break from the formality and uniformity of their sophisticated forerunners. Freestyle Script is a particularly exuberant variety that attempts to capture the looseness and capriciousness of handwriting.

Brush Script
BRUSH ROMAN

Versions of these related styles may be made using different brushes, but in our survey, I focus on those fashioned with the pointed kind. Brush Roman mimics Sans and Serif letterform construction, while connected Brush Script letters closely resemble free-flowing cursive and strive to give an impression of fluid movement.

Sans Serif

A fancy way of saying "without serifs," Sans is a shotgun description for a very wide range of styles. Believe it or not, making printing types without stroke endings was seen as pretty revolutionary when they made the scene in the early nineteenth century. There are tons of offshoots, by-products, and derivatives, but I'll limit our survey to a handful of varieties, which will be covered in Part 3.

Roundhand

Although Formal Script can be based on a number of models, I focus on those derived from English Roundhand. This category has its origins in seventeenth- and eighteenth-century pointed pen writing and copperplate engraving, the kind associated with all things elegant and cultured. Roundhand has gracefully joined letterforms, delicate hairlines, and usually a ton of flourishing.

It's not every day that a client asks you to brand a company whose chief product appears to defy the principles of physics, but it certainly makes for an attention-getting project brief. When Guido Fetta made a breakthrough with a propellant-free space thruster he had invented, he was ready to pitch it to investors. He just needed an identity system that was as compelling as the revolutionary propulsion drive he had created. The House crew met Guido via a mutual friend, Joel Hodgson, creator of *Mystery Science Theater 3000*. The cult comedy TV phenomenon is about a reluctant test subject and a pair of sardonic sidekick robots trapped in space and forced to watch the schlockiest of low-budget movies. As fans of the show, we were ecstatic when Joel introduced himself at a House event in 2010, and even more excited when he mentioned his neighbor, a certain law-breaking scientist.

A Roman military buff, Guido Fetta called his new venture Cannae, after the historic battle that took place in Italy in 216 BCE. This tantalizing tidbit of intelligence formed part of the eventual strategy that House designer-in-chief Andy Cruz and I would use to help shape the new mark. After hearing Guido's plans for launching his drive into orbit aboard a research satellite, our imaginations turned to space travel and the classic NASA "worm" logo. Armed with a pair of seemingly disparate sources of inspiration, we decided to roll back the clock by researching manuscripts and monuments from the dawn of the first millennium.

Everyday handwriting of the time typically favored loose cursive forms, as compared with the more restrained square capitals usually reserved for stone inscriptions. Since many early written examples lacked a predictable system—like the kind we expect from today's established typographic genres—this caused them to look like a patchwork of influences. So as I began drawing, I took the liberty to insert bits of other related styles from roughly the same period, including rustic Roman caps and early Latin uncials. I indicated the use of a broad pen, which might have been used to produce the letters, by carefully disciplining their contours, adding sheared stroke endings, and varying stroke weights. Not surprisingly, however, the lettering looked dated, hardly forward-thinking like the company it needed to embody. Andy urged me to view my work through the lens of a late-1960s sci-fi movie set designer, and to update the lettering by taking a more rational approach. Making the curved strokes superelliptical, and reducing their contrast, gave the lettering a mechanical profile, while echoes of the pen were retained in the terminals to provide a hint of warmth. A circular device, reminiscent of the space drive's shape, completed the design.

Whenever Guido's invention finally does get off the ground, Cannae's logo will help make it look good at liftoff.

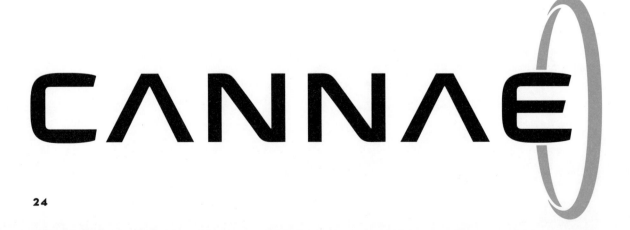

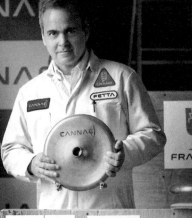

SIDEBAR
WRITING INSTRUMENTS

Many factors have impacted the development of the alphabet and the countless flavors that its letterforms have taken. Forces like technological advances, cultural influences, and intellectual views have all played important roles. However, it is handwriting that has influenced the shapes of letters most significantly. Although the influence may appear to be a distant one for many letter styles and therefore not readily apparent, the defining characteristics of letterforms (such as variation in stroke thickness or general relative proportions, to name but two) have primarily been shaped by writing instruments. Having a basic understanding of these characteristics and their effects can help you make sense of a letter's features, which may otherwise go unnoticed or appear arbitrary to the untrained eye. Most of the letter styles I highlight in this book were impacted by one of three tools: a broad-edged pen, pointed pen, or pointed brush.

The *broad-edged pen*, which has a stiff flat tip, has arguably had the biggest effect on the written word. Not only has it directly influenced different writing styles, but the broad pen also governed the creation of the earliest moveable types. When held at a 30 degree angle to the baseline, the broad inflexible nib of the pen gives a distinct modulation to the strokes of a letter. In typical upright forms, the most noticeable consequence is a diagonal stress that puts the thinner parts of curved strokes in the upper left and lower right, and the heavier parts in the opposite corners. When I dig deeper into models in Part 3, you'll see in the Ad Roman model (page 134) that use of the broad pen also creates bracketed serifs, meaning that the meeting of the letters' stems and serifs is smooth and gradual.

Letters made with a *pointed pen* take on a completely different appearance. Positioned perpendicular to the baseline, the flexible nib creates thick and thin lines in response to the application of pressure. This results in letters with a vertical stress, meaning the modulation of the strokes is mirrored symmetrically across an upright axis. With a few exceptions, serifs meet stems abruptly in an unbracketed fashion. The Modern genre (page 142) is the textbook example of letters influenced by this tool, but we'll also look at related styles like Fat Face (page 146) and Slab Serif (page 148), which share similar characteristics.

The *pointed brush* is a relative newcomer with regard to its impact on the formation of our alphabet. It can be used to create Brush Roman and Brush Script, although these styles can be achieved with other instruments. The pointed brush came to prominence during the mid-twentieth century when commercial letterers used it extensively to letter advertising headlines. Although the pointed brush relies on pressure to create variations in stroke thickness like the pointed pen yet is held at the same angle as the broad-edged pen, the resulting strokes and their stress are different than those created by either writing tool. (Lefties will need to use an overhand position to mirror these results.)

Whichever tool it may be, the consistent manner of its use reveals the logic behind it, a recognizable system that accounts for the kind of marks the pen or brush produces. Skilled letterers don't necessarily have to master an assortment of writing instruments, but having an awareness of their effects on letter formation is advantageous for emulating numerous styles in drawn form.

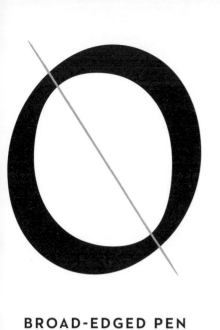

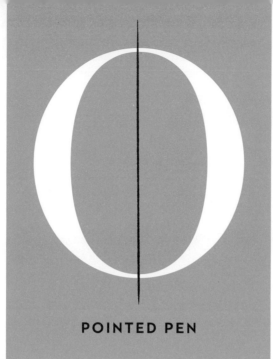

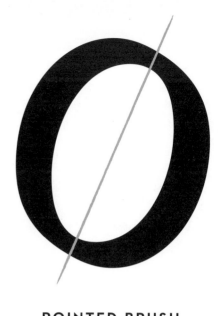

BROAD-EDGED PEN

POINTED PEN

POINTED BRUSH

EXERCISE
LETTERING MASH-UP

If you've never heard a mash-up, it's a music track that mixes two songs by different artists who are usually stylistically distinct. My favorite fuses metal powerhouse Slayer and pop star Britney Spears. It's hard to imagine two performers who are more unalike, yet somehow the pairing works. Successful mash-ups layer tunes by anchoring them to a common element, like a shared beat or musical tone. Two mismatched letter styles can be combined in much the same way, making for an amusing yet useful lettering method.

First, find two subjects for your experiment; they can be written, lettered, or typographic. Like any good mash-up, the more dissimilar the input, the more interesting the results will be. Sometimes it helps if each half of the equation has one or two joint characteristics. One example of a shared trait is contrast, the degree to which a letter's strokes vary in thickness. Another common trait might be letterform construction. Many styles are distinguished by serifs that finish the letters' primary strokes, while other categories lack additional stroke endings.

Once you've gathered the ingredients for your mash-up, take a tally of the qualities that each possesses. How are the examples similar? How are they unique? Perhaps they differ in weight, yet share similar contrast. Make a list of which characteristics from each sample you plan to keep in your mash-up to make sure you stay on track. There are countless ways to remix two separate specimens, so don't sweat it if you're not sure which direction to take; you can always take another stab at it by tweaking your recipe.

Select two sources to mash together. They can be of any kind, as long as the letterforms have some recognizable traits. A ransom-note font or sloppy handwriting with no predictable elements won't be very useful. I'm choosing two models from Part 3 that are on opposite ends of the stylistic spectrum: the sturdy Slab Serif (page 148) and the decidedly softer yet robust Brush Roman (page 188).

Despite their differences in style, structure, and weight, both examples have a low degree of contrast. For my initial sketch, I'm taking the slope and burliness of Brush Roman, and combining those elements with the crisp terminals and round curves of Slab Serif as a way to weave these otherwise unrelated styles together. Make sure to apply your changes consistently to each letter.

I can achieve startlingly different results by focusing on another set of attributes, or simply take my mash-up in a slightly new direction by changing one. Applying the stroke character of the Brush Roman to the structure of the Slab Serif, the letters take on a distinct appearance. In Part 2, I show you how to build on these ideas by identifying other traits that can be adjusted to further modify your lettering.

1

mash-up

mash-up

2

HEAVY STROKE WEIGHT
OF BRUSH ROMAN

BRUSH-LIKE S

ROUND CONTOURS
LIKE SLAB SERIF

mash-up

CRISP SLAB-SERIF
TERMINALS

BRUSH ROMAN CONTRAST
AND PROPORTIONS

3

OVERLAPPING
BRUSH-LIKE STROKES

BOUNCING
BRUSH-SHAPED SERIFS

mash-up

SLAB SERIF
TERMINALS

BRUSHY S

WEIGHT AND FORMS
OF SLAB SERIF

SIDEBAR
MONOGRAMS

I tend to associate different letter styles and techniques with personal memories. I clearly recall mornings at home as my father got ready for work. The smell was an odd mix of sulfuric "dippy eggs" (soft and runny for dipping toast and other items) and the menthol of dad's aftershave. I may have failed to appreciate his breakfast of choice, but I never forgot the distinctive monogram on that bottle of Aqua Velva. Even then, I noticed how a deceptively simple pair of letters could pack a punch (almost as strong as the scent of the lotion).

Generally speaking, a monogram is a graphic device comprising two or more letters, usually initials interconnected to create a decorative motif. They can provide simple yet memorable solutions for both personal and professional applications. Not only are they friendly and accessible, their versatility makes them adaptable to a wide variety of uses. A monogram can complement other elements in a complex signature, or stand on its own. The New York Yankees, Chanel, and Volkswagen—among countless others—employ modest yet powerful monograms to reinforce their brands.

While many monograms rely primarily on the directness of their letterforms, others make a visible effort to mold their components into a distinct emblematic shape. Some designs are more pictorial in nature, with forms arranged to create a particular image, or abstracted to the point that their letters are barely recognizable. Of course, the approach depends on the purpose and application of the final mark.

Although there are countless ways to arrange monograms, most tend to favor either a symmetric or asymmetric layout. Symmetric designs are most easily accomplished when letters repeat or are structurally similar. *Spegelmonogram* (Swedish for "mirror monograms") reflect letters across a vertical or horizontal axis to create perfectly balanced compositions. Asymmetric designs can make for engaging marks, too, and are especially useful for groups of dissimilar letters. Look for common forms among the different letters, or strokes with corresponding shapes and alignment. Try to balance positive and negative forms regardless of the layout. Each monogram must be addressed according to its own unique combination of letters. Their sequence and shapes may make one approach more obvious, and often easier, than another.

When combining styles, choose letters that share a few basic qualities, such as weight or contrast. Or, pair ones made with the same tool or production process—like Roundhand script and Modern letters, common in eighteenth-century engraving. Letter styles developed around the same time period, such as the various kinds of nineteenth-century wood type, are also typically good candidates. Whichever you choose, draw loads of rough thumbnails before exploring any in further detail. If the monogram is a logo, make sure it will work at small sizes, so avoid creating tight negative spaces that might fill in when the monogram is scaled.

Monograms are easy enough to explore, so don't be shy about giving an idea a shot. If it doesn't work out, simply move on to the next one—the letters are bound to come together eventually.

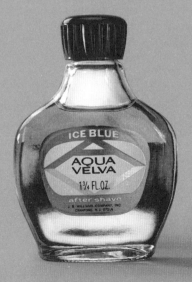

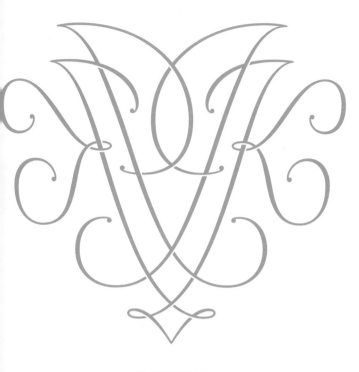

JK MONOGRAM

MIRRORED DESIGN

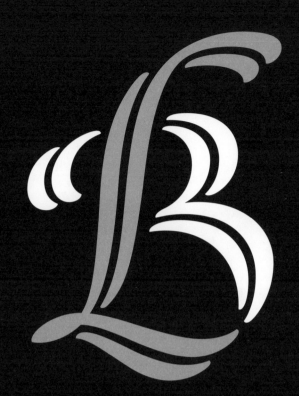

LB MONOGRAM

SHARED STROKES

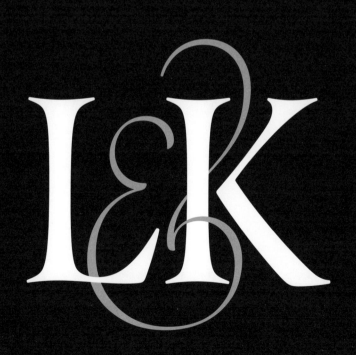

L AND K MONOGRAM

CONTRASTING STYLE AND WEIGHT

K AND C L MONOGRAM

INTERWOVEN LETTERFORMS

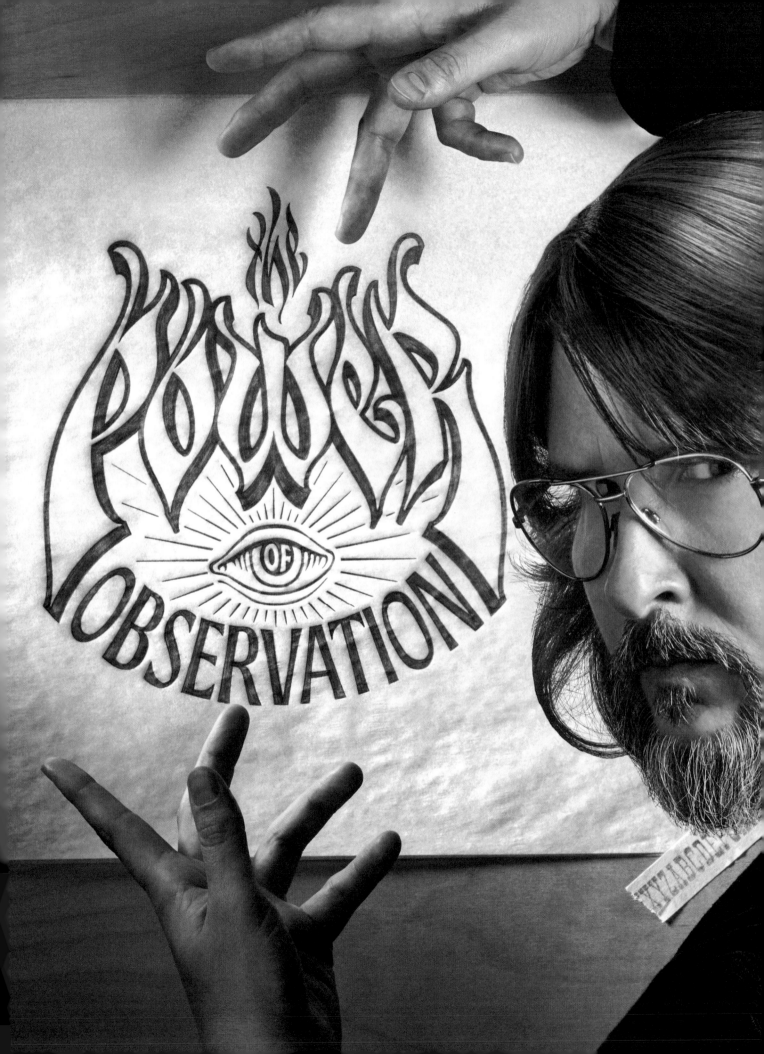

THE POWER OF OBSERVATION

While the essence of letters has changed little over the centuries, that doesn't mean there isn't room for interpretation. Yet, while imitation is a practical method for learning, you shouldn't just thoughtlessly copy lettering models. When evaluating the various letter styles, carefully observe the features of each, particularly how those traits are carried through a set of characters. Note the construction of the letters: Is there anything unique about them? What about the degree of contrast; is it especially low or high? Which tool could have influenced their appearance? How does the scale of the lowercase relate to the uppercase: are the capitals unusually big or small? How could the overall proportion of the letters be described: is it condensed, normal, or extended? These are just a few considerations that cross the mind of a diligent letterer when adapting a style to create a piece of lettering. This is why *observation* is the most important skill to develop. Being attentive to the numerous attributes that define a letter style—and reproducing those details consistently—is crucial to creating successful and memorable hand-lettering.

◀

Conjuring hypnotizing letters relies on an artist's attention to detail. Honing observational abilities takes time, but is an essential skill.

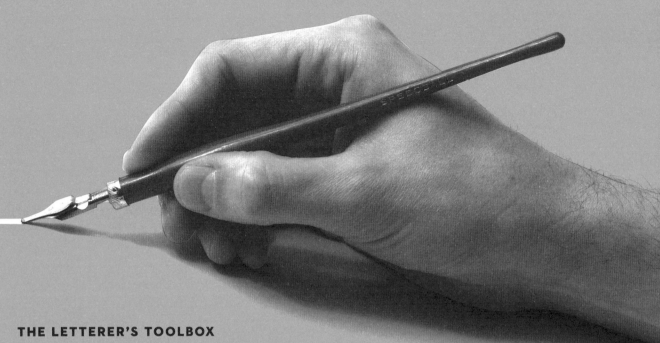

THE LETTERER'S TOOLBOX

Before I get into the finer points of drawing in the next section, let's talk about the tools that will help you get started. While tools play an important role in lettering, as with any trade, no tool will magically give you the answers or suddenly unlock the mysteries of drawing letterforms. True, a broad edge may give a predictable quality to pen work, but only in the hands of someone who knows how to use it properly. More than once I've encountered a student who seemed more preoccupied with getting his or her hands on the "right" tools than investing time in applying the concepts that are the actual secrets to making successful hand-lettering.

While there's no substitute for experience, using familiar materials can make a difference in one's personal process. The few supplies listed here aren't terribly fancy or unusual, but they reliably give me the results I'm after. My process invariably begins with a sketch, usually pencil and tracing paper; it's very rare that I begin anything on the computer. I used to ink artwork before vectorizing it (a digital production method in which the shapes of letters are created by connecting points and lines), which is how most of my lettering is ultimately produced, but I rarely bother anymore. (See page 121 if you're interested in some helpful digitizing tips.) Not only am I able to

achieve a high degree of precision with pencil if needed, but I also discovered that showing clients rough sketches is much more persuasive. They can immediately recognize drawing ability and therefore appreciate that the design process requires skill, even when the subject is letterforms.

Vector art and its production are foreign to most people outside of the design trades, and many assume that all letterforms are the product of fonts. Polished artwork, whether carefully inked or digitized, also has a perceived "finality" to it. Penciled lettering, on the other hand, suggests it's one step in a series of many toward completion that leaves the work open to further possibilities. As any professional can attest, at times the relationship with a client can feel more like a war than a collaboration, and every battle in the campaign, no matter how small, counts. To that end, I favor rather simple tools and materials. (As far as special equipment is concerned, I can usually get by without the need for anything fancy. The dining room table is a perfectly fine substitute for a desk, while the kitchen window works surprisingly well for tracing sketches upon.) Ultimately, the choice of lettering supplies is a personal one. If something is new or unfamiliar, go ahead and take it for a spin—you never know.

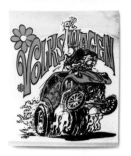

I count books and other influential items among some of my most valuable tools. Over the years, I've amassed a considerable amount of reference material, from old writing primers and instruction manuals to musty type specimens and advertising annuals. Prices have risen along with the popularity of lettering, but gems occasionally turn up at used bookstores and flea markets. Thankfully, out-of-print classics are also regularly being reissued.

While these seem like obvious sources, I've poached ideas from a few surprising places, too. For example, I discovered that textbooks from the engraving, embroidery, cartography, and drafting trades all offer their own take on the alphabet. Everyday magazines from the twentieth century, scoured from second-hand shops and yard sales, are additional sources of inspiration. They're packed with advertisements showcasing practically every imaginable letter style, from Modern to Brush Script and nearly every flavor in between. The local thrift store offers another virtual library of inspiration in the form of hand-lettered album covers, book jackets, and other discarded treasures.

I also keep a "morgue" of pieces clipped from various periodicals, and a digital database of personal photos taken of hand-painted signs and vintage packaging. While no one piece will provide the answer, building a visual lexicon of lettering and its various applications can help to jump-start the design process or offer clues when you've hit a creative wall.

PENCILS AND ERASERS

For most work, I use plain old No. 2 pencils (which are around the same hardness as those marked HB). When I'm too lazy to keep reaching for the sharpener, I'll sketch with a 0.7-mm mechanical pencil. The graphite is thin enough for fine line work, yet beefy enough that the tip doesn't snap every time I apply pressure. When I want to avoid smudging, as softer lead is inclined to do, I grab an F or H grade pencil. The marks they produce generally aren't as dark, but the harder graphite allows for sharper points and finer line work. To get an extremely controlled line, I suggest trying a pencil lead holder. They can be a pain because they require frequent fine-tuning with a lead pointer, but they're tough to beat when precision and control is paramount. Steer clear of cheap wood-composite pencils; they're usually filled with sub-par graphite, difficult to sharpen, and topped with a useless eraser—you've been warned.

When I'm looking for contrast similar to that achieved with a broad-edged pen, I make a preliminary pass with a flat carpenter's pencil, then refine the sketch with a regular one. Don't bother with the special sharpeners devised to accommodate the pencil's broad rectangular lead; a box cutter or utility knife does a superior job. (Just watch out for your fingers!) Square-off the tip with a small hard-backed sandpaper pad.

I'm not picky when it comes to erasers, as long as it's not one of those hard white plasticky kinds that only seem to be good for pushing graphite around. Usually the eraser at the end of my No. 2 pencil works just fine. The pliable kneaded variety is good for gently picking up extra graphite before final drawing or inking, while a gum eraser helps clean up fine remaining details after the lettering is complete. I haven't used a gritty ink eraser since grade school; instead, I carefully scrape away stray ink spots with the point of an X-Acto blade.

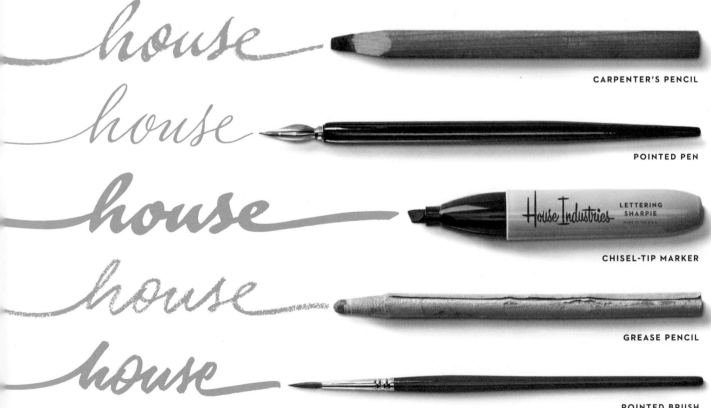

CARPENTER'S PENCIL

POINTED PEN

CHISEL-TIP MARKER

GREASE PENCIL

POINTED BRUSH

PENS

In most situations, my work is ultimately rendered as scalable vector artwork—according to the request of the client or the demands of the final application—so there are few occasions when I draw in ink. I recommend that you explore a variety of pens to find what works best for you and the task at hand. Keep in mind that water-based inks typically don't provide the dense black that permanent alcohol-based inks do, nor do they dry as quickly. However, water-based pens can provide a crisper line in some instances since they're less likely to bleed on fibrous paper.

Considering that I'm a letterer and not a calligrapher, the jobs I do rarely call for unedited pen work—unless, of course, I'm looking for a particular line quality that I can easily get by using a certain tool. There are a number of metal broad-edged fountain pens that come in a variety of sizes and use convenient disposable cartridges. However, like most of my mentors, I usually imitate these strokes by drawing them—this includes the high-contrast kind created by flexible pointed nibs, and even organic strokes created with a brush. Mimicking the effects created by specific tools is a common practice that advertising letterers refer to as forced lettering. In order to pull this off convincingly, however, some awareness of the mechanics of the tool and the results it produces is required. With that in mind, a few felt-tipped calligraphy markers in assorted sizes (3.5 mm and 5 mm) come in handy when it's necessary to get a quick refresher on broad-edge strokes.

Speedball pens are a personal favorite, especially the B and D styles, which feature flat, upturned elliptical tips. Just remember to clean your pens thoroughly afterward. As with any tool, the better you treat it, the better it will treat you.

BRUSHES

I use a pointed sable brush for creating Brush Roman and Brush Script lettering. My all-time favorite, and the go-to for twentieth-century advertising letterers, is the Winsor & Newton Series 7. The springy absorbent tip is composed of hair obtained from the tails of Siberian kolinsky sables. While I dread the thought of all those bald weasels braving the unforgiving Russian winters, no other variety comes close. The cost will set buyers back a couple of bucks, but a brush treated with care can provide a lifetime of faithful service. A No. 2 or No. 3 size can hold enough color to produce a wide range of stroke weights, from fine to beefy brushwork. Just make sure to use India ink or lampblack (basically, pigment made from soot); acrylics and other kinds of paint-like ink will quickly take years off the life of the brush, if not ruin it completely. Make sure to wash brushes under cold water with soap immediately after use.

Brush-tip markers come close to emulating the texture and effect of genuine brushes, but the tips tend to fray after a short period of use. However, they are convenient for brush lettering on the go. During the lettering workshops I teach, I have students use brush markers because it bypasses both the time required to get accustomed to swinging a brush loaded with ink and the potential mess that comes along with it. Surprisingly, children's pointed coloring markers also do the job in a pinch.

Another alternative is synthetic brush pens. Many have replaceable ink cartridges, and a few offer refillable reservoirs, so you can use your medium of choice. The tip holds its point and is more durable than its spongy marker counterpart, but the nylon fibers lack the snap of a true sable brush. There's nothing like the real thing.

PAPER

I like small, pocket-sized notebooks for sketching thumbnails and jotting down memos, but for larger preliminary pencil sketches, I use toothy student-grade tracing paper (referred to as tracing tissue or onion skin in old-school instruction manuals). A standard 9 by 12-inch pad provides enough room to draw at a reasonable size, and allows me to slide sketches under the top sheet for subsequent revisions without having to tape anything in place. Keep in mind that the acid in cheap wood-pulp products will eventually oxidize; the yellow patina looks cool in photos, but drawings may not hold up well over time.

For final drawings, I opt for rag marker paper, sometimes called visualizer paper. It's cotton-based, which makes for a brighter, semi-translucent sheet. It's comparatively pricey, but it's heftier, smoother, less prone to wrinkling, and won't become discolored or brittle like tracing paper. Marker paper is also resistant to bleeding, which makes it a great candidate for inking. I find that frosted vellum and other plastic sheets (even ones with a matte finish) pick up oil and smudge too easily for tight pencil renderings. They also don't absorb water-based ink, so they're not very useful unless you're using permanent markers.

Graph paper (also called grid or quadrille paper) is a time-saver for drawing guidelines. However, I'm usually hesitant to recommend it to students because it tempts beginners to strictly conform to the grid.

OTHER ASSORTED ITEMS

There are a few other indispensable tricks and unexpected tools that I've added to my arsenal over the years. One favorite is a dressmaker's ruler—a transparent straightedge die-cut with a number of long, evenly spaced horizontal slots that make plotting parallel guidelines a breeze. However, the large size doesn't exactly make them travel-friendly. Instead of relying on French curves or flexible rulers, I draw flourishes, ellipses, and arcing guides freehand, and recommend that you take the time to practice honing your hand skills by doing the same. Otherwise, the possibilities extend only as far as your toolbox.

Another standby is a *hake* wash brush, which I use to gently brush away eraser and graphite residue. It's got a wide, flat bamboo handle and is made with fine sheep hair that won't smudge tight pencil drawings.

An everyday correction-fluid pen is handy for fixing mistakes. It's also useful for sculpting inked letterforms, and for editing when the paper has gotten too thin and flimsy from overexuberant erasing.

On the rare occasions that I use tape to secure sketches in place as I refine them, I prefer a removable transparent matte-finish adhesive tape (like Scotch Magic Tape). Pick up a little lint from your clothing before using it on a drawing to ensure that the paper doesn't tear when you reposition or remove the tape. Painter's masking tape is a nice low-tack substitute.

I use a couple of vector drawing programs for final production, but any high-tech gadgets or name-brand drawing supplies that I recommend may well be out of date by the time you read this. Besides, there are always new products hitting the shelves, so try as many as you can and stick with what works.

By now, you should have a solid grasp on the foundations of lettering: how it's made, the various roles it plays, and the advantages it offers. The basic understanding you've gained about the anatomy of letterforms, and the many ways they have been interpreted in common typographic genres, will also help you build on these ideas in the next section. So roll up your sleeves, sharpen your pencils, and prepare to get your mitts dirty as we drill down on the nuts and bolts of lettering technique.

EXERCISE
FOUND LETTERING

Have you ever stumbled across lettering and wondered what other letters in the style would look like? A common method for generating new artwork is to decode the qualities of an existing sample of "found" lettering, and to expand those traits into a new wordmark. Riffing off a limited set of letters—like an old ad caption, neon sign, or car emblem—is a fun and practical exercise for examining unfamiliar forms and exploring new ideas. Drawing from found lettering also lets you retrace the decision-making of other artists to catch a glimpse of a different way of thinking.

Your lettering reference should demonstrate consistency, and have qualities that are suitable for your purposes. If the reference is a well-known mark, be careful not to borrow its distinguishing features. The lowercase of the famous Coca-Cola script isn't particularly special, but the uppercase forms and the logo's overall composition are unique.

If your found example offers insufficient clues, consult lettering in the same vein or a stylistically related typeface to help fill in the blanks. Turn to the categories listed in Lettering Models (page 129) to point you in the right direction.

Just be careful not to imitate others' work too closely. There are only a few letters separating "riff off" and "rip off." Unless you're parodying well-known lettering, or making a tribute, be sure to bring something new to the table, which might be different proportions or a novel layout. To stay on the safe side, stick to older vernacular lettering by unidentified artists that's in the public domain. Flea markets and garage sales are good spots for scoring vintage magazines, packaging, and label designs to serve as inspiration.

40

Dig up some found lettering that gives enough information to extrapolate other letterforms. This photo of a 1960s-era acrylic sign resembles a casual roman letter of moderate weight and proportions with smooth transitions between its strokes and serifs. Similar features exhibited by the Photo-Lettering font, Quicksilver, provides additional clues for missing letters.

Begin by plotting simple shapes to indicate the relative size and placement of each letter. This step helps to establish the general dimensions of the lettering, as well as the overall volume and spacing of the individual forms. I drew my interpretation a little wider and bouncier to mix things up. Remember, further edits can always be made during subsequent rounds of revisions.

As you draw, observe the vertical, horizontal, diagonal, and curved parts. Take note of the strokes' thickness, where they taper, and how they end. Consider the letters' weight and proportions, too. Mix things up by changing the overall look of the letterforms, such as altering their case, width, and alignment as I've done here. (For more ideas, review Modifying Letterforms on page 78.)

Keep in mind that many letters share similar constructions. One letter might hint at the shape of another. Here, flipping the u gave me a head start drawing the n. Make sure your lettering creates an even texture (called color) by balancing positive and negative spaces evenly before you embellish the letters, as I've done by outlining mine.

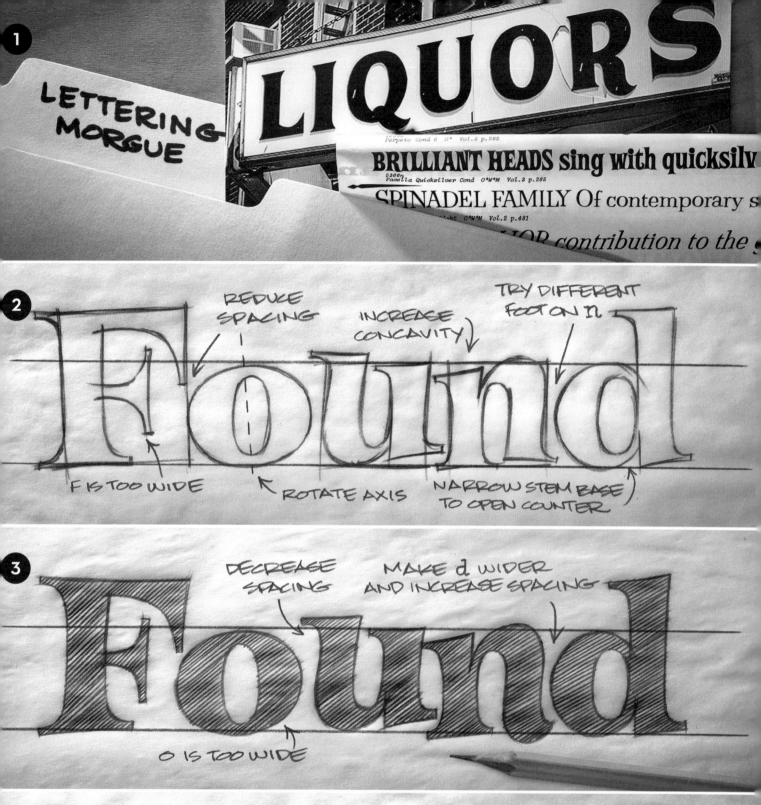

1

LETTERING MORGUE

LIQUORS

2

REDUCE SPACING

INCREASE CONCAVITY

TRY DIFFERENT FOOT ON n

Found

F IS TOO WIDE

ROTATE AXIS

NARROW STEM BASE TO OPEN COUNTER

3

DECREASE SPACING

MAKE d WIDER AND INCREASE SPACING

Found

O IS TOO WIDE

4

★ TRY OTHER EMBELLISHMENTS LIKE INLINES, OUTLINES, AND MORE!

Found

LETTERING TECHNIQUE

The beauty of lettering is that a handful of simple forms can speak volumes, just by the way they're shaped and arranged. But communicating effectively is not merely a matter of style; good lettering depends on sound practice. What separates the forgettable from the phenomenal is well-honed technique. In this section, we get down to brass tacks, beginning with an overview of practical drawing methods. Then, we jump into the most important aspect of the lettering process—color— and the key elements that affect it. After getting the hang of a few more basic concepts, such as optical effects and how they shape letterform construction, we examine practical drawing methods and common mistakes. Next, we build on what has been learned to compose complex layouts. The section wraps up with a look at production, including useful vectorizing and proofing tips. Helpful skill-building exercises peppered throughout this section offer a hands-on peek at how these important ideas come together in Part 3.

SECTION TOPICS

▸ **DRAWING METHODS**

▸ **SKETCHING TECHNIQUES**

▸ **COLOR: THE MOST IMPORTANT FACTOR**

▸ **OPTICAL EFFECTS**

▸ **MODIFYING LETTERFORMS**

▸ **COMPOSITION**

▸ **PUTTING IT INTO PRACTICE**

▸ **PRODUCTION**

Many beginners often try to apply a rational, mathematical approach to drawing letterforms. They mistakenly think that the thickness of all strokes is uniform, or that the height of upper-case letters is all the same. (Spoiler alert: it rarely is.) The truth is, successfully managing a group of letterforms depends largely on optically measuring the space the letterforms occupy. The technical term for this is "eyeballing." It isn't something that can be taught, but rather must be learned through practice. Despite the fact that there is no simple formula for drawing and composing letterforms, there is a handy set of basic principles you can use to guide the decision-making process. Let's begin by comparing various drawing and sketching methods.

COMPONENT DRAWING

AREA DRAWING

PERIMETER DRAWING

DRAWING METHODS

While there are different ways to draw letterforms, the three most common varieties that I've encountered are component, area, and perimeter drawing. Each method has its pros and cons, so I recommend giving each a try—following my suggested applications—and using what works best for you.

1 COMPONENT

2 AREA

3 PERIMETER

COMPONENT DRAWING

This is the approach I use most often, and I find that it is also the most intuitive method for beginners. Component drawing involves outlining the primary parts of the letterform before filling them. It can be seen as the inverse of the area drawing method, in which the general volume of the letter's parts is determined before refining the outer edges. Component drawing is ideal for large-scale drawings (practically anything bigger than a small thumbnail sketch) and heavy low-contrast letters (those with less noticeable variation in stroke thickness).

AREA DRAWING

This technique involves defining the form of a letter by simultaneously providing volume to its strokes. One way to accomplish this is to oscillate a pencil back and forth at a set distance to provide weight and structure to the different parts of the letter. This movement mimics the results you would get using a broad-edged pen or carpenter's pencil. You can also build up the volume of the letterform by making successive straight or curved marks, before polishing the details of the outer silhouette. The area drawing method can be done over the top of a skeletal letterform until you get the hang of visualizing the letter as you draw. This can be tricky for novices and therefore feel less than intuitive, but it is a quick and handy way to assess the visual mass of a piece of lettering. Whether you use area or component drawing, both require practice. I frequently use this technique for thumbnails, or when sketching high-contrast styles (those with significant weight variation between heavy and thin strokes) like Modern and Formal Script.

PERIMETER DRAWING

This method involves drawing a continuous line to define a letter's silhouette. Imagine placing your pencil on a drawing surface and, without lifting it, tracing the edge of a letter until you return to the starting point. Counterforms—the independent shapes within letters, like the negative space inside an R, for example—are made separately in the same way. I generally do not recommend this method for most instances because parts of the silhouette that one would expect to align—especially between the counterform and outer perimeter—usually do not. This is the way that children commonly draw "bubble letters" in order to imply dimension. It has its charms, but I suggest leaving this method to loose thumbnail sketches, or whimsical lettering where a naïve look is desired.

SKETCHING TECHNIQUES

Once you've determined the method for drawing individual letters, you need to consider how they're positioned within a word. This is important because nearly all lettering needs to be designed to work within a specific area. For the time being, we won't concern ourselves with composing an elaborate piece of lettering (more on that soon); rather let's focus on plotting a string of letterforms. The two approaches I use are skeletal lettering and proportional lettering. Like the foundational drawing methods, each sketching technique has it benefits and drawbacks, and both require time to master.

① SKELETAL

② PROPORTIONAL

1. UNDERLYING LINEAR FRAME

2. UNDERLYING FRAME WITH ADDED VOLUME

SKELETAL LETTERING

This technique involves building letterforms on top of an underlying linear frame. (Want to impress guests at your next dinner party? Drop the word *ossature* on 'em, which is just a smart-assed way to describe the same thing.) The skeletal foundation is used to determine the general form, dimensions, and position of each letter. Once the bones of the lettering are established, the volume of the letterforms can be fleshed out before the final nuances of the outer contours are refined. This method pairs well with the area drawing technique, but can be tough to nail on the first draft, especially if you haven't anticipated how added mass will affect the spacing of the letters. But that's what tracing paper is for, right?

◄

The initial underlying framework can be thought of as the "skeleton" of the lettering. Continuing the metaphor, volume further defines its "body," while the details affecting the final silhouette act like "clothing" to give the lettering its distinct personality. I generally don't recommend using skeletal forms as a practical way to plot heavy letters, because it can be difficult to anticipate their final proportions as you add volume to the strokes.

PROPORTIONAL LETTERING

With this technique, you define the volume of the letterforms first by indicating scale and dimension. Just as skeletal lettering can be understood as creating from the inside out (since you build on top of a linear base), proportional lettering can be seen the other way around: beginning with simple shapes suggesting the approximate size and structure of the letterforms, you add definition by working from the outside inward. This approach allows you to account for the scale, placement, and relative proportion before indicating the details of the letters. I typically combine proportional lettering with the component drawing method. It may take a while to get accustomed to thinking of letters as abstracted shapes before giving them any actual definition, but this technique can shave a lot of time off the preliminary sketch phase once you master it.

Getting a grip on drawing and plotting letterforms is a good place to start, but you still need to know how to size, shape, and position them properly in order to create a balanced piece of lettering. The real secret to this lies in the relationship between the letters' positive forms and the resulting negative areas they produce. Understanding this foremost principle and the primary factors that influence it is paramount.

1. BASIC UNDERLYING SHAPES

2. BASIC UNDERLYING SHAPES WITH ADDED CONTOURS AND VOLUME

"COLOR":
THE MOST IMPORTANT FACTOR

Letters are essentially defined by black shapes (strokes) and white shapes (counterforms). When one is changed, the other is also affected. Managing the delicate relationship between foreground and background is the foremost consideration when it comes to lettering. Your goal as the letterer is to create consistency within a piece of lettering by balancing its *overall visual texture*, commonly referred to as "color."

Color is the result of a combination of four main contributing elements: volume, spacing, contrast, and proportion. Harmonizing these interrelated factors, however, requires more than simply training your hand: you must also learn to train your eye. Observing how the primary elements impact color will allow you to judge the successes and shortcomings of any piece of lettering. While these overlapping concepts are not easily separated, you should be able to trace any weak points in your lettering back to one or more of them.

LIGHT "COLOR"

1. VOLUME
2. SPACING
3. CONTRAST
4. PROPORTION

In typography, the color of a text setting refers to its gray value, or how "light" or "dark" it appears. Similarly, lettering should strive for a uniform appearance. However, "weight" isn't adequate enough to describe how even texture is achieved; color relies on other more important contributing factors.

DARK "COLOR"

VOLUME

Volume refers to the overall area an object occupies. A letterform's volume is determined by both its strokes and its counterforms. After all, you can't make a positive shape without defining a negative space. Because each letter has a different form, its positive and negative spaces are distributed uniquely. This not only affects a letter's silhouette but also its spacing, stroke contrast, and relative proportions, as you'll soon learn.

Different varieties of strokes—vertical, horizontal, curved, and diagonal are the most basic—also have particular characteristics that affect their volume, and therefore stroke thickness. It may surprise you to learn that all strokes are not typically the same width at their broadest points, even though they might appear so. You guessed it: it all comes back to harmonizing color.

▶

These simple geometric shapes illustrate the concept of volume. Mathematically speaking, the square and circle have the same height and width, yet the circle appears comparatively smaller because it doesn't have as much surface area as the square. This is obvious when the square is placed behind the circle; the circle clearly lacks volume due to the nature of its shape. By making the circle slightly larger, extending its edges beyond that of the square, the added volume makes the circle now appear the same size as the square. The same goes for the triangle. You can apply this thinking to letters that share profiles similar to these geometric shapes. Although some letters are a combination of basic shapes, they still follow this general rule.

▶▶

You probably noticed that the different shapes create unequal space between them when mechanically spaced. To balance the inconsistent volume of these negative areas, the spacing of the positive forms requires adjustment.

▼

To help determine consistent volume while sketching, draw circles over the widest part of each primary stroke. If the circles differ noticeably in size, you'll know that the strokes need to be adjusted. Despite the slight variations in thickness between the different kinds of basic strokes, this handy shortcut will help keep you on target.

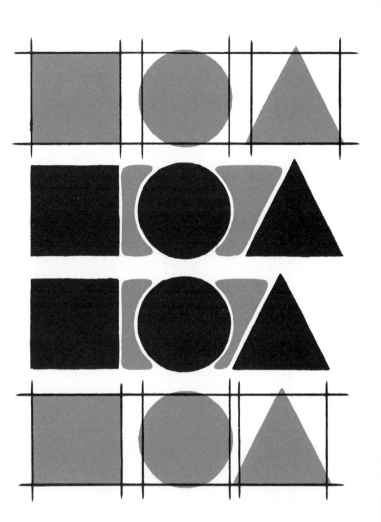

HOA

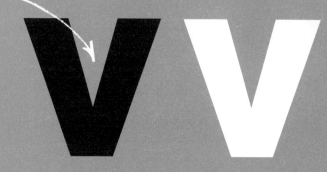

CORRECT CONSTRUCTION **BACKWARD FORM**

Diagonal strokes extending from the upper left to lower right are usually thicker than vertical ones, while those moving from the lower left to upper right are generally thinner. Viewing a letter upside down or backward makes this more obvious. This rule is often broken, however, in bold mono-weight diagonal strokes comprising complex letters like the M, N, and W.

EQUAL STROKE THICKNESS **TAPERED STROKES**

In the case of bold, heavy, low-contrast letters, diagonal strokes are often tapered to alleviate a buildup of volume where they join. Uneven color can also be avoided by cutting into the areas of accumulated volume, creating what is referred to as an ink trap.

We perceive horizontal strokes as heavier than vertical ones, even when their thicknesses are the same. To adjust for this, cross-strokes are made thinner in styles that have a low degree of variation in stroke thickness or contrast. Similarly, arcing strokes at the tops and bottoms of round letterforms are thinned slightly. Placing mechanically mono-weight forms behind the letters helps to illustrate the necessary adjustments.

CURVED STROKES ARE SLIGHTLY THICKER THAN VERTICAL ONES

Just as round forms need increased surface area in order to have the same apparent volume as square forms, curved strokes are usually a little thicker at their widest point compared with vertical strokes. Placing vertical stems behind the O reveals the differences in stroke thickness.

LOWERCASE STEMS ARE THINNER THAN UPPERCASE ONES

The strokes composing uppercase letters are generally thicker than those of lowercase forms. This is because larger proportions mean larger counterforms, which require heavier strokes to provide balance. If the thickness of uppercase strokes were identical to the lowercase, the uppercase letters would appear to be too light. Placing uppercase stems behind this lowercase n reveals the differences in stroke weight.

BRANCHING STROKES ARE TAPERED TO REDUCE VOLUME

Branching and overlapping strokes, especially those of heavy low-contrast letterforms, tend to gain an excessive amount of volume. In order to alleviate the unwanted weight from such areas, strokes are sometimes tapered or thinned significantly.

EQUAL STROKE THICKNESS　　　　**TAPERED STROKE**

mint

mint

While maintaining consistency among strokes is undoubtedly important, beginning letterers tend to overlook the importance of the negative spaces that are simultaneously being defined. Uniform volume is determined by form *and* counterform, both of which demand careful consideration.

To judge the volume of counterforms, fill in the negative areas on a separate layer or sheet of tracing paper, then compare your results. The counters are likely to be different shapes, but the area each occupies should be visually similar. You can also use this trick to gauge the space between letterforms, which should be comparable to the volume of the counterforms.

Upper- and lowercase letters can be loosely grouped according to similar strokes or structures. This is especially useful when creating letters that share common attributes, or extrapolating new letters from a limited sample. Just be careful not to make a Frankenstein's monster of thoughtlessly stitched-together parts; each letter demands special attention according to its individual attributes. This is only an example; letters in other styles might be grouped differently.

UPPERCASE STRUCTURES

VERTICAL STEMS

EFHILT

CURVED STEMS

CGOQS

VERTICAL AND CURVED STEMS

BDPRJU

DIAGONAL STEMS

AVWXZ

DIAGONAL AND VERTICAL STEMS

KMNY

LOWERCASE STRUCTURES

VERTICAL STEMS

filtj

CURVED STEMS

ceos

VERTICAL AND CURVED STEMS

abdgpq

DIAGONAL STEMS

kvwxyz

VERTICAL STEMS AND BRANCHING STROKES

hmnru

SPACING

You've already gotten a glimpse at how letter spacing is connected to the principle of volume. As a general rule, the area *between* letters should correspond to the area *inside* them. Since letters composed of thin strokes generally have larger counterforms, they should be spaced more openly compared to heavy letters. Conversely, heavy letters tend to have relatively small counterforms and therefore should be spaced more closely to one another. Whatever you do, never measure the distances between letters mechanically; this will result in uneven visual spacing and poor color. Spacing must be done optically.

The space between words should also relate to letter spacing. When words are spaced too closely, it can be difficult to make them out. When they are spaced too openly, the reader may be less apt to connect them, and the message can get lost. As a rule of thumb, the value between lowercase forms should be a little larger than the counterform of the n. For uppercase lettering, it should be a bit bigger than the counterform of the H. These values are offered only as a visualization technique to illustrate word spacing. With a little effort, it will gradually become second nature.

This principle also applies to separate rows of words: light lettering should be given more "air" between rows, while lines of darker lettering should be positioned more compactly. Rows of words should also be visually—not mechanically—spaced in order to account for ascenders and descenders, which can disrupt the spacing between lines.

× house
lettering
manual

INCORRECT MECHANICAL LINE SPACING

house
lettering } x
manual } x

✓ house
lettering
manual

house
lettering } x
manual } <x

CORRECT OPTICAL LINE SPACING

minimum

INCONSISTENT SPACING

minimum

INCONSISTENT STROKE VOLUME

minimum

CONSISTENT SPACING AND STROKE VOLUME

SPACING

INCORRECT MECHANICAL SPACING

SPACING

CORRECT OPTICAL SPACING

SPACING

TOO TIGHT

SPACING

CORRECT SPACING

SPACING

TOO LOOSE

SPACING

CORRECT SPACING

▶

Visual rhythm in lettering is primarily created by the regular sequence of positive strokes and negative spaces. This predictable pattern is disrupted when the components are treated carelessly.

▶

Internal and external spaces are best spaced optically. Counter-forms are not insignificant voids; the area they occupy affects the volume of letters as well as the spacing between them. If we highlight the spaces between letters, they should take up the same amount of area despite being different shapes. Compare this to mechanical spacing, which results in an irregular and undesirable visual texture. Whenever in doubt about the consistency of your spacing, throw a piece of tracing paper over your lettering and fill in the spaces; if the resulting forms appear to have similar volume, you're in good shape.

▶

Spacing light letters too closely ignores their open counters, making them appear crowded while spoiling their airy appearance.

▶

When heavy letters are spaced too openly, the strength of their bold strokes is diminished and its impact is weakened.

◀◀

Just as letters require adjustments to balance the negative space between them, so do rows of words. Ascenders and descenders can cause some rows of words to appear closer to one another compared with rows of words without any ascenders or descenders—even if all the rows are the exact same distance apart.

CONTRAST

Variation in the thickness of a letter's strokes
is referred to as contrast. We've already seen
how some strokes call for slight adjustments
in order to maintain volume, but a handful
of letter styles—like Modern, Fat Face, and
Formal Script—are characterized by a fair
amount of difference between their thick and
thin strokes. Such lettering can be described as
high contrast. Other varieties—like Slab Serif,
Ionic, and Geometric Sans Serif—are typically
defined by a lesser degree of variation in the
thickness of their strokes and are called low
contrast. No matter what kind of letter you're
drawing, however, practically all require some
amount of stroke contrast.

Contrast also helps you determine the axis of
a letter. The axis can be revealed by intersect-
ing the areas of contrast in the upper and lower
curved strokes of a round letter. The extent to
which this imaginary line is inclined indicates
the angle of the letter's *stress*. In Old Style, the
axis is oblique or sloped, while Modern letters
have a vertical axis. *Reverse-contrast* or *reverse-
stress* letters ignore typical notions of contrast
altogether; instead, they possess light vertical
strokes and heavy horizontal strokes, which
result in a horizontal axis. Regardless of which
kind of axis a piece of lettering has, it's import-
ant to keep it consistent throughout.

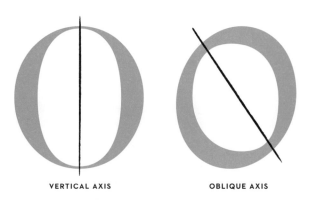

HIGH CONTRAST

LOW CONTRAST

Vertical and Oblique Axes: Locate the parts of a letter's upper and lower curved strokes where they taper to their narrowest widths—the O is a prime candidate—then bisect the letter by drawing a line between the two points. This will reveal the letter's axis and angle of stress.

VERTICAL AXIS OBLIQUE AXIS

In some letter styles, like Modern, it's easy to spot the variation in stroke thickness. In fact, one of the main defining characteristics in some genres of lettering is a high degree of contrast. However, it can be a bit trickier to spot in lettering that exhibits little discernible contrast, like mono-weight Sans Serif, for example. In these instances, it will become more apparent when a letter like the O is turned on its side.

MONO-WEIGHT LETTER O LETTER O ROTATED 90 DEGREES

Script Axes: The axes for Formal Script follow the same principle. However, flourishes often have a horizontal axis, in addition to the primary sloped one. Unless they're upright, the axes for sloped brush letters generally slant in the opposite direction compared with Old Style. Upright brush letters, on the other hand, typically have a vertical axis.

ROUNDHAND SCRIPT AXIS

Remember, as a general rule, strokes moving horizontally are lighter than those moving vertically. The degree of contrast depends on the style of letter. The inverse is true of reverse-contrast lettering.

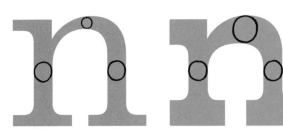

CONVENTIONAL CONTRAST REVERSE-CONTRAST

UPRIGHT BRUSH SCRIPT AXIS

PROPORTION

Proportion refers to the comparative size of different letterforms and their various parts. The visual width of the lowercase in most styles is generally even, but this is not always true of the uppercase. The proportions of the uppercase in some styles can vary significantly. Broadly speaking, classical proportions (sometimes referred to as old-style proportions) are exemplified in Roman inscriptional lettering and derived from a few basic components: the square, circle, and triangle. Letters consisting of one component (O, H, and A, for example) are notably wider than those composed of two (like E, S, and X).

Incidentally, authors of twentieth-century lettering manuals generally felt that letters adhering to such a rigid system were poor candidates for modification, which explains why radically stylized versions weren't so common. Exceptions were made, interestingly enough, for typefaces like Futura, whose caps have proportions reminiscent of Roman capitals. Nevertheless, this attitude didn't seem to last very long, as letterers of the latter half of the century ditched their hang-ups and eyed nearly every letter style as fair game.

Most of the lettering I'll examine in this section features Modern proportions. As you might suspect, this system is derived largely from the Modern genre in which visual uniformity is the aim. This also makes the letterforms infinitely adaptable, and therefore exceptionally

NOSE

versatile. This doesn't mean that all letters should be *dimensionally* proportional, which is to say that they should have the same height and width as one another—they shouldn't. This would completely ignore the complexity of letterforms, and how their construction affects the space they occupy. It's not hard to imagine that a W and an I require different proportions. However, you might not think that letters with similar shapes—an H and an F, for example— also require varied proportions. Drawing letters *volumetrically* proportional allows each letter's unique form and counterform to ultimately determine how the letter is sized.

While the precision of classical proportions leaves some room for the letters to be manipulated, the emphasis on visually uniformity among modern proportions flings the door wide open for modification—as we'll soon see.

NOSE

Consider the relative proportions of an H and an F. Both letters share the same number of strokes and general structural complexity. However, each letter distributes its respective positive and negative space uniquely. The H has two semienclosed counterforms, as compared with the F, which has two open counterforms to its right. For this reason, if the width of F is dimensionally proportional to the H, the F will visually appear to be wider than the H. In order to account for the optical illusion caused by the negative space of the F, the letterform must be made volumetrically proportional to, and therefore narrower than, the H.

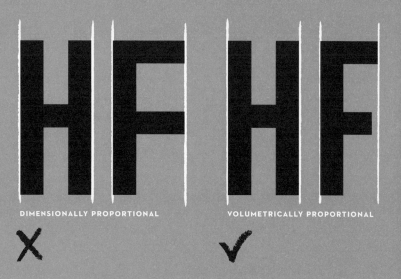

DIMENSIONALLY PROPORTIONAL VOLUMETRICALLY PROPORTIONAL

✗ ✓

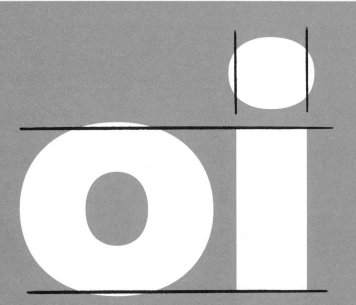

ROUND SHAPES OVERSHOOT GUIDES

Remember the example of the geometric shapes used to illustrate volume? The same thinking can be applied when determining the proportions of letterforms. Round strokes will slightly "overshoot" the guidelines, while square strokes will rest on them. Even the dot (or "tittle," if you want to get nerdy about it) of the i should be wider than the thickness of the vertical stroke below it so that the dot has the correct visual weight. Yup—volumetric proportion applies here, too.

Here's a quick and dirty way to increase the width or weight of letters. On a overlying piece of paper, trace the left side of each vertical stroke in your original drawing. Next, slide the top sheet to the left and trace the right side of each stroke. Then, fill in the remaining horizontal and curved strokes. (Heavy diagonals usually require added weight.) Finally, fill in the strokes to check for uniform volume. The new drawing may require a few adjustments, but this handy trick should give you a good head start.

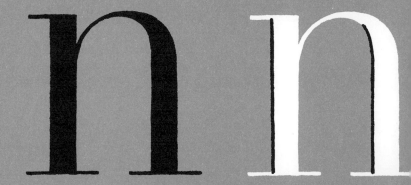

The relative proportions of the upper- and lowercase letters within a piece of lettering can also influence color. This can be achieved by adjusting the x-height. Remember, the length of the ascenders and descenders should be adjusted accordingly.

Small

Large

Narrow

Wide

In addition to describing the size relationship between uppercase and lowercase, proportion can refer to the general width of letters within a group. They can be very narrow, extremely wide, or anywhere in between. Just remember to keep the letters' relative proportions intact. Also, keep in mind that the readability of lettering is greatly affected by letters' proportions: overly condensing or extending letters can negatively impact the important relationship between their positive and negative forms. While it's fun to push the limits of lettering, sometimes a little restraint goes a long way.

n m m n

As you evaluate your lettering, use the elements of color as a mental checklist. Does the overall color look even? If not, is the volume of the strokes regular? What about the negative space? Has contrast been dealt with uniformly? Are the proportions equal? Successful lettering depends on how thoroughly these principles are applied. If they're handled inconsistently, the lettering won't be convincing...or attractive.

How is it then that some lettering appears to snub the rules yet still manages to work? That's because lettering that features intentional irregularities must nevertheless distribute any deliberate quirks regularly throughout.

▶

In this example, drastic variations of volume, contrast, and proportion recur often enough across the lettering that an aggregate effect is created, resulting in visually consistent color. Because the letterforms lack formality, their unpredictable nature itself becomes a feature. Crazy how that works, right?

What brought all of this together for me was an unexpected piece of advice my dad once shared with me when I was young: "Kenny," he said, "pouring syrup on shit doesn't make it a pancake." I had no idea what in hell he was talking about, until I applied that little nugget of wisdom to my lettering work years later. Unless a group of letterforms properly deals with color, no amount of shiny bells and whistles can save it. Polish a poorly balanced piece of lettering all you want: it will still be a turd. This isn't to say that finer points aren't relevant; just don't let minor details and finishing touches get in the way of the big picture.

Mastering the concept of color, and the basic elements that influence it, will do wonders for your lettering. Yet, there are a handful of other visual phenomena that affect the appearance and construction of letterforms that we also need to consider.

It's not uncommon for beginners to become preoccupied with the niceties of a serif, subtleties of an arc, or the details of a decorative element at the expense of color. They often focus on making individually attractive letters, while forgetting that the objective is to make attractive words or phrases. After all, there's no point in fine-tuning things before you've got a solid foundation. Otherwise, you're just wasting your time polishing a turd. The contours of this lettering are far from refined, but the lettering still works because it fulfills more important considerations.

EXERCISE
INVESTIGATE THE ELEMENTS OF COLOR

Consistent visual texture is vital to successful lettering. The important rhythmic patterns created by the balance of positive and negative forms has aesthetic as well as practical consequences. That's why understanding color is a fundamental skill that all letterers must strive to master.

Instead of drawing letters to fit set dimensions as projects often require, for this assignment you'll plot one at a time. This will allow you to focus on the drawing process without becoming distracted by other demands. To get the most out of this exercise, don't trace the model or use a ruler; let's sharpen those drawing skills.

While the results may not wow you, look closely and you'll see that you've put a twist on your letters simply by making them by hand. The nuanced forms reflect your personal perception and drawing decisions. In following exercises, you'll crank up the personality of your lettering even more.

It's not unusual for students to get a little impatient while redrawing letters over and over to refine them. But if you seek out shortcuts or get gung-ho about digitizing, you'll miss the whole point of practice, which is to hone your observational ability by training your eyes and hands.

When I was twelve, my favorite movie was *The Karate Kid*. Although Daniel-san can't understand why Mr. Miyagi is torturing him with monotonous tasks, the Karate Kid ultimately uses what he learned to kick Johnny's ass. (You know you wanted to see Cobra Kai get what was comin' to 'em as much as I did.) Anyway, repetition builds muscle memory, strengthens eye-hand coordination, and develops technique—all of which will improve your lettering skills...even if you don't get to give the bad guy a beat down in the end.

68

Select a letter style in Part 3 as reference, like Ad Roman as I'm using here. Choose a short word whose letters' shapes represent a variety of the general groups shown on page 55. Starting with an uppercase letter, sketch the rest lowercase to establish their relative proportions. Place the forms on a straight baseline, making the lowercase at least one inch tall to allow enough room to articulate adequate detail.

As you draw each form (freehand, no tracing!), evaluate the overall color of the letter style. Do the strokes have significant volume? Is this due to their degree of contrast? How does the weight of the letters and the variation in thickness of their strokes affect the counterforms? What about the letters' overall proportions? When you become familiar with a style's general characteristics, you can visualize it without needing a model.

Trace letters on another sheet of paper to refine them, double-checking that stroke weights are consistent. Use the volume of the counterforms to gauge the space between letters, reducing spacing slightly between round forms and those with awkward shapes or open counters. Extend round strokes slightly beyond the guidelines to add volume if needed. Familiarize yourself with other models in the same way.

1

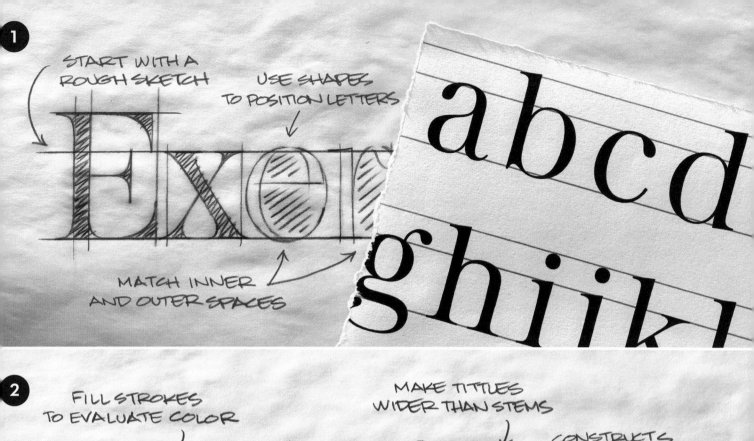

START WITH A ROUGH SKETCH

USE SHAPES TO POSITION LETTERS

MATCH INNER AND OUTER SPACES

abcd ghiikl

2

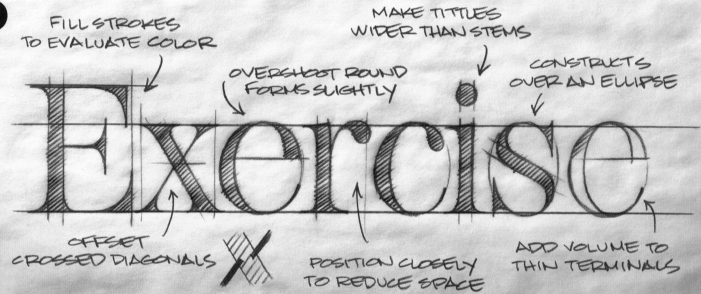

FILL STROKES TO EVALUATE COLOR

MAKE TITTLES WIDER THAN STEMS

OVERSHOOT ROUND FORMS SLIGHTLY

CONSTRUCTS OVER AN ELLIPSE

OFFSET CROSSED DIAGONALS

POSITION CLOSELY TO REDUCE SPACE

ADD VOLUME TO THIN TERMINALS

3

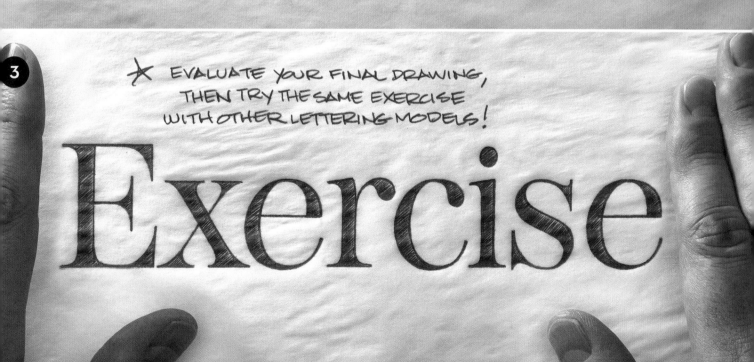

EVALUATE YOUR FINAL DRAWING, THEN TRY THE SAME EXERCISE WITH OTHER LETTERING MODELS!

Exercise

OPTICAL EFFECTS

Magic always fascinated me as a kid. My older brother and I would stage shows for the family in the playroom using my Harry Blackstone magic kit or pulling tricks from a well-worn copy of *Spooky Magic* by Larry Kettelkamp (the 1966 edition of the book rocks some pretty cool lettering). One thing I quickly learned is that the secret to a trick is usually right in front of your eyes. Although the optical illusions that influence letterforms operate a little differently, understanding them provides a peek behind the curtain at how lettering really works and allows you to apply a little sleight of hand in your own work. While it's ordinarily a good idea to give your ruler a rest and to measure letterforms optically, our senses aren't *always* the most reliable. Our eyes (and our brains) play plenty of tricks on us.

PERCEPTUAL BIASES

We have a tendency to emphasize some areas in our field of vision a bit more than others. For example, our eyes are inclined to focus more attention to the top of an object, as opposed to the bottom. As a result, the object may appear to be resting lower within a given space than it actually is, even when it's perfectly centered. That's why the base of a matted picture or bottom margin of a book is a touch larger than the top or sides. It also explains why the horizontal stroke in the middle of a letter needs to be positioned at the letter's *visual center,* which is slightly above its exact midpoint.

This phenomenon also causes a related optical effect. When the upper and lower halves of a letter are equal (like a B or an X, for example), the lower one will seem smaller. This makes the form look top-heavy, and the entire letter to appear disproportionate. Reinforcing the letterform by enlarging its base counteracts this effect. It might help to think about it like a tower: a broader foundation makes for a more stable structure.

If the horizontal stroke in the middle of a letter is placed along the true centerline, the bar will actually appear to be positioned too low. That's why horizontal strokes should be raised slightly. However, in instances where the negative space of a letter is distributed unevenly—like the A, F, and P—the horizontal stroke will normally be shifted down.

HAHA

HAHA

MATHEMATICAL CENTER

VISUAL CENTER

BRIEF

BRIEF

CENTER HORIZONTAL STROKES ADJUSTED FOR NEGATIVE SPACE

The letter S is also subject to these rules, if not a little trickier to draw. In fact, you may come to the conclusion that this deceptively simple letter is your arch nemesis, hell-bent on your downfall. Why? Despite its fairly straightforward construction, the stroke that comprises the S demands careful shifts in volume and contrast in order to properly define the letter's counterforms and proportions. The secret lies in the spine of the S, where it generally carries the most volume. Positioning this central stroke at the visual center of the form will help you shape the letter accordingly.

Our eyes are also prone to extending the visual length of horizontal forms and counterforms, more so than vertical ones. For this reason, letterforms with significant horizontal strokes and open lateral counterforms typically must be narrower than those that lack these features. Otherwise, our eyes will perceive more volume in such letters, causing them to appear disproportionately wide.

✗ ✓

SYMMETRIC STRUCTURE **ASYMMETRIC STRUCTURE**

TOP COUNTERFORM IS SMALLER

✓ ✓

CORRECT S FORM **CORRECT S COUNTERFORMS**

CAPITAL S UPRIGHT **CAPITAL S UPSIDE DOWN**

VIEWING THE S UPSIDE DOWN ALSO REVEALS ITS ASYMMETRY

METHOD FOR DRAWING THE LETTER S

ackstx

BEKRZ

THE LOWER HALF OF THESE LETTERS IS WIDER THAN THE UPPER HALF

 The upper part of a two-story letterform will overpower the lower section unless the proportions of its base are increased and given more volume. The same holds true for outwardly simple forms.

To draw an S, begin by indicating its proportions with an elliptical shape. In most cases, the letter will be somewhat narrower than a corresponding O. Indicate the spine at the appropriate weight so that it passes through the visual center, then taper the ends as it transitions toward the upper and lower guidelines. Finally, add volume at the stroke terminals and adjust the contrast. Remember, the bottom of the letter should be slightly wider than the top.

If we make an E the same width as an H, the E appears comparatively wider. The emphasis of the parallel strokes and negative shapes in the E increases its apparent dimensions. The horizontal force acting on the letterform requires that it be narrower in order to appear similar in width to the H.

INCORRECT MECHANICAL WIDTH

CORRECT OPTICAL WIDTH

HALATION AND IRRADIATION

Have you ever seen a photograph in which bright objects appear to glow? The effect is produced by *halation*, a phenomenon created when light spreads beyond the boundaries of an object, softening its edges and creating a halo-like effect.

Letterforms are affected in a similar way. When light reflects off a bright surface (like the pages of this book), the light becomes diffused. This faint glow scatters just beyond the edges of the letters, making counterforms appear a little fuller and strokes a bit thinner. Conversely, when letterforms are reversed out of a dark background, they will appear noticeably bigger. This illusion is called *irradiation*.

▼

The irradiation illusion: Comparing these two small squares, you're likely to think that the white one on the black background is larger. They're actually identical in size.

▶▶

This lettering was designed to appear on a white background. When it's reversed out of a dark background, irradiation causes the strokes to appear thicker while the breaks in the overlapping strokes—intended to alleviate volume—lose their effectiveness.

THE POGGENDORFF ILLUSION

During the nineteenth century, scientists seemed to be obsessed with optical illusions. One that is of particular interest to us is named for the physicist who discovered it, Johann Poggendorff, who observed an interesting phenomenon when a thin diagonal line crosses a heavy vertical shape: the opposite segments of the intersecting hairline do not appear to align with each other, even though they are part of the same continuous form. Understanding this effect is especially handy for drawing delicate strokes that overlap heavy ones at a considerable angle, which often occurs in high-contrast script lettering. In order to correct for the distortion, each side of the hairline must actually be offset. Although the thin stroke is not a single line, as you would expect it to be, our brain perceives it as such. Weird, but true.

Understanding these optical effects allows letterers to plan for different design situations and environments—whether it's print, screen use, or illuminated signage.

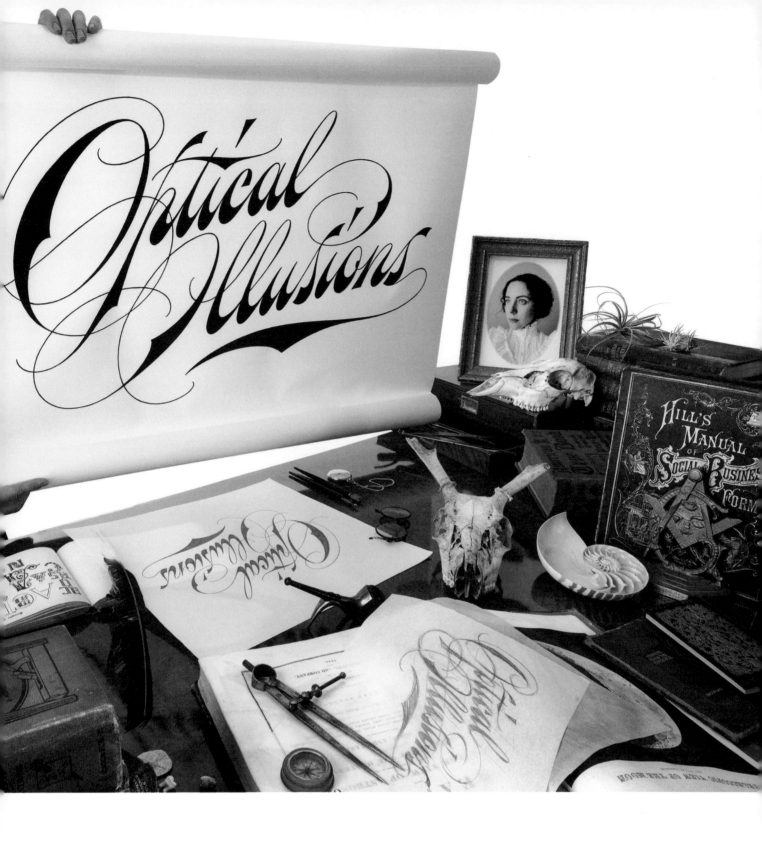

◄◄

In this classic illustration of the Poggendorff Illusion on the far left, the top line on the left-hand side appears to correspond to the thin line on the right. However, the optical effect is revealed in the following image.

Surprising curiosities that affect letters can elude the most scrutinizing, even noted virtuoso Lord Reginald Clamwell IV.

◄◄

In the first pair of letters, the hairline of the l looks disconnected as it crosses the heavy stroke, but the next form reveals that it is a continuous line. The hairline stroke in the second pair appears to cross the heavy stroke uninterrupted. However, the following form reveals that the thin diagonal is disjointed in order to give this impression.

MODIFYING LETTERFORMS

Beyond the elements of color and a couple of optical effects, there are other features that can affect the look of letterforms, like weight and width, to name but two. Yet, all of these options can make contemplating their potential configurations overwhelming...if not completely intimidating. In order to simplify things, let's look at a handful of factors separately, considering each as just one possibility across a vast design continuum.

To illustrate the idea, consider weight. On one end of the spectrum exists a very light letter; on the other end, a heavy version of the same form. Between the two extremes, a countless number of possibilities exist among the transitional steps from one to the next. The same range of potential exists for additional traits: contrast, contours, and so on. Once you understand how these features can be modified and combined with each other, you'll find yourself visualizing your lettering before you even pick up a pencil.

As you explore the design continuum, you will likely discover that only a few features separate some of the different letter styles. Add a bunch of weight to the vertical stems of a Modern letter, and you get Fat Face. Reduce the contrast, and you wind up with Slab Serif. In this way, models can be seen not as final destinations, but rather as departure points or landmarks along an ongoing path of transformation.

Combing features of different styles is a fun way to wander the design continuum, but be careful how you formulate your recipe. If you add every ingredient in your kitchen to a pot of soup, chances are it's not going to taste very good. A smarter approach is to emphasize one or two complementary ingredients, accenting them with a pinch of spice here, and a little extra seasoning there. If you overuse everything, nothing stands out, and the competing flavors result in an unappetizing mess.

WEIGHT

In high-contrast letters, only the volume of vertical strokes changes significantly. For mono-weight letters, which have little noticeable contrast (see below), all strokes increase proportionally. Remember, negative space becomes smaller as the positive form grows heavier. Also, to allow for tighter spacing, serifs should typically shrink in length as a letter becomes heavier.

WIDTH

Adjusting the width of a letter is primarily done by changing the area of its negative space. As a letter grows extremely wide, however, adding a little weight can help to balance out the expanding counterform. Since components should also scale accordingly, serif lengths should become slightly longer as width increases.

CONTRAST

Changing the contrast of a letter refers to adjusting the relationship between its thick and thin strokes. Decreasing contrast usually results in greater apparent volume, while increasing contrast reduces this effect. Even mono-weight letters need some contrast. This effect can also be reversed so that horizontal strokes are thick and vertical ones are thin.

n n n n n

n n n n n

n n n n n

Lettering works the same way. Once you determine what the lettering must do, zero in on those features that will best get the job done. Maybe bold letters are needed to grab attention or elegant ones to set the right mood. Unless you've got a good reason, resist the temptation to add anything unnecessary. When you let the conceptual, aesthetic, and practical needs of the lettering be your guide, you'll be surprised to find that questions begin to answer themselves.

Letterforms can be enhanced and exaggerated in an infinite variety of ways to express practically any feeling or evoke any emotion. That's what makes lettering so persuasive. In that sense, it can be thought of as sculpting— weight can be added or reduced, shapes compressed or extended, contours roughed in or refined. Take into account that each decision is compounded, resulting in a cumulative effect; seemingly minor changes can have a major impact on a piece of lettering. No matter which choices you make, apply them to each letterform to ensure that the word has a cohesive look overall. Of course, there are occasions when drawing and arranging multiple words is necessary. Just as letters can be seen as individual components in a single word, so too can separate words be seen as parts of an even larger whole. Let's take what you've learned about drawing and modifying a group of letters and observe how those ideas relate to more elaborate compositions.

CONSTRUCTION

The construction of letterforms can also be reimagined along the design continuum. This might be the form of a letter's serifs, or the shape of its inner and outer contours. Keep in mind that subtle shifts applied across a large group of letters will change their overall appearance, allowing you to tailor them to suit the desired goal.

CONTOURS AND TERMINALS

The outlines that shape the silhouette of a letter can be configured in a lot of different ways. Strokes can swell (creating a convex effect called entasis), flair out toward its terminals (or stroke endings), have a straightforward appearance, or be faceted. There is an equally wide range of solutions for the construction of serifs.

EMBELLISHMENTS

Inlines, outlines, shadows, shades, and stencils (see the illustration for examples) are just a few kinds of ornamentation that can be applied to lettering. A little bit goes a long way, so some restraint in this department is never a bad idea. Whatever embellishment you add, make sure it supports the theme and purpose of the lettering.

nnnnnn

nnn+n=nnn

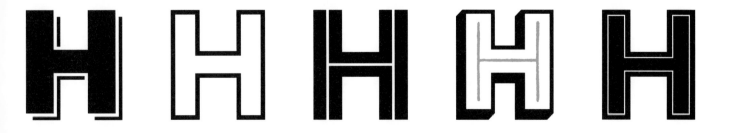

EXERCISE
EXPLORE THE DESIGN CONTINUUM

Letterforms can be molded and manipulated in a virtually endless variety of ways. Their contrast, weight, proportions, and contours—along with loads of other elastic elements—all impact the way they look and interact. In order to help traverse this seemingly limitless ocean of possibilities, you'll get your toes wet by isolating a single potential factor, observing how changes to it alter the look and feel of your lettering. This is a handy technique that builds nicely on principles emphasized in the previous foundational exercise, "Investigate the Elements of Color" (page 68).

Start by drawing a handful of letters following one of the styles highlighted in Part 3. In subsequent renderings, increase or decrease the degree of a particular feature, like weight or width. You may be forced to alter the structure and details of the letters as their forms are exaggerated, but don't otherwise introduce any additional or unnecessary changes.

For the moment, don't concern yourself with a practical application, or any restrictions one might impose. Instead, use this opportunity to familiarize yourself with the general concepts underlying the practice of modifying letterforms. This technique will help kick-start your brain to begin thinking about the effects that various elements have on letterforms, and how they can be effectively applied to a relevant project or particular design scenario. In the next exercise, "Turn Up the Tension" (page 98), you'll see how a number of such expansive changes are synthesized to make lettering even more charismatic.

Begin by selecting one variable to explore. In this example, I've chosen to alter the contours of the letterforms. Adjusting the profile of the strokes can be done in any number of ways. I can make them flared or swelled, faceted or rough. I can also include changes to the terminals, or leave them as is. I'll go with a concave treatment to add a little flavor.

Tracing over my initial draft, I've added a slight inward curve to the straight strokes, as well as to the stroke endings. This is a technique I frequently employ to add warmth and softness to letterforms. Considering that most people aren't terribly good at drawing straight lines freehand, imperfect outlines can appear more familiarly "human," and therefore more friendly and convincing.

Ramping up the concavity even further starts to really move the needle on the treatment of the contours. Overly exaggerating the features of letters can be loads of fun, but when it comes to applying such measures in real-world situations, make sure the outcome enhances the lettering without detracting from its performance.

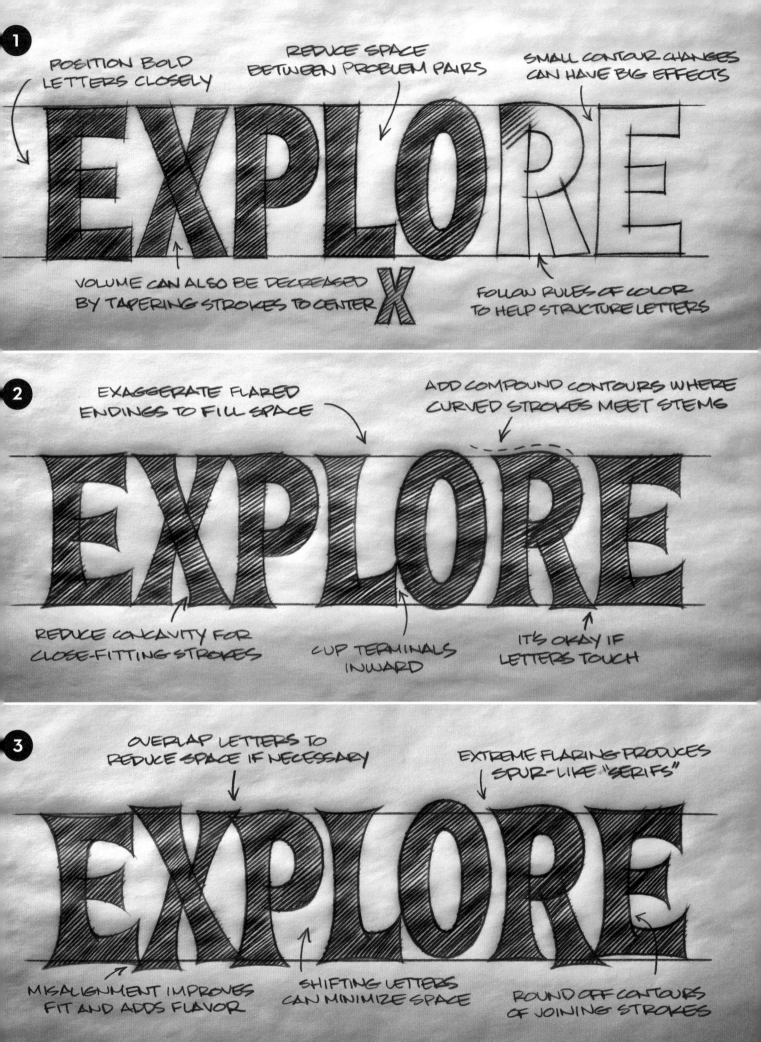

It's tough to imagine a more distinctive way to customize letterforms than to shoehorn them into an offbeat shape. When House Industries was invited to produce a storefront display for the Hermès showroom in Tokyo, that's exactly the angle that Andy Cruz and I took. With marching orders to create a one-of-a-kind experience for guests, Andy hatched a plan to greet visitors with a trotting three-dimensional piece of lettering fashioned into the shape of a horse, as a nod to the French luxury brand's equestrian heritage.

We got cracking on the project by pulling together reference material to help guide us, and quickly found ourselves drawn to examples of art nouveau design, which was popular in France during the late nineteenth century. The incredibly luscious and limber letterforms indicative of the style—like those gracing the flashy entrances to Paris's metro stations, for example—not only provided a convenient cultural touch point, they were the perfect subjects to twist and contort into our emerging scheme. Our research took an unexpected turn, however, when Andy dug up a 1960s water decal (top of page 35) by the legendary car-customizer and illustrator Ed "Big Daddy" Roth, which featured

an added dash of the flavor we were after. There was also the matter of coming up with a suitable horse silhouette, and familiarizing ourselves with riding tack. With a mixed bag of muses, it was time to get down to business and distill them into an engaging wordmark.

It was necessary for the final product to have a recognizable profile, so determining the general shape was a logical place to start. We fiddled around with a few positions for the horse, but ultimately found that a galloping silhouette suited the fit of the letters best. Unfortunately, squeezing letterforms into an unusual outline is less predictable than dealing with a more conventional composition. Sometimes you luck out and discover that the shape and position of a letter fits perfectly; other times, things don't pan out. Experimenting with alternate constructions, different cases, or added flourishes often provides the necessary parts to make the lettering work. The process generally involves a lot of trial and error. But with riskier pieces like this, the payoff is also much bigger.

If there's one thing to take from this example, it's this: don't cover your tracks. No one works in a vacuum, so it shouldn't be surprising to learn that we all build on preexisting ideas. (What's that quote about standing on the shoulders of giants?) That's how innovation works, after all. (Of course, if your lettering ends up looking like a carbon copy of your swipe file, that's no good, either.) Show off your inspirational sources, celebrate your heroes, and take the opportunity to share them with others.

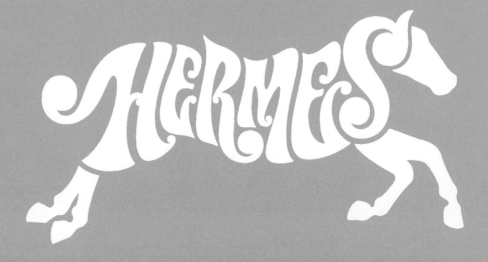

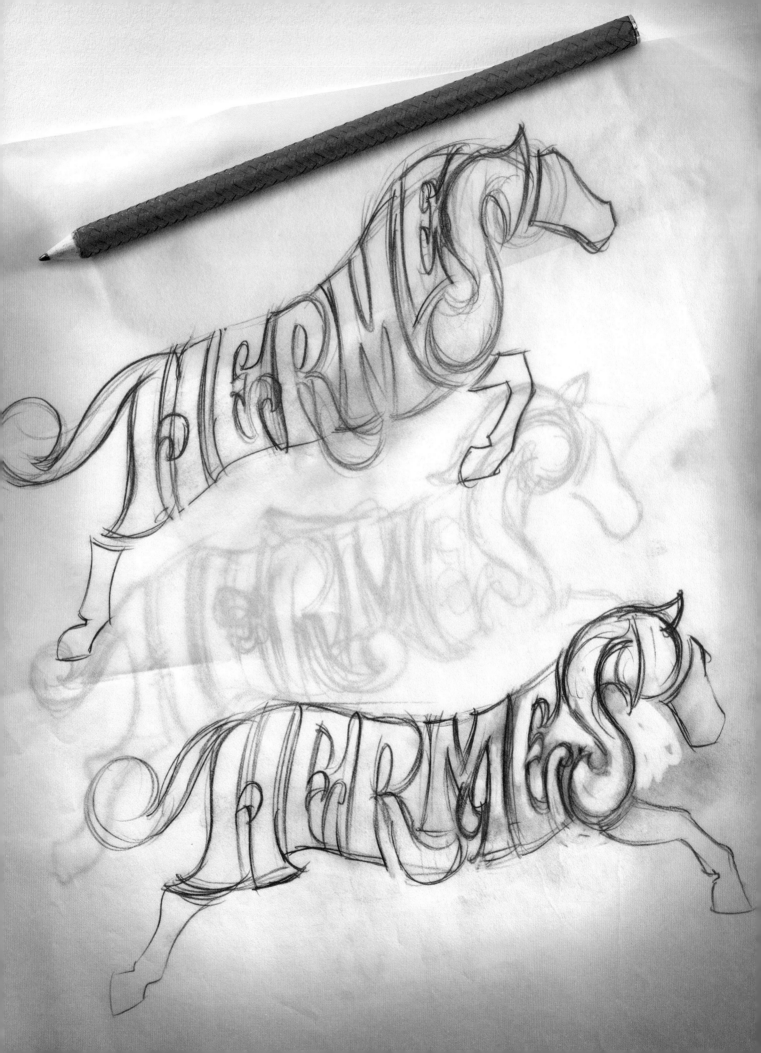

COMPOSITION

Organizing the separate parts that make up a piece of lettering is where the foundational concepts and practical drawing strategies are put into action. Time spent massaging individual letterforms won't do any good if, in the end, you've missed the forest for the trees. After all, the goal is to build persuasive words and phrases, not simply to make beautiful letters.

As with any complex undertaking, it helps to have a plan. Thankfully, much of the info needed to compose a piece of lettering effectively is often determined before you even get started, whether it's the application of the lettering, the environment in which it appears, or the demands of a client. Magazine nameplates have to fit specific dimensions. Apparel lettering must be flexible enough to hold up under a variety of production methods. And logos need to embody the *spirit* of a brand. Of course, sometimes lettering has to fulfill several different requirements all at once.

In order to help build a strategy for successfully arranging the parts of lettering—whether that's an individual letter, a word, a phrase, or

Garrison's
CYCLERY

another design element—I like to take a top-down approach to composition. As I present each ingredient that contributes to a layout, ask yourself what the lettering must do. Does it need to inform, entertain, or persuade? Must it represent a particular person or product? Does the lettering have to fit within a given space? Or, does it have to perform in a certain environment? The answers to these questions will help guide how the composition shapes up.

This composition shows convincing visual unity. The meaning is grasped easily, and the content of the layout balances the space equally.

The formal qualities that these different letter styles share in common provide this layout with a considerable amount of conceptual unity.

Kentucky Kid

Lynn Eva

UNITY

Whether a layout is composed of only one component or a half dozen, its parts should be organized in a coherent way. People appreciate a successful composition as a single entity, before noticing all of the nuances of its individual pieces. Although the relationship between these critical elements relies on the entire structure, collectively they make something that has a personality all its own. (I slept through much of my Psych 101 class in college, but this notion is similar to a tenet of *gestalt*: the whole is something other than just the sum of its parts.)

In order to create a composition that has a sense of overarching cohesiveness, a layout can be unified in different ways. *Visual unity* is achieved by arranging the various components in a clear and harmonious way. The message is understandable, and the relationship of the individual elements makes for a strong overall silhouette. *Conceptual unity* is accomplished when the components share stylistic or thematic elements. This might include complementary letter styles or other related motifs.

Pairing compatible letter styles is one way to visually *and* conceptually unify the parts of a composition. The easiest way to do this is to reference typographic models that share similar qualities, like their overall color and proportions, or axis and stroke contrast. Complementary pairings may also include styles developed during the same era, or show evidence of having been created by the same tool. Incorporating more than two or three letter styles, however, can turn your composition into a yard sale. Whatever you do, don't use two kinds of script in the same design, or they're liable to steal the limelight from each other.

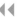

Considering that script lettering already has loads of personality, it generally pairs well with understated styles.

Despite employing an oversized initial letter to grab the attention of readers, this wordmark uses a bold outline and deep shade to unify the design.

◀◀

Not only do Modern letters and Formal Script have similar traits, but they're also influenced by the same tool (pointed pen) and time period (seventeenth and eighteenth centuries).

▼

Modern compositions that riff on nineteenth century–style poster design is one exception to the rule against using loads of different letter styles. The more the merrier.

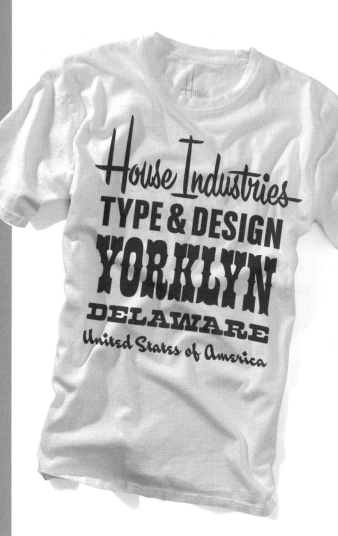

HIERARCHY

Unity is determined to a large extent by the emphasis given to the individual parts of a piece. All the parts of a composition are essential (be it a movie title or brand name), yet some carry more significance than others. Key words should therefore be given visual priority over less important ones. This results in a *hierarchy* of dominant and subordinate elements, which can be highlighted or understated by adjusting their respective scale, weight, contrast, and so on. *Dominant elements* are typically larger or bolder, while *subordinate elements* are often smaller or lighter in weight.

A dominant element often becomes a *focal point* within a composition. This is achieved by playing up or down the letters' various features. Be careful that two or more dominant elements given equal prominence don't compete with one another for attention. This can be solved by matching their relative scale, style, or alignment within the layout. An individual letter or part of a letter can also be singled out by an unusual size, color scheme, or other embellishment. When executed properly, the focus draws the viewer into the composition and serves to carry the eye through the design.

▶▶

Consider these different approaches to arranging the contents of a composition. Each example contains the same components, but uses scale to achieve different results. In the first composition, the brand is emphasized, while the second stresses the subject of the book. In the third layout, the actual product is given prominence, and the last example treats the subject and product equally. They're legitimate approaches, but each composition communicates a little differently.

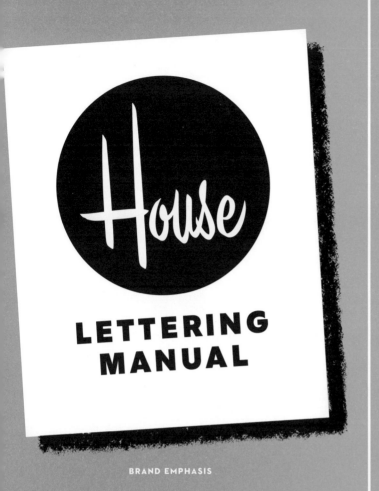

BRAND EMPHASIS

SUBJECT EMPHASIS

PRODUCT EMPHASIS

EQUAL EMPHASIS

OPTICAL DIRECTION

A well-established hierarchy contributes to the visual flow of a composition. Controlling how the viewer is directed through it is important, so that each element is read in the intended order and the overall message is understood clearly. The *alignment* of individual components is one way to imply movement in a layout. Straightforward symmetrical formats can move top to bottom, left to right, or simply emphasize a central point. Components in more elaborate configurations are often positioned left to right and top to bottom (corresponding to the way we read), or diagonally from upper left to lower right. Depending upon the specific wording or complexity of the design, one solution may be more suitable than another.

Individual characteristics and embellishments can also weave visual threads through a piece of lettering, while the suggested motion of sloped styles (like italic and script) inherently add a feeling of momentum to a layout. Lettering with generous shading or offset shadows provides a sensation of depth and perspective, steering the reader in a similar way.

Don't forget negative space: it should be treated as part of a layout, too. This is particularly important for lettering where areas of white space can be used to shape the outer silhouette of the composition. Not only do well-positioned empty areas provide cues to direct our eyes, but they can also help to fit asymmetric layouts comfortably in tough spaces. Of course, these are just a few common solutions; there's more than one way to skin a cat.

ASYMMETRICAL COMPOSITION

Each case is unique, but the components of a symmetrical composition can be stacked centrally from top to bottom, or positioned from left to right.

In asymmetrical layouts, the elements often cascade downward from the upper left to the lower right. Don't neglect to factor in white space, which can dramatically influence the entire shape of the composition.

House

Lettering & Printing

MASTER WORKSHOP

TENSION

Have you ever noticed that there's a palpable energy to certain pieces of lettering? It's tough to put a finger on why, but the elements seem to pull and push against one another without creating chaos or confusion. (Although sometimes a certain amount of volatility *does* have its place.) The lettering doesn't even have to be particularly animated; even simple or reserved wordmarks can look compelling and full of life. Much of this is due to the tension among the letters and words comprising the layout.

Tension is created by forces at play inside letters or between parts of a composition. It provides a dynamic feeling by working against common visual tendencies and expectations, like biases toward symmetry in a layout or uniformity among a letter's strokes. Deviating from these norms can make lettering more intriguing...even alluring. Exaggerate tension too much, however, and the effect becomes agitating and off-putting.

Lettering isn't the only thing that utilizes tension. Filmmakers exploit it by pitting the familiar against the unexpected. I'm not a fan of horror flicks, largely because I do not enjoy watching an otherwise normal-looking child intone ancient spells in a mysterious language while crawling on the ceiling, or a sinister circus clown lure unsuspecting victims into a sewer drain. Call me a wimp, but that sort of stuff is too far beyond the ordinary for my comfort level. Consider music that emphasizes complex syncopated rhythms, architecture that features amorphous shapes, or food that incorporates unusual ingredients. Tension is everywhere. Some things exhibit a little, while others have it in spades. Letterforms aren't all that different.

One of my favorite ways to crank up tension is by changing how the volume is typically distributed. Strokes tapering playfully, or surging unexpectedly, energize a letterform. Varying proportions or spacing creates tension, too.

Changing the relationship that letterforms have to each other and to their environment can impart a particular mood by creating a sense of cadence. For example, vertical shift alters the relative placement of letters along the baseline. Vary the degree of offset slightly so the resultant movement appears random. Sliding every other letterform the same distance looks mechanical and stilted.

A proportional shift modulates the comparative size of each letterform. Again, this shouldn't be done in a stiff and routine way, but rather should feel organic. Rotational shift provides yet another way to add rhythm to letterforms and the words they form. Slightly spin each letter clockwise and counterclockwise, alternately, as you move from one to the next. Depending upon the shapes of the letterforms or their sequence, some may not require any rotation at all. Just be careful: a little tension goes a long way—especially as effects are piled on top of one another.

Tequila!

Vacation

Surprise

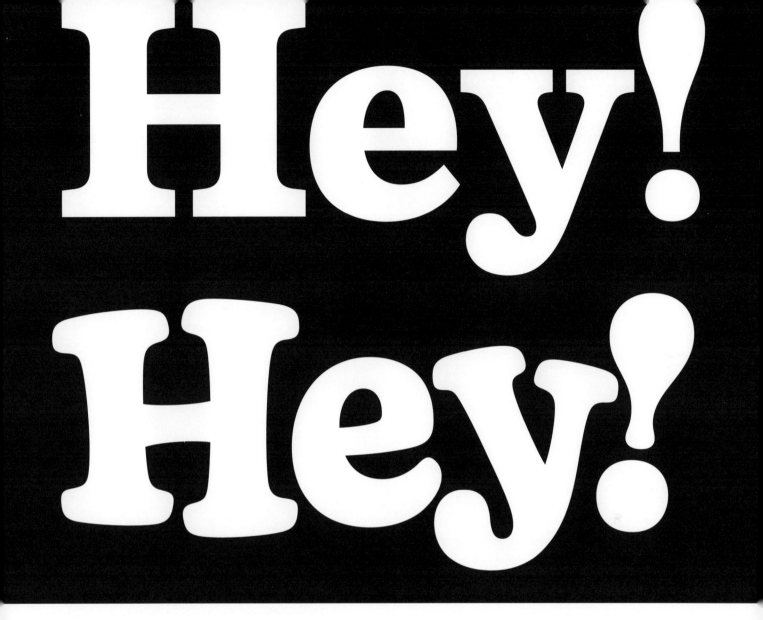

A handy visualization technique for understanding vertical shift is to abstract letters as simple shapes. The position of each letterform moves up and down along the guidelines creating a "bouncy" effect.

Abstraction is also useful when modulating the relative size of each letter. In this case, imagine each letter threaded along a centerline, the body of each extending a similar amount above and below its midpoint.

Rotate the axis of each letter, alternating left and right, throughout the lettering. Pay attention to the unique construction of each letter; spinning them one way or another may help with problematic combinations.

Tapering and widening the strokes of its letters can add an element of tension to a piece of lettering. Swelling and contracting contours can create a whimsical tone, or be used to soften the look of an otherwise conservative style.

It's okay for serifs to overlap, or for parts of neighboring letters to collide. In fact, moments like this can create a desirable tension between letters or words. Just make sure volume doesn't build up, and the rhythm of spacing isn't disrupted.

EXERCISE
TURN UP THE TENSION

The most alluring lettering generates interest by making an audience want to pay attention. In this exercise, you'll take what you've learned and go full tilt by turning up the tension to draw eye-catching letterforms.

Start with a model illustrated in Part 3, pushing attributes such as weight, contrast, and proportions. Create further excitement by altering the placement and behavior of letters. You can call attention to a single form by increasing its scale or adding embellishments. Changing the way letters are aligned along the guidelines or positioned in relation to each other is another surefire way to attract more eyeballs. There are tons of options, but you don't need to turn up all the knobs to 11. When each letter attempts to look special in its own way, none of them do.

You can alter your lettering in subsequent steps, or make multiple design decisions all at once. Make a list of the various traits that you want your letters to express, to help keep you on track. Just remember that each decision is compounded, resulting in a cumulative effect; minor changes can have a major impact on a piece of lettering. Whichever choices you make, apply them consistently to ensure that the piece has a cohesive look.

Of course, there's no single formula for pumping up the personality of letterforms. You can return to your starting point and move the levers controlling the letterforms' features in various ways to get completely different results. This is also a handy strategy for generating a variety of solutions for a project. After a few rounds of sketches, you've got a bunch of new ideas.

Referencing a model, alter different aspects of the letterforms in successive steps. Once you get the hang of it, multiple changes can be made all at once.

Increase the weight of the letterforms, as I've done in this step, or try exaggerating some other feature, such as width, contrast, or proportion.

Decrease contrast by making thin strokes heavier. Add even more flavor by beefing up the weight along one half of the letters, or softening their contours.

Up the ante by trying an entirely different framework, like rolling guides. Just make sure to maintain previous changes to ensure that the lettering is visually anchored.

What good is a piece of lettering without a little icing on top? There's nothing like an outline and shading to call attention to a wordmark.

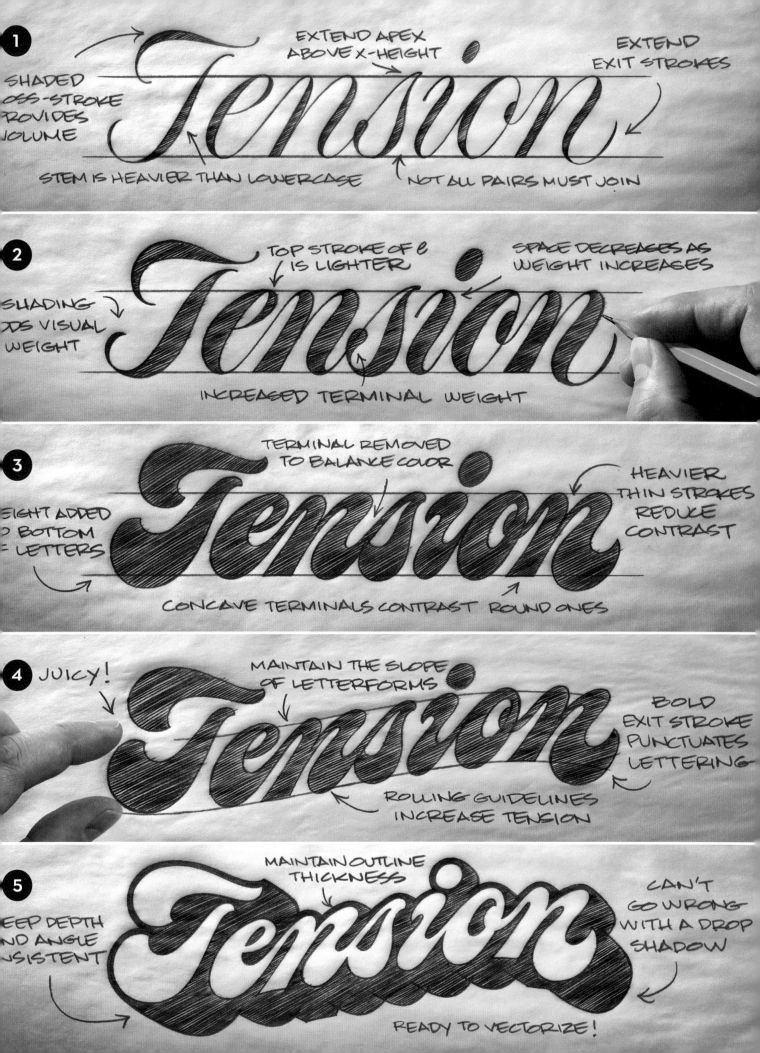

1

EXTEND APEX ABOVE X-HEIGHT

EXTEND EXIT STROKES

SHADED OSS-STROKE ROVIDES OLUME

STEM IS HEAVIER THAN LOWERCASE

NOT ALL PAIRS MUST JOIN

2

TOP STROKE OF e IS LIGHTER

SPACE DECREASES AS WEIGHT INCREASES

SHADING DS VISUAL WEIGHT

INCREASED TERMINAL WEIGHT

3

TERMINAL REMOVED TO BALANCE COLOR

HEAVIER THIN STROKES REDUCE CONTRAST

EIGHT ADDED O BOTTOM F LETTERS

CONCAVE TERMINALS CONTRAST ROUND ONES

4

JUICY!

MAINTAIN THE SLOPE OF LETTERFORMS

BOLD EXIT STROKE PUNCTUATES LETTERING

ROLLING GUIDELINES INCREASE TENSION

5

MAINTAIN OUTLINE THICKNESS

CAN'T GO WRONG WITH A DROP SHADOW

EEP DEPTH ND ANGLE NSISTENT

READY TO VECTORIZE!

FRAMEWORK

The underlying architecture of a composition is where the meat and potatoes of unity, hierarchy, optical direction, and tension come together. Bearing in mind that the composition of lettering should be considered as a whole, establish the margins of a basic template first, then work from the outside inward. I usually begin by "blocking in" primary components as simplified shapes. Only after the general layout is set do I start to fuss over the (comparatively) minor details of each component. Otherwise, it's easy to spin your wheels on a layout that might not ultimately work.

A single word or group of words can act as a component within the composition. The final say as to how they're separated and emphasized, however, is determined by their importance in regard to the message. Components can be oriented similarly, or differently, depending upon the desired effect.

These basic building blocks can be understood according to their general movement. Letters are typically placed on an imaginary guide called a baseline, or positioned along a *centerline* that passes through the middle of each form. Linear guidelines, arranged horizontally, are the simplest. They can also arc like a rainbow or ascend from left to right. Guidelines descending from left to right, however, are inclined (apologies for the pun) to create a dwindling effect. Rolling guidelines, which have a gentle S-like curve, are deceptively simple but pack a lot of punch. That's probably why they're one of my favorites.

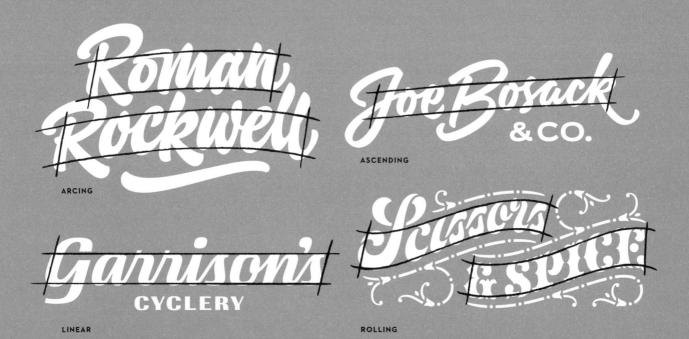

ARCING

ASCENDING

LINEAR

ROLLING

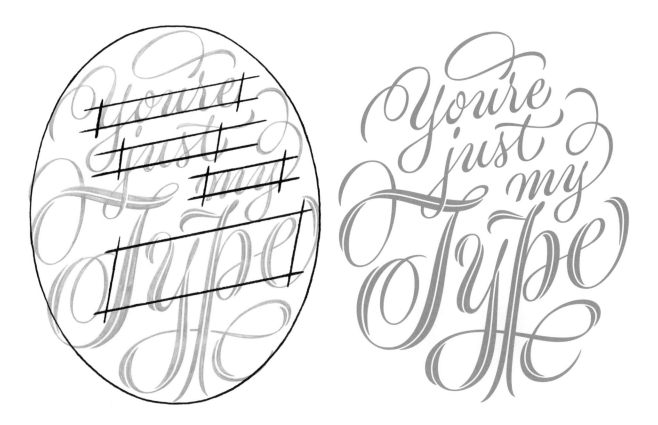

Whichever guideline you use, it's generally a good idea for the axes of letters to share the same alignment, whether they're upright or sloped. Don't make the axes perpendicular to the guideline unless it's horizontal. Letters will appear to slide backward off ascending or arcing guides, or look restless and twisted along a rolling guideline. Lettering needs a few consistent aspects that provide visual anchors to help settle the gaze of its audience, especially as effects are compounded. Although a vigorous and frenetic appearance is sometimes called for, the lettering will otherwise look unstable.

Finally, in the immortal words of lettering legend Ed Benguiat, "Don't stack letters like an ass." Roman letters are meant to be placed side by side, not on top of each other. Dissimilar proportions and awkward negative spaces make vertical positioning a tall order (pun intended), aside from being counter to the way we read. Play it safe by rotating lettering 90 degrees. Not only will its color be more manageable, but the lettering will be grasped more easily, too.

▲

Once you determine the final dimensions of the lettering, work from the margins of the framework inward, indicating components as rough shapes. After the hierarchy and optical direction are established, add increasing detail in successive passes.

◀◀

Whichever baseline is employed—arcing, ascending, linear, or rolling—subtlety is the name of the game. Exaggerating the shape or complexity of guidelines makes it tough to position letters along them.

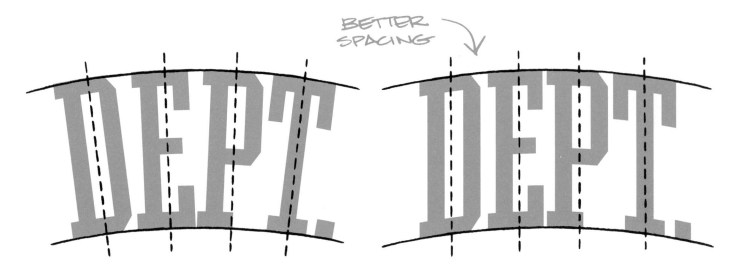

BETTER SPACING

PERPENDICULAR ALIGNMENT

PARALLEL ALIGNMENT

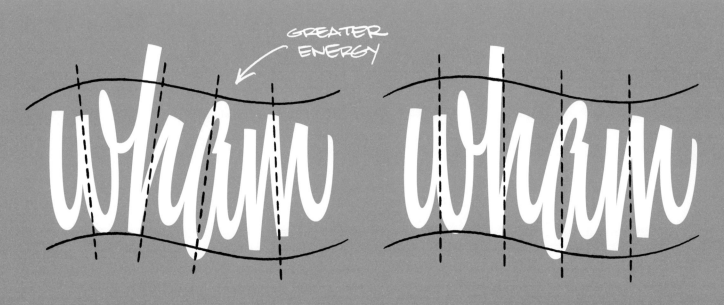

GREATER ENERGY

PERPENDICULAR ALIGNMENT

PARALLEL ALIGNMENT

MORE STABILITY

PERPENDICULAR ALIGNMENT

PARALLEL ALIGNMENT

As you're plotting your layout, periodically take a moment to evaluate it. A quick and easy way to get an idea of your progress is to step back from your lettering and squint your eyes. This makes everything a little fuzzy, softening details that might be distracting. It forces you to see the bigger issues affecting your composition. Do any letters stand out as being too heavy or too light? What about the spacing between letters and words, or the hierarchy of parts within the composition? Momentarily looking past lesser points, and turning your attention toward more important influencing factors keeps you moving in the right direction.

How lettering is composed, however, is determined by the role it must play. Its intended use is what will fundamentally steer your decision-making process. With that in mind, next I'll walk you through a typical job to familiarize you with the general course of a paying gig. You'll get a sense of the various design stages, understand the value of offering clients a peek at your creative process, and become acquainted with the two most common applications of commercial lettering.

▶

Not confident about making freehand rolling guidelines? Establish a pair of baselines first, then draw gentle S-curves intersecting each at its midpoint. The guides can be parallel, or diverge to add a little extra tension.

◀◀

In the top example, the awkward spaces resulting from letters placed perpendicular to the arcing baseline are eliminated when their axes are upright. In the middle illustration, positioning the letters perpendicular to rolling guidelines can create a frenetic mood, while aligning their axes parallel to one another mitigates this effect. The letters in the bottom example look ready to slide off the ascending baseline when they're arranged perpendicular to it; aligning the letters vertically gives them more stability.

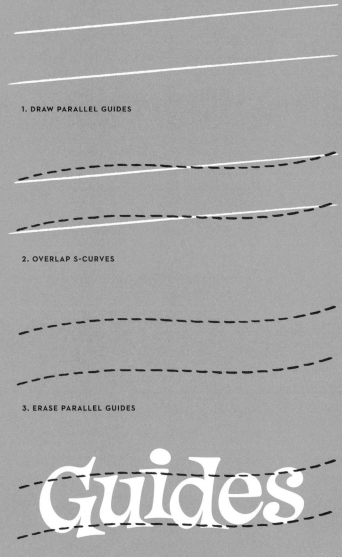

1. DRAW PARALLEL GUIDES

2. OVERLAP S-CURVES

3. ERASE PARALLEL GUIDES

4. APPLY LETTERING

CASE STUDY

JIMMY KIMMEL'S COMEDY CLUB

Jimmy Kimmel and House Industries have been mutual fans for a long time. After we overhauled the logo for his late-night talk show, Jimmy invited us to cook up the identity for his new comedy club in Las Vegas. As Andy Cruz and I started mining references for the project, our favorite lettering from the vintage hotel and casino signs that once dotted the town's famous Strip immediately sprung to mind, with The Mint, Golden Nugget, and Frontier toward the top of the list. However, we soon turned our attention to the expressive brush styles exemplified by the Moulin Rouge and Thunderbird marquees to see if they might spark a few other ideas.

I started hashing out the composition by first ranking the hierarchy of the individual elements. To set the club apart from competing venues, while capitalizing on Jimmy's celebrity status, it made sense to emphasize his name. As the most important element of the design, it's also the largest. Bold caps draw the viewer's eye into the layout, while uniform brush script points to classic sign lettering, providing both conceptual and visual unity. Next in the pecking order of significance, "Comedy Club" underscores the mark in a neutral Sans Serif style. The idea for the club-shaped monogram came from Jimmy himself, who proposed that we double down on the Vegas theme by cashing in on the double meaning of the symbol.

Developing a balanced composition is usually full of its share of unexpected twists and turns. Sometimes even the most well-intentioned client suggestions can make the job trickier. Fortunately, Jimmy's input wasn't only helpful, it was vital to the final product.

After considering the practical demands of the project, I was ready to see if my general concepts would work out visually. First, I tested various hierarchical schemes featuring different letter styles reminiscent of vintage casino signage and ephemera. I compared how changes in scale, weight, and positioning changed the dynamic between the components in my rough compositions.

Once Jimmy, Andy, and I sifted through my initial sketches, I began fleshing out a favorite in greater detail. As a nod to golden-era Vegas, I drew Jimmy's name in a jaunty Brush Script arcing across an understated Sans Serif. To help steer viewers through the design, I beefed up the initials and took up Andy on his suggestion to crown the design with a "peelable" JK monogram.

When the bulk of the heavy conceptual and aesthetic lifting was finished, I began refining the logo by fine-tuning the elements of color, regularizing the volume and contrast of the strokes, and adjusting spacing and letter proportions. I also composed the mark so that the individual components could work independently, or be rearranged to fit a vertical layout.

1

2

3

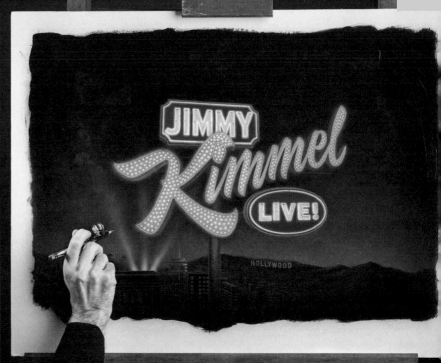

Jimmy Kimmel's
COMEDY CLUB
LAS VEGAS, NEV.

Jimmy Kimmel's
COMEDY CLUB
LAS VEGAS, NEV.

Jimmy Kimmel's
COMEDY CLUB

Jimmy Kimmel's
COMEDY CLUB
LAS VEGAS, NEV.

- NO CAFE
- INTEGRATE ♣ ♣
- COMEDY CLUB MORE LIKE 'LIVE'
- OK IF SCRIPT IS DIF. FROM JKL SCRIP
LCD MARQUEE TYPE

1. INK BLOB ENDINGS
2. SHARP TERMINALS & ROUND ARCS
3. SQUARE-ISH ENDINGS & ARCS
4. JKL LOGO SCRIPT STYLE

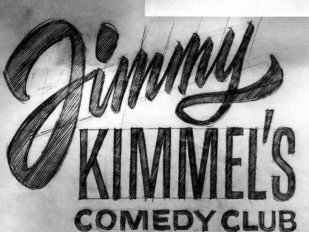

Jimmy
KIMMEL'S
COMEDY CLUB

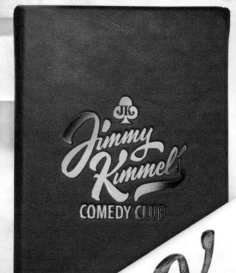

Jimmy Kimmel's
COMEDY CLUB

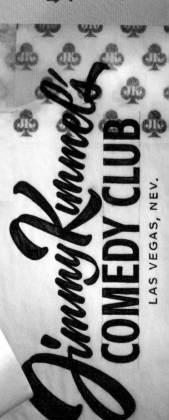

Jimmy Kimmel's
COMEDY CLUB
LAS VEGAS, NEV.

PUTTING IT INTO PRACTICE

Unless you're helping out a friend with a lost dog sign, or just drawing for the hell of it, you're making letters for commercial use. Most jobs begin with a written brief outlining the details of the project such as where and how the lettering will be used, the deadline for the finished art, and the budget for the work. A typical project includes several rounds of exchanges, beginning with a handful of proposed rough ideas, followed by a tighter drawing of the chosen direction, and finishing with the delivery of the final lettering. Sadly, there aren't widely accepted standards for quoting lettering gigs, which makes pricing a particularly tricky dance that usually requires some experience before learning how to navigate it with confidence. Ultimately, the price tag you put on your time and talents must satisfy your financial needs, be appropriate for the scope of the project, and fit the client's budget.

As you negotiate the terms of a project, keep in mind that clients are regular folks—whom you just happen to work for. (Although, in an ideal partnership, you work *together*.) Whatever the case, general rules of good conduct apply. Be nice: you can stand by your work without being a jerk. Be professional: that means show up on time, listen, ask questions, and deliver the goods. Be honest: don't sign on for anything if you can't swing it. The same basic guidelines of good behavior go for colleagues, coworkers, higher-ups, employees, and book editors, too. (Admittedly, I've still got some work to do on that last one.)

Whatever you do, make sure to show the client your sketches along the way. Even design-savvy customers may fail to realize that there isn't an instant-lettering button on your computer keyboard. Sharing pencil drawings serves as a reminder that lettering is an elaborate process that takes skill and time. I make sure my proposals are neither too sketchy nor too polished. Show off the pencil strokes, smudges, and a little paper texture, too. (Digital sketches admittedly make this more challenging.) Whatever you do, don't throw in straw dogs just to meet a concept quota. If you hate the idea, the client is guaranteed to love it. It's Murphy's Law.

In order to make sure your sketches are appropriate for an assignment, you'll need to determine how the lettering will eventually be used. The application of lettering can be divided into two broad categories: identity and advertising. The biggest difference between the two is scale: identity marks must reproduce well at small sizes, while advertising lettering must work at large sizes. But simply dividing them along one metric doesn't do us much good. There are other considerations to factor into the equation. Ultimately, it's not important under which category it's filed, as long as the lettering fulfills the practical, conceptual, and aesthetic demands dictated by its use. Since both of these general categories have different requirements, let's examine them separately.

▶▶

Before you sign on the dotted line, make sure to read the small print. Sometimes it's easy to miss.

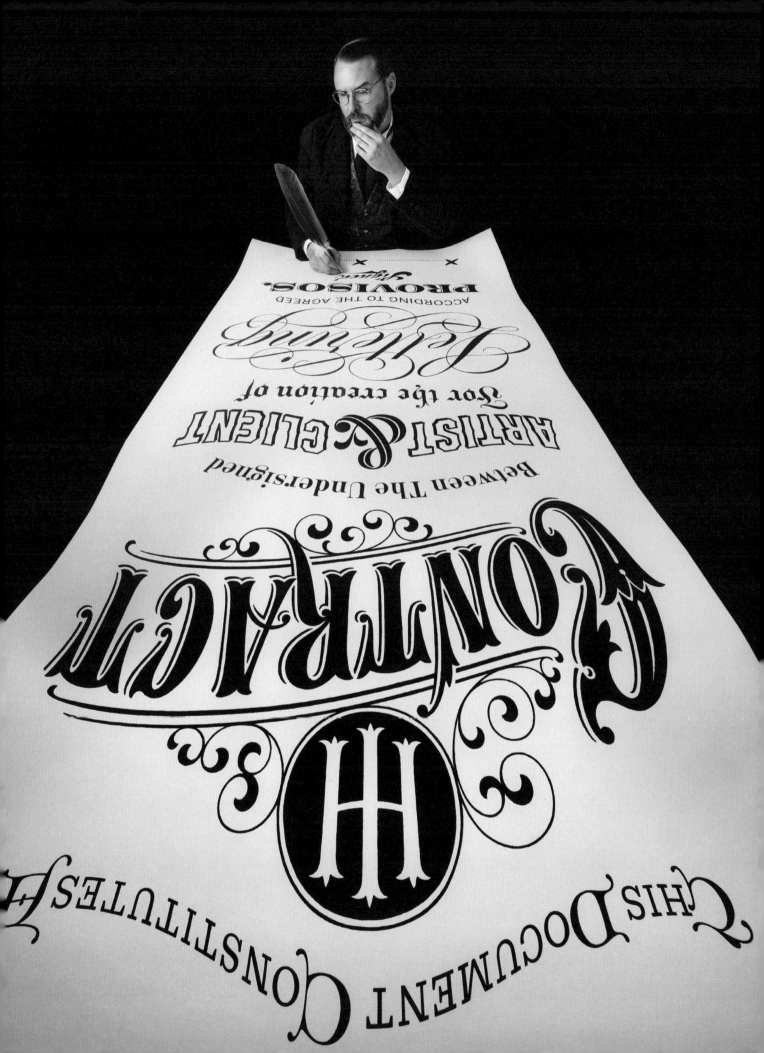

LETTERING FOR IDENTITY

How many times have you found yourself drawn to a brand because of an attractive piece of lettering? Brand identity relies on a lot of moving parts, but the visual cornerstone is usually its logo—the graphic embodiment of the person, product, or company. Considering the competitive nature of today's marketplace, it's critical that a brand possesses a unique personality that connects with consumers.

The components of a logo may include a name, symbol, or both. A *signature* includes a separate name and symbol treated as a single mark. A solitary letter or symbol that acts as a stand-alone identifier is called a *seal*. A *monogram* is a unique combination of two or more letters, which are usually initials of the person or brand. *Wordmark* is a general term referring to lettering that can function as a company's primary logo, sub-brand, property, or slogan. It can also be used in a broader sense to describe any distinctive word-based mark.

Practically speaking, a logotype should be designed with the least hospitable environments in mind, able to function in a wide range of sizes and applications, work in a single color, and perform under less-than-ideal circumstances. To that end, it should generally have moderate contrast, adequate spacing, generous proportions, and a simple composition with few components. Because the application of supplementary marks is usually limited to particular instances or falls within the category of advertising, there's often more leeway in their design.

▶

Logos can be configured in a variety of ways. Multiple components lend "peelability" to a mark by allowing its parts to be implemented independently.

▼▼

Wordmarks don't have to sacrifice flavor in favor of practicality. Sometimes a quiet feature expressed throughout a wordmark is enough to set it apart.

▶▶

An effective logo has aesthetic aspects that make it compelling and unique to consumers. That doesn't mean it has to be over the top; even a conservative logo can have individuality.

WATSON·GUPTILL
CALIFORNIA | NEW YORK

CORPORATE SIGNATURE

SEAL

WATSON·GUPTILL

WORDMARK

SEAL

Hampsten

HILTON

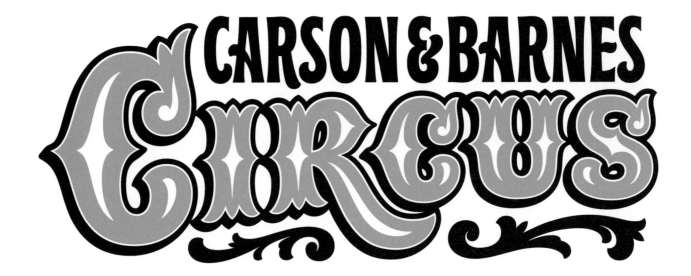

Conceptually, a wordmark epitomizes the characteristics of an individual, or reflects the values of a company. Consider which qualities are essential, and match those traits with appropriate models. Power might be represented by bold or unsophisticated letterforms; beauty can be symbolized by delicate or refined ones. I try not to get too hung up on being predictable; the best solutions are often the most obvious. Besides, I'd take *good* over *novel* any day of the week.

A logo should also be aesthetically distinctive and appealing—that's where your ingenuity and skills really shine. When I start a project, I like to get the lay of the land by sniffin' around to see what competitors are doing. Working in a vacuum and ignoring what everyone else is doing can be liberating, but working with blinders on isn't helpful when you're trying to set your lettering apart from the pack. You want to see what sort of visual language is the norm in a certain market, so you can decide whether it's more sensible to go with the flow, or to swim upstream. As lettering great Doyald Young once said, "The basic rule for logotype design is simple: do your homework."

When it comes to the nuts and bolts of establishing the unity, hierarchy, optical direction, and tension of a composition, there are a number of characteristics that can be exploited in multi-word logos (and advertising lettering, for that matter). Different components can exhibit uniformity by having the same letter size, weight, case, and style. On the other hand, the size of one component can be emphasized or its weight can be increased as a way to establish prominence. Another way to differentiate between the parts of a layout is by switching up the case or letter style.

Keep in mind that brand identities often extend beyond the use of a solitary logotype. Supplementary lettering is frequently used in graphic campaigns to expand the design palette of the company, product, or message. This can be done through the creation of a supporting mark—like a tagline or catchphrase—or with additional graphic elements.

▲

You can find clues to formulate the concept for a wordmark by considering factors such as the brand's vision, position, background, and audience.

Altering the size, weight, case, or style of a mark's components can change their hierarchical position and how they are unified within the composition.

Potchky Potchky

SAME SIZE, WEIGHT, CASE, STYLE

Fancy BRIGADE

DIFFERENT STYLES

JAZZSEASON

DIFFERENT WEIGHTS

thePIEDMONT

DIFFERENT CASES

BARRY KATZ

DIFFERENT SIZES

CASE STUDY
THE WINE GALLERY

Mr. Tadaaki Narita is one of the top sommeliers in Japan, renowned for both his vast knowledge on the subject of wine and his exceptional gastronomic sense. His restaurant, Esperance, in the popular Roppongi district of Minato, Tokyo, is widely acclaimed for its wonderful marriage of fine wine and French cuisine, making the establishment highly sought after among aficionados. In 2016, Mr. Narita planned to open the boutique of his dreams: a destination along the famous Omotesandō Avenue in the country's capital where wine enthusiasts could obtain select offerings from a thoughtfully curated cellar. As such, the mark on the door welcoming guests needed to indicate that they were being transported to an exciting and luxurious world. That's where House Industries entered the scene.

The Wine Gallery is not an ordinary "shop," but rather a place where patrons can personally interact with experts in a relaxed atmosphere, while learning about various regions, styles, and vintages. Beyond being a simple retail space, The Wine Gallery provides an immersive experience to customers. Its innovative attitude combines an authentic approach with a hip vibe in an exclusive setting. There are no bottles visible in the salon, only a large central table where stewards can present items from the cellar based on clients' preferences or food pairings. Many of the products in the collection can only be found at The Wine Gallery, and often carry a price tag that reflects their limited availability.

House's own design steward, Andy Cruz, and I wanted the logo to be as uncommon yet engaging as The Wine Gallery's unique outlook and environment. In the course of exploring a range of potential directions, my initial concepts took a few different tacks. One group of thumbnails pulled from French art nouveau design, while another explored stencil lettering commonly used for marking casks and bottles. A third phase of drawings featured elegant scripts, typical of many labels. Yet another round of sketches illustrated a mash-up of my previous ideas. Despite a range of approaches, my proposals seemed predictable, lacking the modern spirit that Mr. Narita's new venture embodied. The logo had to be rooted in tradition, yet as racy as the wines on offer. That's when Andy remembered the logo of a department store that he frequented as a child.

Woolco was a mid-twentieth-century nationwide chain of suburban variety stores whose identity starred an impressively bold and daring W. This gutsy design maneuver prompted us to take a similar angle with our project. The Wine Gallery logo features an audacious undulating initial, fortified by a supple stylized lowercase. The bottom-heavy leggy script expands on conventional models to produce a familiar yet updated look, while producing the letters' unmistakable typographic terroir.

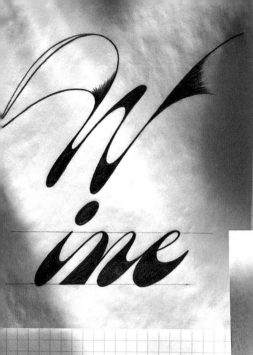

The Wine Gallery

The WINE Gallery

THE Wine GALLERY

Wine

Wine

The Wine Gallery

The Wine Gallery

THE Wine GALLERY

THE Wine GALLERY

Woolco
We want to be your favorite store

Woolco
Woolco
Woolco
Woolco
Woolco
Woolco
Woolco
Woolco
Woolco
Woolco

Wool

THE COMPLETE BOOK

Erotic Art

Erotic Art,
Volumes 1 and 2

81 COLOR PLATES
781 BLACK AND WHITE PLATE
COMPILED
BY
DRS.
PHYLLIS AND
EBERHARD

LETTERING	DIMENSIONS	COMPLEXITY	CONTRAST	SPACING	PROPORTIO
ADVERTISING	LARGE	HIGH	HIGH	TIGHT	VARIED
IDENTITY	SMALL	LOW	MODERATE	OPEN	UNIFORM

LETTERING FOR ADVERTISING

The job of most advertisements is to sell you something—be it a product or an idea. Whether ad lettering is part of a print ad, film title, TV commercial, or promotional campaign, when it's done right, it sets the perfect mood, captures a desired look, and speaks to its target audience—all at a glance. While advertising lettering must still meet practical, conceptual, and aesthetic requirements, it functions a little differently than lettering for brand identity. Lettering in advertising is typically designed to work at a larger scale, which can allow for greater complexity in compositions. There's no need to sweat details getting lost when the lettering is plastered on the side of a building, or on a billboard towering above a six-lane highway.

Having more real estate may be a luxury, but it doesn't mean the context of the lettering can be ignored. A reader might very well be seduced by the subtleties of an editorial design as they casually thumb through the pages of a magazine, but not every audience is a captive one. Lettering displayed on the wall of a bus stop will be experienced differently than that same poster pasted on the side of a bus barreling down the street. Environmental factors, including physical forces like distance and velocity, must also be kept in mind.

Other situations will present material challenges that steer the decision-making process. The thickness of a stroke has real-world consequences when a sign fabricator has to bend a tube of neon through a steel-channeled extrusion of that letter. A delicate hairline flourish in a piece of Formal Script might fit the bill for a poster, but how will it hold up when it's screen-printed? Moreover, do those niceties translate when seen from across the street? Four-color printing, pixel values, and other production methods each have their up- and downsides, too.

Lettering in marketing and advertising often has a short shelf life compared to logos. Building brand recognition requires that consumers gradually become familiar with a company or its products, but that usually takes time. By comparison, ads and promotional schemes are ephemeral, rarely lasting for an extended period. Short-lived lettering can cash in on trends and passing fashions, but that strategy probably won't work for a brand attempting to increase the equity of its corporate mark. (Nevertheless, some outfits *do* roll the dice by occasionally switching up their logo, though they're usually companies that already have a large and loyal fan base.)

Whether you're composing lettering as part of a brand's identity or for advertising use, don't get too intimidated by the number of factors that have to be taken into account. When I begin a piece of lettering, many details have already been decided for me: the wording has been determined, as well as the space allotted for it. If I've done my job quizzing the client, I'll also have a good idea about stylistic preferences, color ways, and final application.

Drawing a piece of lettering is a lot like using a pair of binoculars: the image starts off blurry and indistinct, before it's eventually brought into focus. Start with the important parts, which will look a little loose and fuzzy at first. Then slowly sharpen the finer details as you get closer to the finished product. Don't worry: the right decisions will become clear soon enough.

The way that letterforms are drawn depends on how they will be used and the settings in which they are likely to appear. In the accompanying chart, lettering for advertising and identity are compared, illustrating how their purpose and application affect the design and visual characteristics of each. For example, since the dimensions of advertising lettering (like the kind seen in magazines, posters, and billboards) are often larger than identity marks like logos, their design can be relatively complex. This also affects other drawing considerations like the contrast, spacing, and proportions of their letterforms. Of course, in certain instances, ad lettering may have to perform at small sizes or in less-than-ideal scenarios (onscreen, for example), so its forms should be designed accordingly.

Because lettering drawn for advertising is typically reproduced at a larger scale compared with identity marks, it allows for more complexity, greater contrast, and varied proportions among its component parts. A logo with the same attributes won't fare as well.

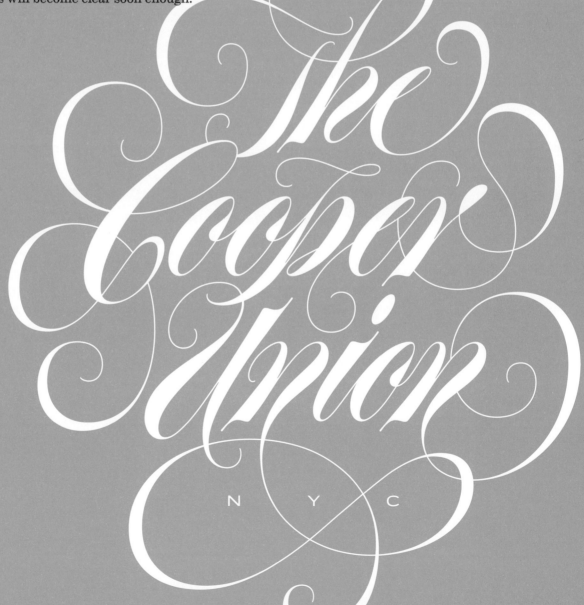

The Cooper Union

N Y C

Despite growing up on the East Coast during the 1970s and '80s, I imported many of my early music, fashion, and design influences from California. Bands like the Germs, Agent Orange, Black Flag, and Bad Religion provided a good part of the soundtrack to my teenage years, while *Maximumrocknroll*, *Breakout*, and *Thrasher* magazines sucked me further into the punk, surf, and skateboarding scenes on the other side of the country. I also blame artists Raymond Pettibon and Shawn Kerri for helping to set me on my eventual career path. So, when streetwear innovator Rick Klotz offered to host a House Industries exhibition in his new gallery in LA, I was itching to tap my brimming storehouse of adolescent inspiration.

Reserve was a boutique and gallery co-owned by Na'ama Givoni, which featured a collection of new and vintage art and design books and LPs, in addition to selections from Rick's well-known Freshjive and Gonz! clothing lines. The store was situated along historic Fairfax Avenue, right across the street from the famous Canter's Deli and

skate-shop-cum-streetwear label Supreme. The House Über Alles exhibition included paintings and other one-off pieces of artwork, as well as a limited run of clothing produced especially for the show. We just needed some lettering to help spread the word.

Andy and I got to work by digging though our own reserves of reference material. The title of the show tipped its hat to the song "California Über Alles" by San Francisco iconoclasts Dead Kennedys, providing the essential punk piece of the puzzle, while a beefy blackletter "House" looming above a hefty chain-link border added 1960s and '70s biker motifs. Underneath, a viscous "Über Alles" hinted at surf and streetwear culture of the 1980s, taking cues from favorites closer to home, like the classic splashy script logo that Tom Carnase lettered for Grumbacher, an art supply company. Finally, the lightning bolt–shaped "Reserve" lettering drew from skate graphics and advertisements of our youth, particularly Jim Phillips's influential illustration work for Santa Cruz Skateboards.

As a piece of advertising intended to plug the exhibit, the primarily use of the lettering afforded us plenty of luxuries when it came to the complexity and embellishment of its composition. Subtle highlights intended to give the "Über Alles" script a liquid look, as well as details in the intricately illustrated framing device, typified the sorts of nuances that usually prove too intricate for logos. In this case, those same features reproduced admirably when scaled, adding richness to the lettering as it was adapted as signage in the gallery's window front.

Although the final piece pulled from a mixed bag of sources, albeit filtered through our personal stereotypes of the West Coast lifestyle, they somehow managed to make a significant impact on us thousands of miles away, and continued to resonate with House Industries decades later.

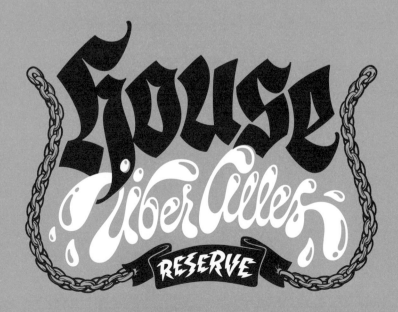

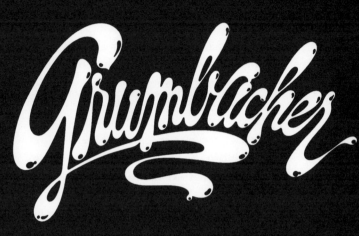

Grumbacher

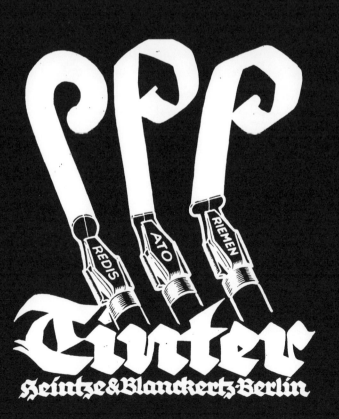

Tinter
Heintze & Blanckertz Berlin

DEAD KENNEDYS
DEAD KENNEDY

SAT FEB 5

PUT YOUTH TO WORK BENEF

DEAD
KENNEDYS

7pm SHARP SHOW STAR
BOX OPENS 5PM $7
OFFICE
INFO RRZ

INFO:
VO 213- 654-8743
654-0214
PKS
213-851-1700

KNAC 437-O366
KLA UCLA 825- -91o4
XLU 642-2866
ULTY 931-1373
KROQ

LA
weekley
462-6911

CSUN North Campus
California State University, Northridge
18000 Devonshire Street
Northridge, California 91325

PET
ROCK

WiTH
FLIPPER

win
tickets

YOUTH BRIGADE

no CRISIS

PRODUCTION

The lettering you make may ultimately exist as a tangible thing affected by physical properties. The ability to recognize and understand letterforms is restricted by the physiological limitations of our eyes and brains, the environment they inhabit, and the conditions under which we experience them. These limitations establish the boundaries of a letter's breaking point. Too fine a line, and pixels can't adequately form the letter. Too bold, and ink closes the important negative spaces that help us differentiate letters and words. Too narrow or wide, and the positive and negative shapes are disrupted to such an extent that we no longer recognize the helpful rhythmic patterns that this crucial interplay of figure and ground creates.

Before releasing your work into the wild, you need to determine whether the lettering is going to pull its weight. The best way to judge the performance of letterforms is to proof them, or in other words, put them through the paces by mimicking the conditions under which they're likely to be encountered.

PROOFING

During this proofing process, I try to imitate an array of potential settings. Testing iterations of a logo in a range of small sizes on the office printer is a pretty common tactic. Just remember to reverse it out of a black background to get the full effect. Gauging how lettering will hold up onscreen at small sizes is pretty easy, too: take a shot of it and scale it up and down on your screen.

Testing lettering at larger sizes is a little bit tougher. To assess the Suzanne Roberts Theatre sign that House Industries designed for the Philadelphia Theatre Company building, I had an oversized printout made at the local photocopy joint. Then, we hung it up to have a look. The artwork wasn't full size, but it did give a pretty good indication that the lettering would work as planned. (And, yes, the giant proof on the opposite page is legit.)

It's not always possible to anticipate conditions that may negatively impact lettering, but it's worth giving it some thought. Whenever you're able, I strongly recommend requesting samples, especially if you haven't used a certain medium or applied a particular method before. A lot of unexpected things can happen when letters are woven in fabric, stamped in foil, or embossed in leather—not to mention the tons of other ways lettering makes its way out into the world. As much as I love the warmth of penciled letterforms, an image with limited detail or rough contours may limit the extent to which that lettering can be scaled, modified, or implemented. Most applications of commercial lettering demand that it be produced by means that do not restrict its use, which means that rendering letterforms as scalable digital artwork is often necessary.

VECTORIZING

Vectorizing (or *vectoring*) is a digital process of creating two-dimensional forms by plotting a series of points that are connected by lines. The biggest advantage to using vector graphics is that lettering can be sized to an unlimited degree without adversely affecting its resolution or amount of detail. Not all scenarios require vectorized lettering, but it's a safe bet that most clients will request it—especially for logos and advertising campaigns. There are a number of vector-based drawing programs on the market, most of which will provide the same results.

Begin by photographing the lettering at a high enough resolution that the image retains sufficient detail when you zoom in onscreen to make close-up adjustments. If I'm concerned that a hurried photo will potentially result in distorted proportions, I'll slap my drawing on the scanner at the highest resolution to make sure it's exactly as intended.

Next, place your sketch file—black-and-white pixelated images usually work best—into a program that can handle vector drawing. (I've been using Adobe Illustrator for as long as I can remember.) I prefer to use layers to separate the original scan from my vector artwork. Plot the points with a pen tool the same way you would draw them, overlapping the contours of the individual strokes. This allows you to edit crisscrossing outlines without them affecting one another. (I always merge outlines in the final artwork. Otherwise, the client may be tempted to make edits themselves.) Oh, and don't phone it in by using automated vectorizing algorithms; they rarely capture the subtleties achieved by manually plotting points. Besides, they can create a ridiculous number of points that make adjusting outlines a nightmare. I might be lazy, but I'm not *that* lazy.

It's always a good idea to keep things simple by limiting the number of points in an outline. Reducing the complexity of contours makes the editing process easier and more efficient.

✗ AVOID USING TOO MANY POINTS

✓

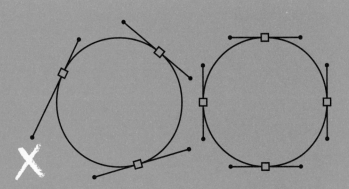

Whenever possible, place points at the extrema of curves, and position handles at right angles. Orthogonal drawing allows for easier modifications because it conforms to the underlying grid.

✗

PUT POINTS AT THE EXTREMA ✓

It's generally a good policy to avoid crossing the handle of one point with the handle of another point that defines the same segment. This practice goes a long way toward ensuring smoother contours.

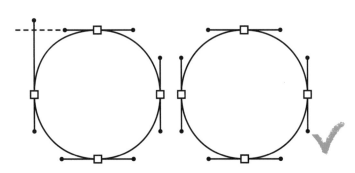

✗ DON'T CROSS HANDLES

✓

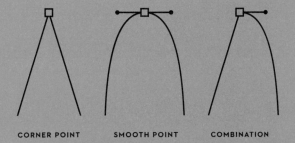

CORNER POINT **SMOOTH POINT** **COMBINATION**

Points connecting two segments of a vector outline can be joined as corner points, smooth points, or a combination of the two. Make sure that you're using the right kind of point for the job.

USE THE RIGHT POINT ✓

Make handle lengths proportional to the shape of the segment that they define. If a curved segment is twice as wide as it is tall, the handles controlling height and width should have the same ratio.

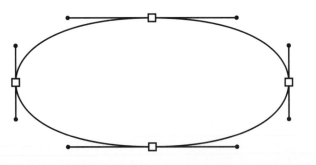

✓ MAKE HANDLES PROPORTIONAL

Type & Lettering

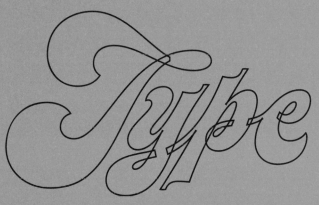

OVERLAPPING OUTLINES

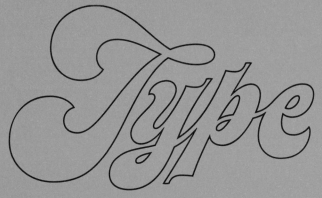

MERGED OUTLINES

When preparing final artwork for printing or other production, make sure to create a new file before flattening layers, expanding effects (like stroked line segments), and merging all outlines.

Typeface designers and most lettering professionals use a vectorizing method often referred to as orthogonal drawing. This process involves placing points at the extrema of contours, and pulling the *handles* (that extend from points defining curved line segments) at right angles. While this technique works in most cases, there are instances where additional points are necessary. *Extrema* refers to the outermost edges of a shape along the top, bottom, left, and right of its silhouette. You can also think of it as where the outline, or path, changes direction. Follow the contour of an object while imagining north, south, east, and west as located on a compass; shifts between the directions mark the placement of points. Alternatively, think about it like a clock, with points at 12, 3, 6, and 9 o'clock.

When tracing your original drawing, the pixilation of the artwork may also give clues for point placement. Remember classic arcade video games like Pac-Man and Donkey Kong? The graphics look like they're made up of small blocks. The pixels of high-resolution images are similar, but just a lot smaller. Pixels defining the edge of an image often level off before stair-stepping in the other direction. This usually indicates the extrema of the outline, and is a good place to plot a point.

Points control a line segment's length and shape. (A segment is any part of a path with a point at either end.) The shape of a segment may be defined by one, two, or zero handles extending from its points. For smooth outlines, keep handles constrained to right angles. Just don't cross two handles, or the general direction in which they're pulled. I've found that making the length of handles proportional to the dimensions of the ellipse they're describing makes for pleasing curves.

If you find that using two handles to shape the curve of an outline is unnecessary or overkill, pare down to using one. This is particularly helpful for very short line segments, or for those where only a subtle arc is desired. This technique is useful for entasis, providing warmth by making otherwise straight segments slightly concave or convex. For complex curves or multidirectional outlines, an *ogee* (S-shaped curve) often comes in handy—like when you're tracing (big surprise) a letter S.

There are other good reasons for using orthogonal drawing. Not only is the logic behind the process pretty sound, but it's also rather efficient once you get the hang of it. If two or more people need to edit a file, the shared technique makes life much easier. The integrity of curves is also maintained when vector artwork is converted to an unforgiving low-resolution pixel grid. Most important, since it follows the logic of vector graphics, it's the best shot you've got at getting the most out of your outlines.

Sometimes it's necessary to add a small segment at the ends of fine hairlines and extremely sharp angles. Otherwise, the loss of volume will cause them to visually recede into the background and disappear.

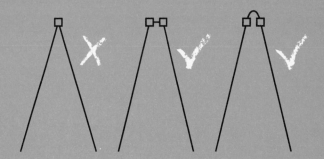

BEEF UP ACUTE ANGLES

Overlap outlines in the same way you sketch individual parts of a letter using the component drawing technique, covered on page 45. Join the ends with an extra segment to complete the path.

OVERLAP OUTLINES ✓

Overlapping otherwise conjoining segments is a useful vectorizing strategy because it allows you to adjust one part of the letter without throwing off another, making the editing process that much easier.

✓ MAKE EDITING EASIER

A compound S-shaped curve often goes by the name ogee, which is just a fancy way of saying continuous double curve. It's ideal for defining the spine of the letter S and similar complex shapes.

USE COMPOUND CURVES ✓

To ensure that hairlines remain consistent in high-contrast script, draw them as single-stroke segments, while outlining the contours of heavy strokes. Then, expand the hairlines, and join all paths.

✓ VECTOR HAIRLINES EVENLY

HELPFUL HINTS

If you start to get fazed by all the principles, rules, and effects that influence lettering, here are a few helpful pointers to keep you on track as you move on to the next part.

Make the elements of color—volume, spacing, contrast, and proportion—your mantra. When you internalize these concepts as part of your workflow, you will begin to instinctively apply them without giving it a second thought. Your lettering will thank you for it.

Get out of your own way. It's surprisingly easy to prematurely obsess over details, so try to resist getting hung up on a particular concept or fine-tuning a sketch before it's necessary. Get the gist of an idea by fleshing out rough thumbnails fast, then move on to the next.

Draw a lot. Sketches don't take much time, and there are always plenty of tracing pads and pixels around to make more. If an idea isn't working out the way you expected, reach for another piece of paper. Even if you cook up a decent solution, the next one might be even better.

Don't draw too small. Thumbnails are a great way to quickly realize ideas, but eventually your lettering will need more real estate when it comes time to articulate finer details. There's an adage about trying to cram ten pounds of crap in a five-pound bag that's probably relevant here.

Don't slavishly imitate models. Referencing typographic sources is a helpful way to get acquainted with different letter styles, but you may end up wasting your time drawing something that could have been accomplished more quickly and easily with typography.

Hoard your sketches. You may want to revisit them when a project changes direction or an alternate mark is needed. Even if something doesn't work for one job, it might end up being a good fit for another down the road. There's no sense in letting a perfectly good idea go to waste.

Don't draw too large. When the size of your sketches is too big, you're forced to step back in order to properly review your work. It's like watching a movie from the front row of a theater: sitting that close to a huge screen causes you to constantly shift your attention to take in all the action.

Kill your darlings. Yeah, I know it's trite, but getting attached to a certain letter style, construction, or feature doesn't mean it's appropriate for every job. Try to remain detached as you assess your lettering. How does that expression go? "If you love something, set it free..."

Fill in your letters. It's common for beginners to forget this simple yet crucial step. Remember, it's all about color: you can't accurately judge the volume, spacing, contrast, or proportion of letterforms if there are no black-and-white shapes to compare to one another.

Draw upside down. Can't figure out why some contours don't look quite right? Rotate your lettering 90 degrees, or turn it on its head. Changing perspective allows us to see letters as pure form, and ignore any preconceived notions about how they "should" look.

Hold your breath, literally. It reduces subtle movements that may disturb your hand as you draw, especially when you're executing a final pen or pencil rendering that requires a polished finish. This is particularly helpful for pulling long lines and tracing broad arcs.

Ditch the ruler. Sure, it's fine for laying down guidelines or cleaning up edges, but overuse can make for mechanical-looking letters. Instead of reaching for French curves, take the opportunity to hone your hand skills so you can make exactly the shapes you want.

Throw your body into it. Our arms are influenced by radial movements. Fingers and wrists make small arcs, elbows larger still, until reaching the shoulder. So, next time you draw a broad curve, stiffen your hand and rotate from the elbow or shoulder instead.

Embrace creative slumps. Use them as an excuse to reference typefaces or other lettering. (Just remember, there's a fine line between "inspiration" and "infringement.") Or let your ideas marinate for a while, then come back to them with fresh eyes.

Don't sweat developing a personal style. Your individual preferences, decision-making process, and problem-solving approach will come out naturally, and ultimately manifest in work that's uniquely yours. You couldn't *not* do your thing, even if you tried.

Remain open to new ideas. Remind yourself to give something else a try every now and then, be it an unfamiliar letter style or an unusual composition. It could be a dead end or an undiscovered avenue. There's only one way to find out.

Don't take it personally. This is especially helpful when getting feedback from a client or colleague. Keep in mind that the goal is to create something that fulfills the task at hand. You may have hatched the ideas, but in the end, it's not about you.

Keep some things to yourself. It's tempting to publish each little scribble you make—and sometimes unsolicited input is genuinely helpful—but feeling compelled to broadcast every creative urge can be exhausting. Keep your head down, and continue crankin' away.

Give yourself a break. Looking at others' work can be motivating, but without a positive outlook it can also be unproductive—especially if you're comparing your lettering to that of someone who's been doing it for their entire career. You're making headway with every sketch.

Don't get down on yourself. Lettering is a skill that requires time and practice to perfect. Hell, I'm *still* learning new things—which is exactly what continues to hold my fascination with lettering. Just stick to it, and you'll catch on before you know it!

LETTERING MODELS

Now that you've got a handle on the mechanics of lettering, let's take a look at some references to get you sketching. Most of the following examples are linked to established typographic models, although a few do maintain a closer connection to handwriting. When the twentieth century rolled around, commercial artists began modifying versions of these letters to fit layouts when metal type didn't cut it. As letterers redrew styles to suit specific needs, they routinely "fixed" features they didn't like. This often meant adjusting letters' proportions, contours, and construction. In the process, letterers effectively reinvented the old standards while establishing the foundation for contemporary lettering practice.

These models are meant to serve as guides for freehand drawing, and to offer departure points for further experimentation. I generally don't advocate tracing models as a way to appreciate and understand letter styles. It is a separate hand skill that doesn't require you to carefully observe letters and think critically about the decision-making process behind their formation.

Most instruction manuals from the last century used models similar to these to teach lettering. Not every style is represented here—these are mainly House Industries standbys guaranteed to give the most bang for your buck—but they've all been run through the studio's patented creative blender. I also crack open the House vaults to share prized pieces of reference, loads of time-tested techniques and unusual examples, some historical bread crumbs for continued study, as well as plenty of tips and tricks to help you concoct your own secret lettering sauce.

As you've already learned, not all letter styles fit neatly into strict categorical boxes. Serif letters, which are defined by supplemental stroke endings, have a bunch of subgroups, as do Sans Serif ones. Script and Brush Styles, on the other hand, can be interpreted in a seemingly endless number of ways. We'll look at a handful of these genres primarily as a means to understand some of the unique characteristics that designate different kinds of letters, and to provide jumping off points for new lettering.

Clarendon / **Slab Serif** / Fat Fa

TUSCAN / Modern / SQUAI

Latin / Reversed / SLA

RIF / GEOMETRIC / Roman / M

MODERN / **Clarendon** / *MODE*

Serif

SERIF STYLES

The influence of twentieth-century advertising is largely responsible for the diversity of contemporary commercial lettering. However, many of the models we use today were derived from typographic sources. One of the most popular in early American fashion magazines and advertisements was Caslon, a seventeenth-century Old Style typeface that eventually became the template for many hand-lettered headlines and captions. Also in vogue during the mid-twentieth century was the Modern letter. Introduced at the close of the eighteenth century, the style had crisp serifs, sparkling contrast, and a vertical axis that allowed letterers to manipulate its forms in an endless variety of ways. Fat Face, a ridiculously heavy offshoot of Modern, was developed during the early nineteenth century to respond to the demands of industrial society. Created for advertising, it was used on posters and billboards to attract consumers. The style was followed by an even meatier letter named for its monolithic strokes: Slab Serif. If Fat Faces were meant to grab people's attention, Slab Serifs were built to wrestle them into submission.

During the previous century, these letters dominated hand-drawn serifed headlines, and continue to be useful to today. This section gives an overview of each category, identifies key features, illustrates stylistic spin-offs, and shares tips on how contemporary letterers can squeeze the most out of these essential styles.

AD ROMAN

Magazines of the early twentieth century leaned heavily on typography. Even large headlines were often photographic enlargements of small settings. One of the most common typefaces in turn-of-the-century captions and editorials was Caslon. (William Caslon was a British type founder whose spin on Dutch Old Style in the 1700s put him on the map. When the colonies over the Atlantic imported his fonts, the type's popularity was cemented stateside.) In the late 1800s, Caslon was adopted by fashion magazines and advertisers, making it the de facto serif for American letterers. Most hand-drawn Caslon remained close to the mark, but by the 1950s and '60s letterers modernized the style by overhauling its basic structure to make it more adaptable. Much to the horror of some type purists, "Caslonesque" hybrids revamped conventional Old Style.

The model we reference here isn't traditional in the typographic sense. It favors uniform proportions, making the letters more agreeable to customizing, and borrows features from Transitional types that bridged the Old Style and Modern genres. The lowercase also has a generous x-height as well as short ascenders and descenders, which conserve space and allow for tightly arranged layouts.

Stylistic details can be turned up or toned down to create marks that run the gamut from casual to conservative. It all depends on which stylistic levers you grab...and how far you pull them. Whatever the flavor, Ad Roman is a handy and dependable workhorse.

$\frac{1}{2}$X

X

< $\frac{1}{2}$X

shag

NOT ENOUGH
CONTRAST

TITTLE IS
TOO CLOSE

LETTER NEEDS
TO BE WIDER

IMPROPER SERIF

mistakes

SERIFS LACK
VOLUME

BRANCH THIN
STROKES SMOOTHLY

EYE IS
TOO LARGE

SPINE LACKS
VOLUME

Casual
roman

STROKES TAPER
AT WAIST

BEAKS ARE
ANGLED

ABCDE

BAR DIVIDES
SPACE EVENLY

CROSSBAR IS
OPTICALLY CENTERED

FGHIJK

ARM IS LOWERED
TO BALANCE SPACE

INNER SERIF IS LONGER

J HAS MODERN
PROPORTIONS

LMNOP

ENLARGED SERIF
PROVIDES VOLUME

THIN VERTICAL
STROKES

CURVED STROKES
TAPER AT TOP AND BOTTOM

QRSTUV

SPINE IS ABOVE
THE CENTERLINE

ELONGATED SERIFS
BALANCE SPACE

WXYZ

SHORT OUTER
SERIFS IMPROVE
SPACING

BASE IS
WIDER

WAIST SITS
BELOW CENTERLINE

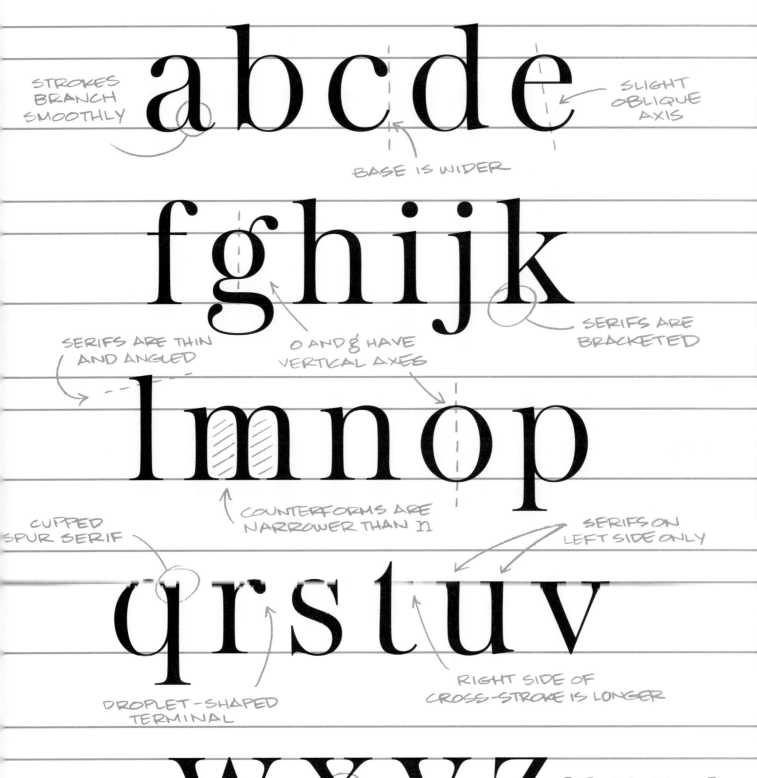

STROKES BRANCH SMOOTHLY

SLIGHT OBLIQUE AXIS

BASE IS WIDER

SERIFS ARE THIN AND ANGLED

O AND g HAVE VERTICAL AXES

SERIFS ARE BRACKETED

COUNTERFORMS ARE NARROWER THAN n

SERIFS ON LEFT SIDE ONLY

CUPPED SPUR SERIF

DROPLET-SHAPED TERMINAL

RIGHT SIDE OF CROSS-STROKE IS LONGER

THIN STROKES ARE SLIGHTLY OFFSET

BOTTOM SERIF IS LARGER THAN THE TOP ONE

DRAWING AND MODIFYING AD ROMAN

Unless you're going for conservative lettering, I recommend losing the ruler. Mechanistic forms look stiff, especially in vectorized art. Drawing freehand, however, gives letters lively tension.

To ensure proper color, make sure the letters have even volume. Undersized serifs, *beaks* (vertical serifs found at the ends of some strokes), and weighted stroke endings will appear disproportionately light. Add a little weight to the tips of thin terminals so they don't visually shrink, and extend serifs to compensate for awkward negative spaces. Arcing strokes usually branch somewhat abruptly from stems, but they can extend smoothly, too.

As long as you don't get too hung up on type protocol, Ad Roman can be surprisingly elastic. Flare stroke endings or shorten serifs to create a spurred effect. Or, ditch brackets and hike up the contrast to get a more Modern feel. Ad Roman can handle its share of weight, too. Just keep an eye on bold high-contrast variations— thin hairlines might not provide enough visual glue to hold everything together.

Ad Roman is receptive to swashes and flourished letters in small doses. Embellishing is a bit like cosmetic surgery: sometimes folks should know when to say when. No matter how you modify Ad Roman, don't lose sight of the kind of letter you *want* to make. Where it ultimately falls on the design continuum doesn't really matter, as long as it does the job.

▶▶

Despite being a muscular letter, Poster Roman features curvaceous contours and soft stroke terminals. This casual style can be created by increasing the weight while reducing the contrast of the traditional variety.

MECHANICAL DRAWING

FREEHAND DRAWING

UNEVEN VOLUME

EVEN VOLUME

SMOOTH BRANCHING

ABRUPT BRANCHING

SWASH EMBELLISHMENTS

Aloha

ITALIC AND RELATED STYLES

It helps to bear in mind that Old Style is derived from earlier pen-based typefaces, so some traces of the broad edge will be evident in the Ad Roman italic.

The uppercase is essentially a modestly slanted version of its upright counterpart, give or take a few minor adjustments, though the construction of the lowercase differs more dramatically. The lower left and upper right areas of curves typically swell—as in the a, e, and so on—carrying some volume into the strokes as they turn along the guidelines; this can be observed in the entry and exit strokes of vertical stems as well. However, the o (and o-like form of the g, for that matter) maintains an axis that's closer to vertical, preserving the thin strokes at the top and bottom. With the exception of swashed strokes in a handful of the diagonals (v, w, and z), basic components comprising the lowercase repeat throughout. As with typography, hand-lettered italics are usually a touch lighter and narrower than the roman.

A beefier lower contrast Ad Roman with rounded serifs and soft details became fashionable during the early part of the twentieth century, especially among advertisers looking to create punchy yet friendly headlines. As the name suggests, Poster Roman pulled its weight especially well at large sizes.

AD ROMAN ITALIC AND SWASHED ALTERNATES

abcdefghij
klmnopqrst
uvvwwxyz

139

MODERN

The Modern letter is one of the most versatile serif styles in the letterer's arsenal, hands down. Dress it up for formal occasions, or let it all hang out when the situation calls for something more laid back.

Modern emerged at the close of the eighteenth century, and was exemplified by the work of Firmin Didot and Giambattista Bodoni. Their types explored a "rational" approach to design, resulting in letterforms with uniform proportions, unbracketed serifs, high stroke contrast, and a vertical axis. Sometimes referred to as Didone—in honor of the two pioneers—the style was also influenced by pointed pen writing and fine engraving of the time. Letterers of the twentieth century appreciated the unparalleled adaptability that this provided, and modified the style extensively for all sorts of uses.

Our model has all the traits of the commercial letterer's ideal: even proportions in the uppercase and lowercase; generous symmetrical curves; substantial contrast; crisp, thin unbracketed serifs; and juicy ball-shaped terminals. (Incidentally, many of these features are shared by Roundhand script, making the two ideal for pairing.)

Although their fine details make them obvious candidates for large applications, beefed up Moderns perform pretty well in small settings, too. Altering the mood of Modern letters is as easy as playing up or toning down the right attributes. Whatever you need, the Modern letter has got you covered.

Modern

AN AN

aaaaa

gky gky

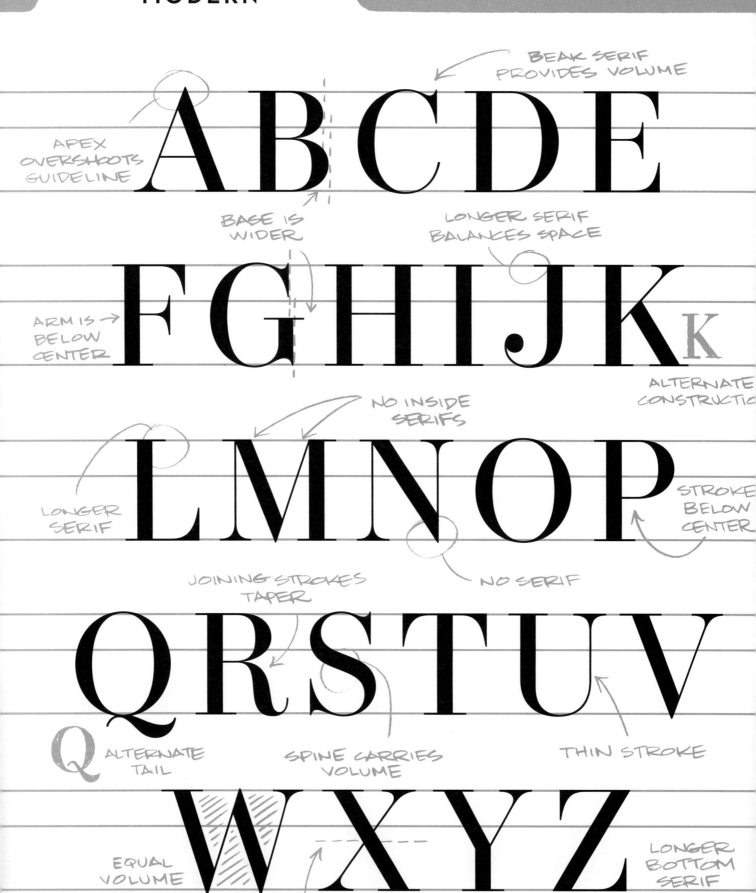

BEAK SERIF
PROVIDES VOLUME

APEX
OVERSHOOTS
GUIDELINE

BASE IS
WIDER

LONGER SERIF
BALANCES SPACE

ARM IS
BELOW
CENTER

ALTERNATE
CONSTRUCTIO

NO INSIDE
SERIFS

LONGER
SERIF

STROKE
BELOW
CENTER

JOINING STROKES
TAPER

NO SERIF

ALTERNATE
TAIL

SPINE CARRIES
VOLUME

THIN STROKE

EQUAL
VOLUME

LONGER
BOTTOM
SERIF

STROKES CROSS
AT OPTICAL CENTER

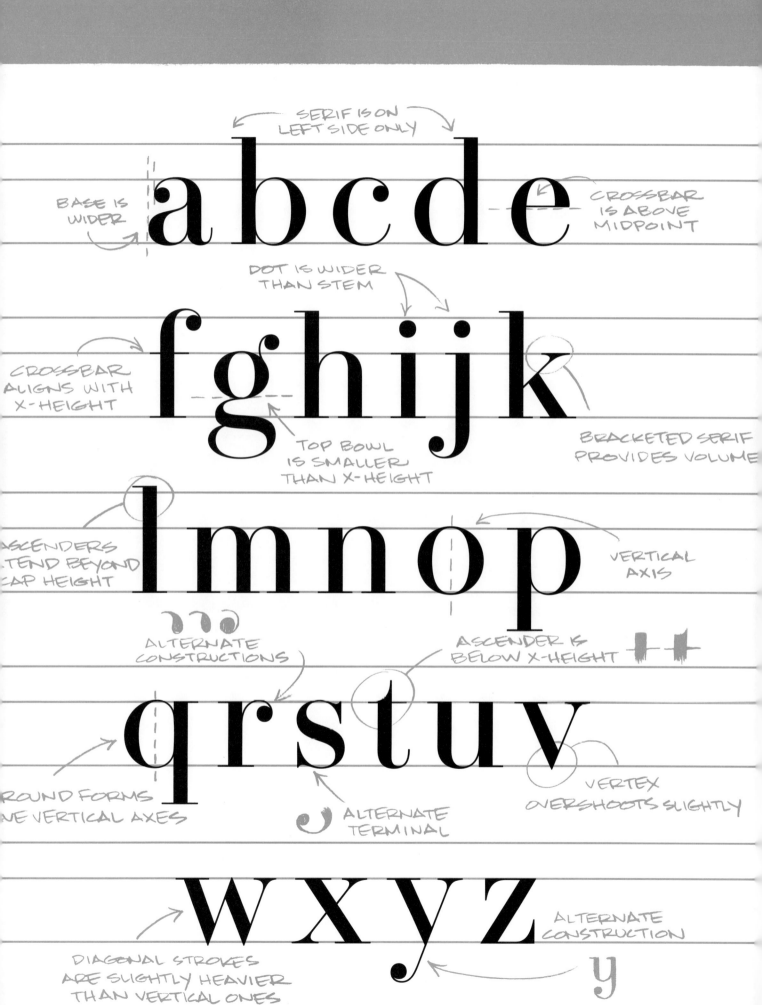

DRAWING AND MODIFYING MODERN

Modern is a sleek and stylish letter style at heart. Shape curves generously, thinning the strokes at the top and bottom. Hairlines should be crisp and consistent, but can be thicker for small uses. Arcing strokes should sprout smoothly from stems, not branch perpendicularly.

Keep modifications proportional, too. Tall slender letters require long vertical serifs, while broad sturdy letters need wide ones. The lengths of horizontal serifs should also expand or contract as the letters do. Weighted serifs, beaks, and other stroke endings should appear visually equivalent in mass, regardless of the letter's overall proportions.

The tapering of S-shaped strokes—like the right leg of the italic *n*—reduces their volume, causing them to appear sloped at a lesser angle. Overslanting them visually compensates for this illusion. The f curves in the opposite direction, so its body is back-slanted slightly.

Altering serif construction is a simple way to tweak Modern letters. Brackets will steer them toward Ad Roman, while wedge-shaped serifs give a Latin look. Keep them slim to easily stagger letters on a bouncy baseline.

You can hot-rod round forms, too. Instead of making them circular or oval, draw super-ellipses (imagine a rectangle with rounded corners and convex sides, like an old television screen). The effect can be applied to inner, outer, or both contours of practically any curved stroke.

Remember that each turn of the stylistic dial—whether it controls weight, width, or whatever—moves the letter one more aesthetic rung along the design continuum.

ry ry

SPACE TOO OPEN SPACE JUST RIGHT

CONTRAST

Contrast

HIGH CONTRAST

Contrast

LOWER CONTRAST

PROPORTIONAL VERTICAL SERIFS

EE

INCORRECT CORRECT

superelliptic mechanistic

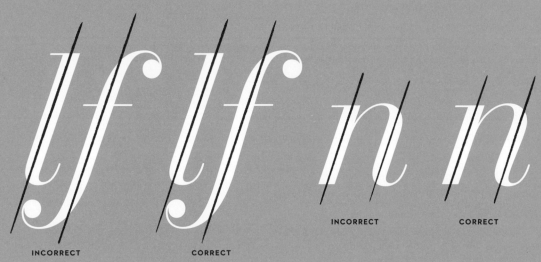

INCORRECT

CORRECT

INCORRECT

CORRECT

abcdefghijklm nopqrstuvwxyz

ITALIC AND RELATED STYLES

Modern italics were heavily influenced by pointed pen calligraphy and the copperplate engraving of its day. It almost looks as if formal Roundhand script was made a touch wider, gently slanted, then disconnected. Letters composed of vertical strokes have distinct entry and exit points. The f, k, and y adopt cursive forms, as do the v, w, and x. The a and g have a single bowl whose axis slants slightly more than the normal slope of the letters. This applies to the b, d, p, and q, too.

The uppercase, for all intents and purposes, is a sloped version of the upright letters. You can tack on a few swashes, but they usually cheapen its image. Both uppercase and lowercase forms are usually a touch lighter and narrower than the roman, and sloped at a moderate angle.

During the early nineteenth century, type manufacturers took Modern and bumped up the weight of its heavy strokes, creating an extremely bold spin-off called Fat Face. This ridiculously heavy, high-contrast style was built with advertising purposes in mind and used primary on handbills, posters, newspapers, and other printed ephemera. Its primary strokes are considerably thicker than off-the-shelf Modern, while the thin strokes remain essentially untouched. This makes for an extreme degree of contrast and greater volume, necessitating that thin serifs be bracketed. When your lettering needs to pack a punch, Fat Face is a solid choice.

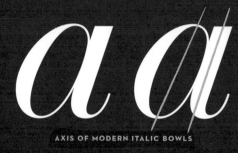

MODERN ROMAN VS. ITALIC CONSTRUCTION

AXIS OF MODERN ITALIC BOWLS

FAT FACE STYLE

ALTERNATE ENTRY STROKES

SLAB SERIF

Sometimes bigger does mean better—at least early advertisers thought so. The growing demand for eye-catching ephemera in the nineteenth century was met by the production of Slab Serif, a hulking, down-to-business typeface.

The style was introduced in the mid-1800s and went under a slew of names, including Antique, Egyptian, and Square Serif. Thick strokes, low contrast, and dense color answered the call of a thriving consumer market.

The popularity of Slab Serifs endured into the following century. Commercial letterers capitalized on the gravity of the style to suggest strength and authority. Rugged Slab Serifs conveyed reliability and security, and were often condensed or expanded, but never to the detriment of their sturdy frame.

True to its typographic roots, our model provides a clean slate for easy modification. The bones of Modern and Fat Face can be seen in Slab Serif, most notably its unbracketed serifs, vertical axis, and uniform proportions. Serifs can be boxy or wedge-shaped, and weighted terminals either plain or stylized.

It might seem that Slab Serif is the "minivan" of type, but it's more than just a roomy and sensible letter. The style isn't overly concerned with practicality; relaxed and lighthearted moods can be squeezed out of Slab Serif, particularly when you slap on some brackets or draw it in lighter weights. Underneath Slab Serif's formidable exterior lies a surprisingly limber letter.

ABCDE E

FLAT APEX ALIGNS WITH CAP LINE

TERMINAL SWELLS TO ADD VOLUME

MIDDLE SERIF IS REMOVED IN BOLD WEIGHTS

FGHIJK F J

ALTERNATE SQUARE SERIFS

OUTER SERIF IS SHORTER

ALTERNATE TERMINAL

LMNOP

THE N'S STEMS ARE LIGHTER

LONGER SERIF BALANCES SPACE

QRSTUV R

ALTERNATE LEG

SERIFS ARE LONGER THAN E AND F

LEFT STEM IS LIGHTER

WXYZ Z

W IS WIDER THAN M

STROKES DO NOT ALIGN

a abcde

A SHORTER TAIL
IMPROVES SPACING

TERMINALS
ARE HORIZONTAL

TITTLES CAN
BE ROUND

fghijk

BASE IS
WIDER

LARGE
X-HEIGHT

BOTTOM BOWL IS
WIDER THAN TOP

lmnop

CURVED STROKES
TAPER AND BRANCH
SMOOTHLY

IONIC SERIFS
ARE BRACKETED

r SERIFS CAN HAVE
BALL TERMINALS

qrstuv

BOTTOM SERIF IS
LARGER THAN THE TOP

SERIFS ARE
LIGHTER THAN STEMS

wxyz

CENTER SERIF CAN BE
REMOVED IN BOLD WEIGHTS

LETTERS HAVE
MODERATE CONTRAST

DRAWING AND MODIFYING SLAB SERIF

The general structure of Slab Serif is based on a Modern template and therefore is comparatively simple and straightforward. However, there are a few opportunities to have a little fun, like the tail of the Q and the legs of the K and R. Some early specimens show plain terminals in the a, c, f, j, r, and y, but later examples soften these up by applying ball terminals. When it comes to the proportions, don't be stingy: draw lowercase letters large in relationship to caps and shorten extenders to underscore their dark and compact color.

Out-of-the-box Slab Serifs are great for clean, direct interpretations, but they can be loosened up, too. Bouncy Modern letters make it easy to avoid serif collisions, but the chunky forms of this style will likely need to overlap: just keep your eyes peeled for areas of undesirable color. Dust off your ruler to render conservative versions, but draw round forms and animated lettering freely.

Slap some brackets on Slab Serif, and you've essentially got yourself an Ionic, also called Clarendon (see page 21). Strip letters down to their skeletal frame to provide a smart and sophisticated look, or draw heavy letters in outline to subdue their powerful profile. Slab Serif forms also provide a sizable canvas for embellishing. Whatever raw power is lost by losing weight is gained in other areas.

REVERSE-CONTRAST

ABC

IONIC

ABC

TUSCAN

ABC

GEOMETRIC

CCCC

ALTERNATE SERIF CONSTRUCTIONS

LATIN

abcdefghi jklmnopqrs tuvwxyz

ITALIC AND RELATED STYLES

The italics are similar to Fat Face, but with considerably less contrast. As with Fat Face, they're modestly sloped and typically narrower and lighter compared with the roman. Letters like the k and y usually don't take cursive forms as they often do with Modern, but that doesn't mean alternates are off limits. Keep in mind that extremely dense mono-weight versions don't leave much real estate to add swashes.

The Slab Serif species has a range of cross-breeds. Clarendon is an early derivative with moderate contrast and bracketed strokes (smooth transitions between stems and serifs). Historically, the style was used to highlight text, but proved equally effective at large sizes. Horizontally stressed interpretations are sometimes referred to as Italian/Italienne or French Clarendon/Antique—it just depends on whom you ask. The Latin variety has wedge-shaped or *cuneal* serifs. (How's that for a fifty-cent word?) Slabs with splayed serifs, on the other hand, are categorized as Tuscan. Round letters in Geometric Slab Serifs are virtually circular in shape, while their forms in oblong mechanistic Slab Serifs look like rounded rectangles with flat sides and semicircular ends.

Exploring other variables—like weight, width, or contrast—in any of these styles will offer a boatload of options for your lettering. Whichever detour you take, just make sure to handle all stylistic details the same across the board.

Few movies have fans who are more dedicated and passionate than those of *Star Wars*. After the blockbuster success of the first films, subsequent ones were given code names for shooting on location as a way to divert the attention of curious film buffs and journalists who might otherwise be tempted to crash the set. With franchises as famous as *Star Wars*, the attention of passers-by is less likely to be piqued by a production with an unfamiliar title. Take "AVCO" for example; the moniker for *Star Wars: The Force Awakens* was taken from the theater where director JJ Abrams first saw the phenomenon that started it all back in 1977. Without these measures, outsiders are liable to leak plot lines and spoilers. Working titles themselves have become heated points of contention among ardent devotees, who often debate at length about their meaning, and more important, what they might reveal about a forthcoming movie. So, when JJ summoned House Industries to join the inner circle of his latest project, we knew it was serious business.

Some pseudonyms have detailed backstories to help throw the press and prying zealots further off the scent. Others are simply mischievous puns. *Solo: A Star Wars Story* was nicknamed "Red Cup," in reference to the iconic Solo brand of red plastic cups, familiar to us all from college keg parties. JJ's new undertaking, Episode IX in the *Star Wars* saga, was dubbed "trIXie," playing off the Roman numeral for nine. However, Andy and I thought that the playful mix of uppercase and lowercase might draw undue attention by placing too much emphasis on the letters-cum-numerals. Instead, I began testing other ways to set the IX apart without making it too obvious. One thought was to take another route altogether, by instead playing with various stroke endings and flourishes to subtly suggest the figure of a conventional number 9. Ultimately we returned to the original concept, however, using all caps to tone things down.

In order to make the IX prominent yet not overly conspicuous, I had the idea to slightly diminish the weight and size of the outer letters as they approached the margins of the logo. Keeping the central letters the boldest would enable me to allude to the inside joke, and retain a relatively even texture across the lettering. A bold Latin provided the perfect amount of heft needed to pull off the design, while its tapered serifs allowed the elements to be scaled and spaced with minimal overlap and unwanted volume. Few styles are versatile enough to be this brawny, yet still light on its toes.

Although many fans have speculated about the significance behind the curious working title for *Star Wars: Episode IX*, there are some secrets behind lettering that I'll never divulge.

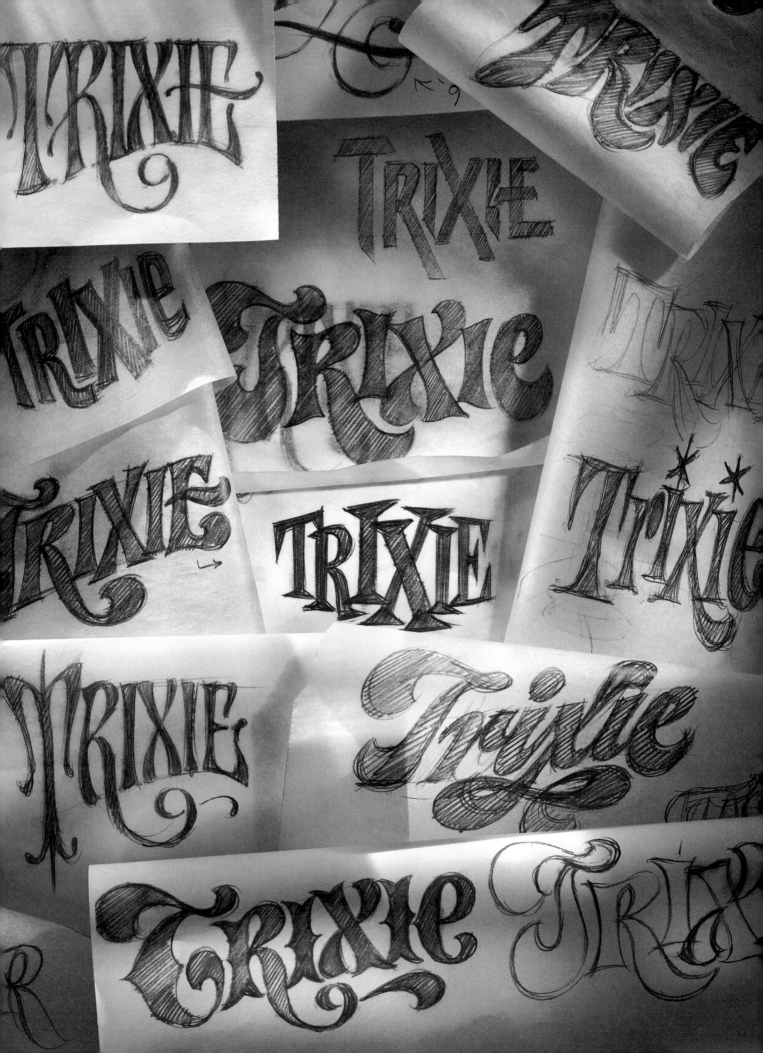

SANS

SANS SERIF STYLES

Don't let the no-frills look of Sans Serif letters fool you—they've become a standard in typography and design for good reason. Their bare-bones construction allows a degree of flexibility that would make even the most agile Serif style jealous.

Sans Serif types were an innovation of the early nineteenth century, along with other publicity faces like Fat Face and Slab Serif. Once it became clear that there was virtually no limit to the adaptability of Grotesques and Gothics, as seriless letters were commonly known, families of fonts in various weights and widths hit the market. By the next century, the spectrum of Sans Serifs had grown to include renditions spanning delicately modulated to

mechanically precise. Austere geometric typefaces like Futura were among some of the most popular. During the mid-1900s, many early models were given face-lifts. One such Neo-Grotesque would become one of the most ubiquitous typographic phenomena of our time: Helvetica.

The vast palette of designs provided a playground for lettering artists of the twentieth century, who persistently put Sans Serifs through their paces. Highly stylized versions took the lead in hand-drawn headlines and wordmarks, while relatively neutral offerings played supporting roles when paired with comparatively flashy lettering. The all-purpose Sans Serif did it all—and it still does.

AD GOTHIC

There is no one set of characteristics that encapsulates your average Sans Serif—except for the lack of stroke endings, that is. Believe it or not, the earliest examples didn't even include lowercase. Going back to its roots, however, is a good place to dive into the style.

The first Sans Serif type appeared in an 1816 specimen book of William Caslon IV, grandson of the famed English type founder. It's hard to imagine that serifless letters were once seen as unusual, but eventually the style took off. Since Sans Serifs didn't carry the same kind of historical baggage that other typefaces did, their forms could be interpreted in practically any conceivable way. Instead of being dictated by the behavior of a pen, Sans Serifs could be shaped by a system of logic. This was huge. Twentieth-century lettering artists, in particular, profited from the floodgates that this brand of thinking opened up.

Ad Gothic was a generic catchall, perhaps a little dated now, describing a plain Sans Serif that reflected the warmth of a letterer's touch. Their scope included iterations that echoed early typographic models, took a mechanical bent, or revealed a calligraphic influence.

Our model is a hand-drawn geometric, similar to Futura, but with a few distinctive details. Often referred to as Rounded Gothic, its forms are clean, contemporary, and highly versatile. Don't worry; we'll also look at ways to strike a few different stylistic chords.

CLASSICAL PROPORTIONS

MODERN PROPORTIONS

MECHANICAL PROPORTIONS

ALTERNATE TERMINAL ANGLES

mistakes

TITTLE IS TOO SMALL

LEFT SIDE OF BAR IS TOO LONG

ARM DOESN'T TAPER ENOUGH

INCONSISTENT TERMINALS

INSUFFICIENT CONTRAST

INCORRECT SYMMETRICAL CONSTRUCTION

SMALL COUNTER ADDS WEIGHT TO STEM

CROSSBAR IS TOO HEAVY

STROKES TAPER
TOWARD WAIST

BOTTOM
ARM IS
WIDEST

RIGHT STROKE
IS HEAVIER

ABCDE

TERMINALS ARE
VERTICALLY SHEARED

FGHIJK

HORIZONTAL STROKES
ARE LIGHTER

NARROW FORM
MINIMIZES SPACE

LMNOP

LIGHTER DIAGONAL
BALANCES COLOR

VERTICAL
STRESS

QRSTUV

HEAVIER THAN
VERTICAL STEMS

BOTTOM COUNTER
IS LARGER

LEFT STROKE
IS HEAVIER

WXYZ

APEX AND VERTEXES
HAVE SIMILAR WIDTH

OFFSETTING STROKES
RAISES OPTICAL CENTER

a
SINGLE-STORY
ALTERNATE

abcde

NARROW STEM BASE
REDUCES VOLUME

ik
ALTERNATE FORMS

fghijk

TOP OF CROSSBAR
ALIGNS WITH X-HEIGHT

BOWL IS SMALLER
THAN X-HEIGHT

NOT PERFECTLY
CIRCULAR

lmnop

ARM EXTENDS
ABOVE X-HEIGHT

† ALTERNATE
FORM

qrstuv

STROKES TAPER
AT VERTEX

EASE IS
WIDER

BRANCHING STROKES
THIN AT STEMS

wxyz

LIGHTER MIDDLE
STROKES
REDUCE VOLUME

LETTERS HAVE
LOW CONTRAST

INCORRECT UNIFORM STROKE THICKNESS

CORRECT STROKE THICKNESS

STROKE THICKNESS ADJUSTED FOR EVEN VOLUME

OFFSET OVERLAPPING DIAGONAL STROKES

TAPERED STROKES TO REDUCE VOLUME

DRAWING AND MODIFYING

Rounded Ad Gothics are defined by a mono-weight appearance and nearly circular curves. Round strokes require some modulation, however, so be sure to add contrast by thinning them at the top and bottom. Otherwise, the strict geometric shapes will look severe and unnatural. This goes for branching strokes, too, which create unwanted volume if not thinned when joining verticals.

Overlapping diagonal strokes can also be a headache. You can offset connecting strokes or taper diagonals slightly to minimize uneven color in the A, K, M, N, R, V, W, X, and Y. Don't forget the lowercase, too. Like serifed forms, diagonals may vary in thickness: upper left to lower right strokes are often a bit heavier than those sloped in the opposite direction. Consult the notes on volume (see page 50) and optical effects (page 70) when in doubt.

Terminals can be handled a few different ways. Endings are typically sheared vertically, horizontally, or perpendicular to the stroke direction. Each slightly alters the overall texture; just stay consistent across related letters.

Hand-lettered Ad Gothics usually favor uniform proportions. Light versions can have long extenders, but heavy letters should stay compact to preserve color.

The apparent simplicity of Rounded Ad Gothics accounts for their wide appeal, but it can also make them tough to draw. Don't be tempted to diagram letters mathematically; this will fail to capture important subtleties and leave you with lifeless lettering.

Since Ad Gothic encompasses such a broad range, there's no reason you have to stick to the geometric variety. Early Grotesques were comparatively warmer, with even proportions, greater contrast, and perpendicular terminals, plus a few roman traces (usually a spurred G and two-story a's and g's). For typographic reference, check out Franklin Gothic.

Among the first to include a lowercase, however clumsy, was Flat-Sided Sans. Turn-of-the-twentieth-century types like Alternate Gothic transformed the idea into a coherent system of *obround* (oblong-round) shapes. The semicircle-capped rectangular letters loosen up surprisingly easily, and are a great choice when space is limited.

Superelliptical letters take a similar tack, but their faintly bowed, boxy curves ease the mechanical vibe. Eurostile is probably the best-known example. Around the same time, designers brushed off older Grotesques, applying a rational approach along with a mono-weight appearance—though hand-drawn Neo-Grotesques can take a casual tone.

Exaggerating contrast by giving Sans Serifs fine hairlines can result in strikingly elegant forms reminiscent of engraving. Just remember to add a touch of volume at thin stroke endings, or else they're liable to disappear.

In most cases, the Sans Serif italics are modestly sloped roman forms. However, make sure they don't look mechanically skewed.

This is just a sampling of potential directions. Once you start pushing and pulling the levers that shape Sans Serif lettering, who knows where you'll end up?

Gothic

FLAT-SIDED SANS SERIF

Gothic

SUPERELLIPTICAL SANS SERIF

Gothic

GROTESQUE SANS SERIF

Gothic

AD GOTHIC ITALIC

How do you visually express the essence of a legendary performer like Cher in four simple letters? That's the question that faced House Industries when noted art director Drew Hodges asked the studio to create the lettering for a Broadway musical based on the star's celebrated career. *The Cher Show*—produced by Flody Suarez and the mastermind behind the blockbusters *Hamilton* and *Rent*, Jeffrey Seller—takes audiences through revealing moments in the celebrated performer's personal life while chronicling her meteoric rise to stardom.

Hodges was confident that House was more than up to the task of delivering on what he calls the "emotional promise" that a production's branding makes to theatergoers for a fun and engaging experience. Yet, creating a logo that reflects the individuality of a renowned entertainer as influential and stylish as Cher would prove to be as tough as it sounded. She's enjoyed a long and accomplished career that has spanned significant eras of music, fashion, and design. Consequently, the mark would need to be fluid enough to touch on the various periods of her life without appearing contrived or overly nostalgic. Capturing a range of distinctive qualities—like poise, wit, and charm—in a handful of letterforms would be no easy undertaking.

In preparation for the project, House Industries' design oracle, Andy Cruz, and I scoured recordings of *The Sonny and Cher Show*, gathered visual cues from the singer's albums and posters, and even gleaned a few clues from vintage toy packaging. Aided by a melting pot of inspirational sources, I drafted nearly two dozen roughs during the preliminary sketch phase. Not surprisingly, many of our initial ideas focused on curvy organic lettering evocative of the decades covering Cher's early career, from the 1960s to the '80s. But a schmaltzy era-specific mark would be too narrow and limiting to address the range of themes covered in the show, or demonstrate enough flexibility for branding and advertising applications. Our challenge was to distill elements of Cher's personal traits, tastes, and talents into something that was more conceptually and aesthetically inclusive. Thanks to some unassuming geometric Sans Serif forms, with a few added stylistic touches, we were able to produce a straightforward yet chic logo.

The secret lies in the letters' stripped-down serifless frame, which allowed us to create direct and readable lettering without sacrificing any style. The crisp yet sinuous forms share common structural elements that give the lettering a playful personality, while its linear profile provides a canvas which can be left open, or flooded with color. The decidedly modern mark also embodies an understated elegance, while subtly nodding to the past. With the help of simple Sans Serif letterforms, a sleek composition, and vibrant palette, *The Cher Show* logo hints at the various time periods and motifs that are featured in the musical production itself.

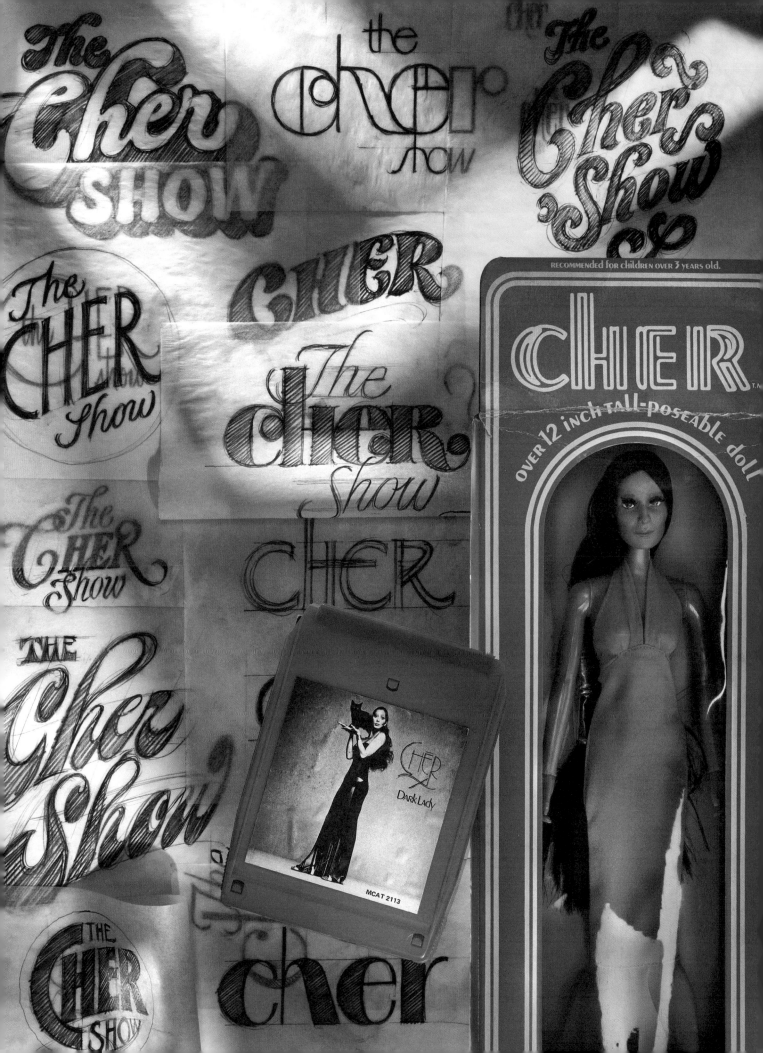

One of my prized possessions as a little kid was my collection of Hot Wheels. The souped-up Paddy Wagon and candy-apple Spectraflame Peeping Bomb were among my favorites. I eventually blew up most of my toy cars with firecrackers or stripped their axles to make finger-sized skateboards, yet I always admired the letters emblazoned on their short-lived blister packs, especially how they meshed together within the logo's iconic flaming pennant. For me, it remains the epitome of cool to this day. As my interest in lettering grew, I was attracted by similar treatments elsewhere:

mid-century book jackets and album covers, art nouveau advertising, and trippy 1960s psychedelic posters. At House Industries, we found that wrenching letterforms within a tightly knit group was a surefire way to give some extra torque to the right wordmark.

The trick to the technique is varying the size and shape of the letters to eliminate unwanted negative space or to avoid colliding serifs. Once you've settled on the appropriate style for the job, take a moment to evaluate the wording. Draw a loose thumbnail sketch, and consider how successive letters might interact with one another. Look for gaps between problematic pairs, where letters might be shrunk to fit into the negative spaces of an adjacent uppercase L or T, for example. Or, exaggerate serifs of letters following an F or P to fill the open areas of their silhouettes. Interlocking lettering is frequently all caps because of their uniform height, but lowercase forms can also provide potential advantages. Although "unicase" lettering is often too ambitious or gratuitous to pull off convincingly elsewhere, it's not unusual for this approach. And, because the method isn't overly concerned with stylistic faithfulness, results are often a mix of Serif and Sans Serif. In fact, interlocking lettering may routinely exhibit irregular volume and contrast, too, maintaining overall texture by balancing such inconsistencies throughout.

If you want to mold letters into a custom shape, indicate the framework of the composition first, then block in forms, modifying their shape, case, or construction to suit your layout. Flare or warp stroke contours to create a smooth fit from one component to the next. When neighboring serifs or shapes are uncooperative, try alternate constructions, or open counterforms to accommodate adjacent forms. Bear in mind that there's rarely one right answer but, with a little elbow grease, a solution usually presents itself after some tinkering.

Sure, interlocking lettering requires its share of time to sculpt, but there's no better way to supercharge your lettering with added visual horsepower that's guaranteed to turn heads.

SUPER

CALUMET

HOUSE

Script

SCRIPT STYLES

Few styles can match the warmth and personality of script lettering. From formal hands to casual brush, the style is highly adaptable to scores of design scenarios. The flexibility and familiarity of the script letter is undoubtedly the reason for its continued appeal.

Script styles come in a countless variety of flavors, but all are ultimately derived from cursive handwriting. Whether letters actually link to one another or simply imply connection, they carry the eye from one form to the next, giving the impression of flowing movement.

The granddaddy of much contemporary hand-drawn script is English Roundhand, an often-flourished formal variety that reached its peak during the mid-1700s. A century later on the other side of the Pond, it was adapted into a fluid handwriting method called Spencerian. During the late 1800s, burly built-up versions of this unique style were adapted for use in advertising and packaging. Modern-day Display descendants include many iconic wordmarks, like the Ford and Coca-Cola logos to name a few.

Roundhand remained popular throughout the twentieth century, even as letterers began playing with looser and more expressive captions and headlines. One of the most important contributions of the era was Freestyle, a carefree script that capitalized on the spontaneity of individual handwriting. Since then, commercial letterers have embraced a liberal approach to rendering script forms, resulting in innumerable arrays of interpretations.

ROUNDHAND

Among script styles, Roundhand tops the list as the epitome of grace and sophistication. Its slender forms, long extenders, delicate contrast, assertive slope, and fluid movement make it ideal wherever lettering needs to convey a sense of quality or elegance.

During the mid-seventeenth-century, English scribes adapted cursive handwriting using the flexible pointed pen, providing letterforms with refined qualities distinct from those traditionally made with a broad nib. Advances in copperplate printing allowed engravers to interpret sharp hairlines and dizzyingly complex flourishes with greater precision. Roundhand quickly rose in popularity, thanks in large part to the publication of instructional copybooks like George Bickham's *The Universal Penman*, printed in 1741. (Incidentally, Modern letters were influenced by the same tools and techniques, making them an excellent sidekick for Roundhand.)

Hand-lettered Formal Script was used extensively in twentieth-century advertising and design. Although contemporary Roundhand adhered fairly closely to historical samples, lettering artists frequently updated antiquated forms with ones considered more suitable for commercial use.

Our Roundhand model draws from traditional specimens, as well as from more recent advertising examples. Its crisp, clean forms work admirably on their own, while offering ample opportunities for both flourished and casual interpretations.

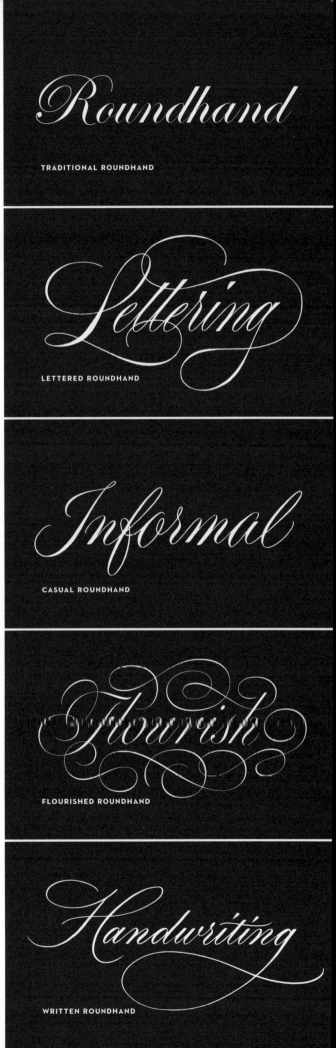

TRADITIONAL ROUNDHAND

LETTERED ROUNDHAND

CASUAL ROUNDHAND

FLOURISHED ROUNDHAND

WRITTEN ROUNDHAND

Aa Bb Cc

SOME SWASHES HAVE HORIZONTAL AXES

OPTIONAL FLOURISH

OBLIQUE AXIS

PRIMARY STROKES ARE THE SAME AS T

Dd Ee Ff

UPSTROKE SWELLS SLIGHTLY

TOP STROKE IS ANGLED IN I AND J

Gg Hh Ji

BOWL ENDS ABOVE BASELINE

JOIN PRECEDING LETTERS SMOOTHLY ON LEFT

Jj Kk Ll

STROKES THIN AT LOOPS

AXES OF COUNTERFORMS MATCH SLOPE

Mm Nn

COMPOUND STROKES HAVE GREATER ANGLE

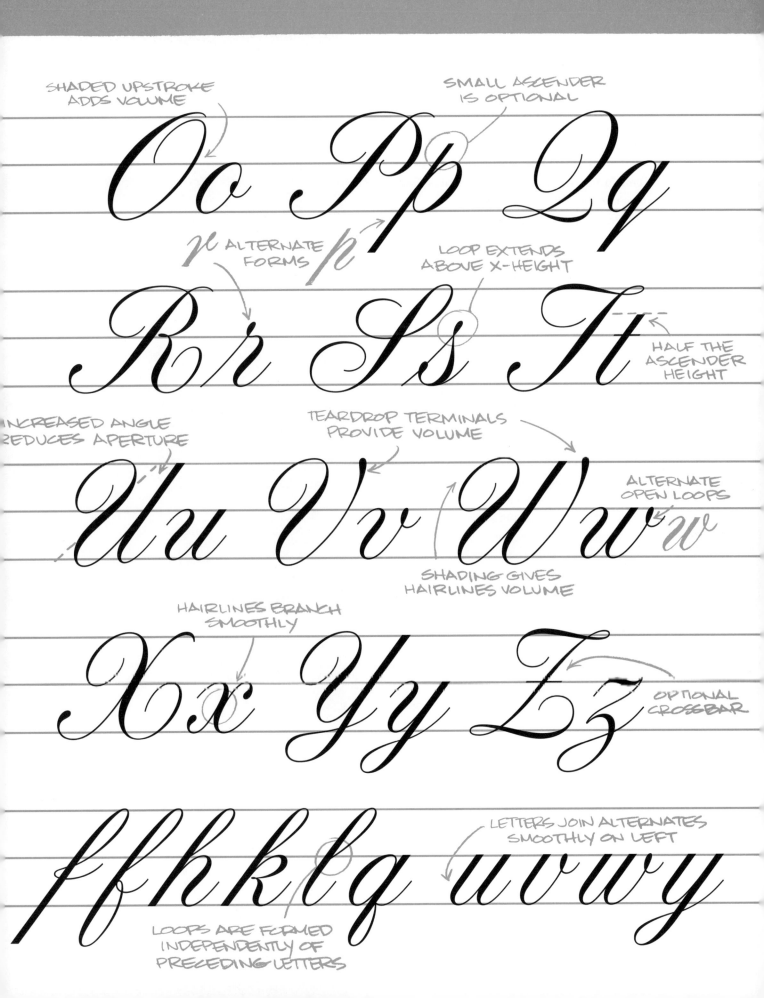

SHADED UPSTROKE
ADDS VOLUME

SMALL ASCENDER
IS OPTIONAL

Oo Pp Qq

ALTERNATE
FORMS

LOOP EXTENDS
ABOVE X-HEIGHT

Rr Ss Tt

HALF THE
ASCENDER
HEIGHT

INCREASED ANGLE
REDUCES APERTURE

TEARDROP TERMINALS
PROVIDE VOLUME

ALTERNATE
OPEN LOOPS

Uu Vv Ww

SHADING GIVES
HAIRLINES VOLUME

HAIRLINES BRANCH
SMOOTHLY

Xx Yy Zz

OPTIONAL
CROSSBAR

LETTERS JOIN ALTERNATES
SMOOTHLY ON LEFT

ffhklg uvwry

LOOPS ARE FORMED
INDEPENDENTLY OF
PRECEDING LETTERS

DRAWING AND MODIFYING

Although commercial Roundhand is drawn, it helps to recall the pointed pen used to write it. Applying force to downstrokes splays the nib, producing thick vertical stems; releasing pressure creates thin upstrokes and cross-strokes. This forms the basis for the component strokes that comprise the lowercase.

Oval strokes form the bowls of round letters. They should taper to hairlines at the top and bottom, while remaining thin on the right side (except in the letter p). Ovals connected to vertical stems should slope at a slightly greater angle.

Entry strokes curve downward from the x-height into stems, while exit strokes leave stems turning upward from guidelines. Whether joining parts of a letter, or connecting letters, they should always branch smoothly in and out of components. Compound strokes have entry and exit strokes at either end; straight strokes have neither. Looped strokes are only used for select ascenders and descenders. The s-stroke, on the other hand, is its own animal.

To create the considerable angle of Roundhand, intersect the corners of a 3×4 unit grid. (Informal script has a gentler slope.) Make caps and extenders twice the x-height to accentuate the style's elegance. Fill in small loops—keeping those in the r and s above the x-height—and match their weight to ball terminals and tittles.

Some capital letters share similar strokes, but otherwise the uppercase uses fewer repeating components. There are only rare occasions that call for all uppercase, so unless you're designing a stomach tattoo or underground hip-hop mixtape, stick to initial caps.

Remember, lettering is not handwriting. Study the model and examples carefully; many letters are not constructed or connected the same way they're written.

il abdfilqtuwy

EXIT STROKES

llunoly

COMPONENT STROKES

/hkpq

STRAIGHT STROKE

i hkmnrpuvwxy

COMPOUND STROKE

s

S STROKE

o abcdegopq

OVAL STROKE

lfhk gjyz

LOOPED STROKES

imn

ENTRY STROKE

FLOURISHED ROUNDHAND

Roundhand was traditionally embellished with intricate line work. Not only were flourishes used for decoration, but they also often signified official documents and gave artists an opportunity to flaunt their skills.

Capitals usually have at least a small degree of ornamentation, if not an elaborate amount. Lowercase flourishes can extend from entry/exit strokes, ascenders/descenders, and cross-strokes, or be entirely freestanding. Enveloping an entire piece of lettering forms a *cartouche*.

Most flourishes are made by combining two basic strokes: the shallow S-shaped ogee stroke and the spiral. Overlapping a spiral creates a loop; connecting a series of loops with ogee strokes produces a figure-eight pattern. A composite flourish is made by combining two or more basic strokes. Superimposing separate

flourishes results in a compound flourish. Though not typical of Roundhand, *vinework* is a variety of flourishing whose strokes branch outward from other flourishes.

If Roundhand letters are siblings, flourishes are their cousins. They're part of the family, but behave a little differently. Flourishes are typically lighter than letters and have less contrast. Avoid overly complicated, tightly spaced, and aimlessly meandering strokes that do not create a coherent design or serve a clear purpose. Ideally, the axis of flourishes should be parallel to the slope of the lettering, or horizontal. Make negative spaces equivalent in volume if possible, and do not overlap shaded segments. Finally, flourishes shouldn't obscure or detract from lettering, but only serve to enhance it.

X ✓ *nan nan*

DON'T STAB EXIT STROKES INTO ADJOINING LETTERS

JOIN STROKES SMOOTHLY ALONG THE CENTERLINE

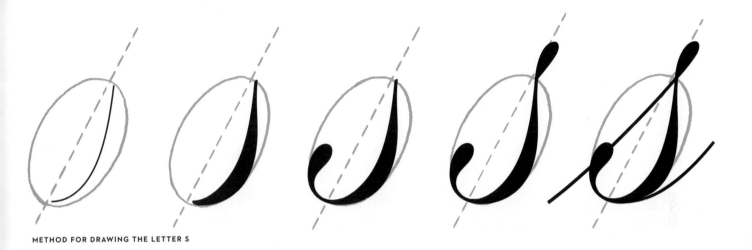

METHOD FOR DRAWING THE LETTER S

TAPER STROKES ALONG TIGHT RADII AT THE GUIDELINES

INCREASE SLOPE OF CONNECTING OVALS AND COMPOUND STROKES

TOO MUCH VOLUME

INFORMAL CONSTRUCTION

TOO MUCH SPACE

TOO LONG

TOO MUCH VOLUME

other mistakes

INSUFFICIENT SLOPE

CONFUSING CONSTRUCTIONS

STEM LACKS VOLUME

STROKE IS TOO HEAVY

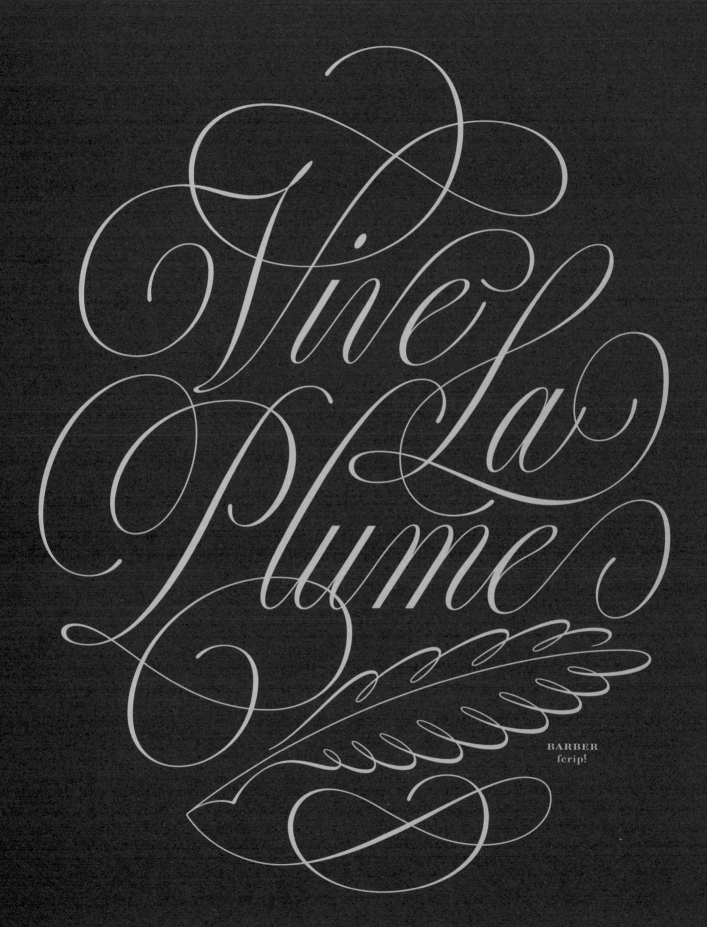

Vive La Plume

BARBER
script

EXAMPLE OF A FLOURISHED CARTOUCHE

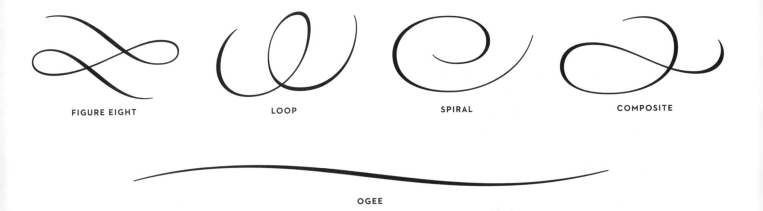

FIGURE EIGHT **LOOP** **SPIRAL** **COMPOSITE**

OGEE

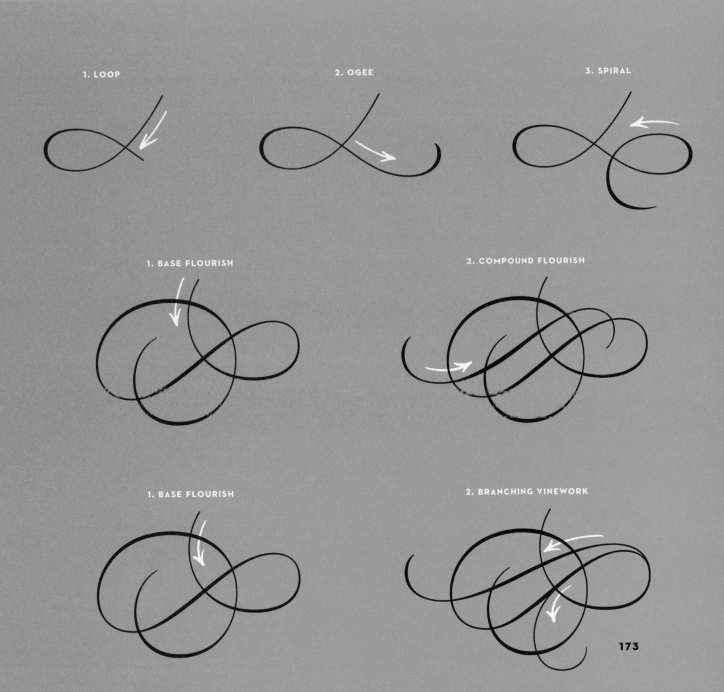

1. LOOP **2. OGEE** **3. SPIRAL**

1. BASE FLOURISH **2. COMPOUND FLOURISH**

1. BASE FLOURISH **2. BRANCHING VINEWORK**

RELATED STYLES

Altering the elements of Roundhand can radically change the direction it takes. Some of the earliest scripts used for branding and marketing were created by bulking up the stems of traditional Roundhand while reducing contrast. Softening terminals and scaling proportions generate a bold, informal script reminiscent of disciplined brush letters (but let's not get ahead of ourselves).

Reducing letters to a hairline frame will create bare yet charming mono-weight script. Pumping up stroke thickness while keeping contrast at a minimum makes them more friendly. Add convex contours, round terminals, or an upright axis to lighten the mood even more. Scaling proportions of individual components, as well as separate letters, increases the casual feel.

Freestyle goes a step further by simulating the fluidity of everyday handwriting. Ironically, the apparent spontaneity of Freestyle Script needs to be carefully planned, despite appearing to have been knocked out quickly.

Spencerian Lettering is a related style developed during the late 1960s. Confusingly, it is very different from nineteenth-century Spencerian handwriting, and its bolder hand-drawn Display offshoot. Spencerian Lettering is actually an exaggerated form of Roundhand that has a higher degree of contrast, convex contours, and deeply cupped stroke endings. Its razor-thin hairlines are often wildly flourished, punctuated with bold shading, and finished with tight spirals. Italian Hand is an offshoot identified by its swollen round terminals and bulbous closed loops.

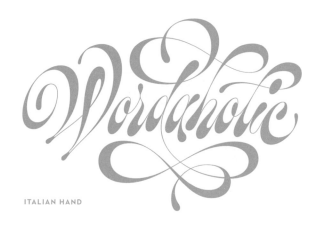

ITALIAN HAND

SPENCERIAN DISPLAY

MONO-WEIGHT SCRIPT

SPENCERIAN LETTERING

1. FREESTYLE WRITING

ADJUST SPINE

2. BROAD-EDGED PEN OVERLAY

FLIP CROSS-STROKE

3. PENCIL TRACING

JOIN STROKES

175

4. FINAL LETTERING

CASE STUDY
THE PAST FORWARD AWARD

In 2015, the esteemed Henry Ford Museum of American Innovation invited House Industries to design an award for the historic Detroit Autorama, "America's Greatest Hot Rod Show." Curator Marc Gruether thought our studio's ethos of respecting the past while looking toward the future reflected the museum's outlook and the theme of the new prize. In celebration of automotive imagination, the Past Forward award would be given to the builder during the event who most creatively combined tradition with originality and skill, while embodying the no-holds-barred attitude of hot-rodding. Realizing that our design needed to do the same, House's head design wrench, Andy Cruz, mused, "Instead of slapping some lettering on an award, what if the lettering *was* the award?"!

Fortunately, the American automotive industry isn't short on alphabetic inspiration. Campaigns of the last century sported some of advertising's most memorable lettering, while car emblems were just as stunning as the rolling sculptures they adorned. My favorite auto badges are tamed versions of an erratic script called Freestyle, which provided the perfect road map for our plan to turn our fetish for letters into a fetish object of their own.

After I vectorized my pencil drawing, our creative engines shifted into high gear when we hooked up with a fabricator who eventually transformed the letterforms into a sixteen-inch-wide, five-inch-tall, and four-inch-deep polished stainless steel trophy worthy of its recipient's hard-earned efforts. For us, the process forced us to consider the intricacies of form on a much deeper level. We yielded to the materials and production methods, turning physical limitations into advantages by allowing the process to guide the look of the final product.

I've been collecting auto badges ever since I popped one off of my junkyard-bound Buick Skylark back in college. My taste in car emblems has since evolved, but I'm still a sucker for freestyle versions. The first round of thumbnails explored other approaches, however, and included several concepts that paired complementary letter styles. But, the mono-weight script offered the most flavor and flexibility.

In the course of refining the lettering, it was important to create regular points throughout the piece where parts of letters could overlap to join the two words, and provide physical support for fabrication. For example, the P rests on "Forward" below it, while an exit stroke joins it to the following letter. The adaptability of freestyle allowed for these crucial adjustments in order to ensure structural stability.

The materials and production means continued to influence the design process during the vectorizing stage. The acute angles of intersecting strokes needed to be minimized as much as possible to accommodate the four-inch-wide ribbons of steel that were hand-wrapped around the edges of the lettering before being soldered in place to produce the sculpture's emphatic dimensional presence.

BRUSH STYLES

When I first started to pay attention to brush lettering—whether it was in an old magazine ad, part of a car emblem, or on a department store sign—I was blown away by all the forms it could take. There were springy, playful scripts, and others that seemed like leisurely upright romans. Some letters looked disciplined and formalized, while looser ones felt more frenetic. Whichever persona they adopted, it was clear to me that Brush Styles were engaging yet approachable.

At the turn of the twentieth century, magazine captions still leaned toward reasonably conservative typography. As the voice of advertisements became more conversational, however, hand-lettering was used to reflect this relaxed attitude. By the 1930s, letterers borrowed considerably from everyday handwriting, which eventually led to the creation of freer forms like Brush Script. To this day, the style remains a guaranteed way to strike an energetic or easygoing tone.

A favorite marketing device of the day was multiframe ads, called continuities, which cashed in on the popularity of comic strips. Letterers bulked up the writing style typical of cartoon word balloons, creating an early form of Brush Roman. Their unconnected forms and simple construction, however, share more in common with the general structure of ordinary Sans and Serif letters than flowing Brush Script.

Although both varieties owe a lot to the tools originally used to create them, examples that appeared to be hastily dashed off were often painstakingly edited. In other cases, the brush letters were simply drawn from scratch.

POINTED MARKER SCRIPT

HAND-LETTERED BRUSH SCRIPT

DISCIPLINED BRUSH SCRIPT

SABLE BRUSH SCRIPT

BRUSH SCRIPT

If Roundhand stands as the pinnacle of formality and poise, then Brush Script lounges casually at the opposite end of the spectrum. It's tough to imagine a more relaxed lettering that's so readily modified.

The general mood of design and advertising gradually started to lighten up during the first few decades of the twentieth century. Letterers made logos and ads more welcoming to consumers by stylizing familiar handwritten forms. This ultimately led to greater experimentation, making way for freeform lettering. When the pointed sable brush was added to the equation, Brush Script was born.

The average commercial letterer's toolbox is stocked with an array of brushes, but the most traditional one is the reliable Winsor & Newton Series 7 brush. An old standby in watercolor painting, the springy hairs of the Kolinsky sable carries loads of ink and provides exceptional control. I use pointed markers and synthetic brush pens out of convenience, but they don't come close to the snappiness of the genuine article.

Brush Script comes in so many flavors it's impossible to single out a prime example. Still, our model hits all the right buttons when it comes to the hallmarks of the style: moderate stroke contrast, a gradual slant, and contours characteristic of the pointed brush. More importantly, it's a great launchpad to explore more dynamic varieties.

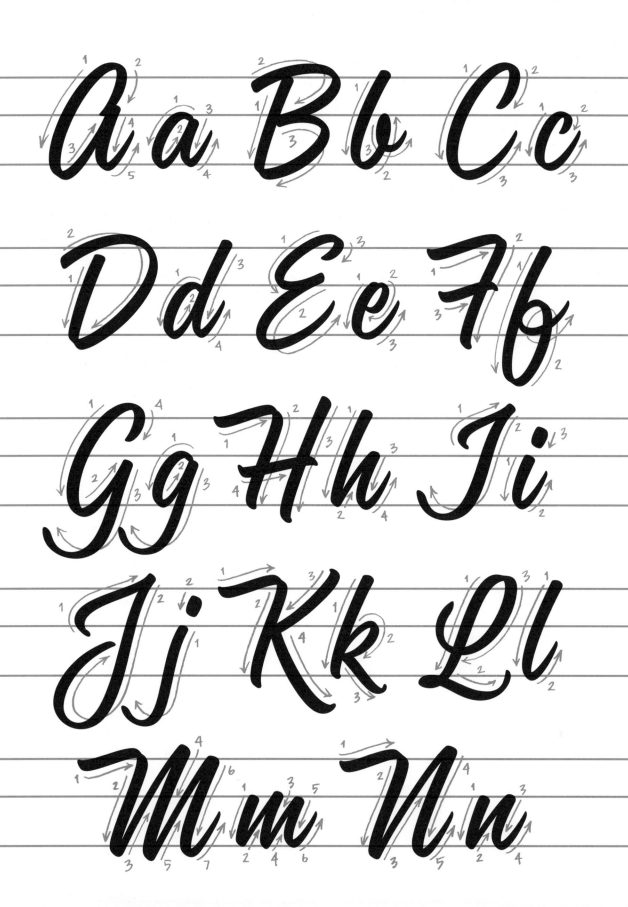

Oo Pp Qq

Rr Ss Tt

Uu Vv Ww

Xx Yy Zz

USE THE SIDE OF THE BRUSH
TO MAKE HEAVY STROKES

USE THE POINT OF THE BRUSH
FOR LIGHTER STROKES

−tn ʃgjy sss

HORIZONTAL STROKE COMPOUND STROKE COMPOUND S STROKE

ı abdfhikln

pqrutvwxy

STRAIGHT STROKE

(abcdefg

kopqwz

CURVED STROKE

COMPONENT STROKES

Although Brush Script is often drawn, it helps to understand how component strokes are made with the brush. Just don't allow your handwriting to affect the forms of the letters.

Form straight stems by pulling strokes downward using the side of the tip. Keep pressure consistent throughout to avoid unwanted tapering. Push round strokes upward to the left before curving downward to produce bowls. Using the point of the brush, reduce pressure and extend connecting strokes upward from the base of stems to join parts of one letter or adjacent letters. Make heavy diagonals moving to the lower right like straight strokes, but with the hand rotated to utilize the side of the brush. Make horizontal strokes left to right to cross stems (like on the t) or to exit words. Pull compound strokes down to form the s, or elongate them for descenders. Although two different strokes can be combined in one continuous movement, don't make complex letters without lifting the brush. Since letters are typically built by making one stroke at a time, you can stop in the middle of a word—hell, in the middle of a letter—and return to finish it later.

A chisel-tip marker can also be used to suggest brush strokes. With the long edge of the nib, pull downward to create heavy straight stems and curved strokes. Rotating the pen 180 degrees in your hand, use the point to make light connecting strokes and cross-strokes.

To ensure greater control, move your arm from the elbow at a moderate pace instead of flexing the fingers or wrist. If you move too slowly, strokes will look shaky. Once you get the hang of it, gradually increase your speed to capture a spontaneous feel.

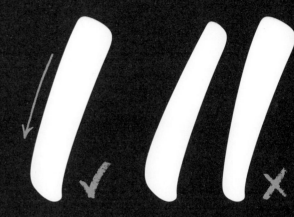

EVEN VS. UNEVEN PRESSURE

EVEN PRESSURE UNEVEN PRESSURE

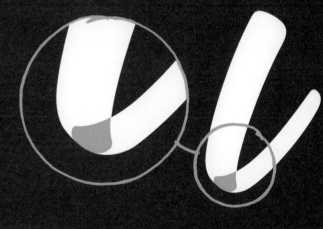

PROPER POSITIONING OF CONNECTING STROKES

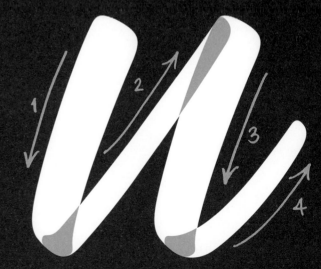

ORDER OF DOWNSTROKES AND UPSTROKES

DRAWING AND MODIFYING

Without any historical conventions or stuffy tradition weighing it down, Brush Script is a nimble and open-minded innovation that's completely receptive to new ideas.

You can fine-tune preliminary write-outs by drawing overtop of them, or simply sketch letters freehand. In either case, draw the letters in much the same way you would construct them with the brush: define each stroke separately, overlapping them to build letters.

How the contours are treated is up to you. Disciplined script is created by applying a system of logic to letters, using the behavior of the brush and the marks it naturally creates as a basis. Reshaping the strokes of the letters can result in forms that could not have been directly made with any writing instrument.

Explore the principles of tension to vary the thickness of strokes, or formalize contours in other ways. Squaring off terminals creates an angular or faceted effect, while exaggerating round stroke endings produces plump, juicy letters. Just make sure to keep your decision-making process as consistent as possible.

Add more sizzle by scaling the proportions of letters, threading them along an invisible centerline. Instead of staggering their positions, extend the dimensions of each letter above and below the guideline. This will give the lettering a bouncy, syncopated rhythm. Fluctuating the thickness of downstrokes and cross-strokes is another fun way to play with cadence. So, go ahead and pull out all the stops—Brush Script is usually happy to oblige.

REFINING BRUSH SCRIPT WRITE-OUTS

1. PRELIMINARY WRITE-OUT

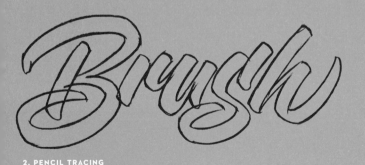

2. PENCIL TRACING

3. FINAL LETTERING

BRUSH ROMAN

Sans-serif Brush Roman caps pair really well with Brush Script, so we'll focus on them. They share some basic strokes with script, but the construction of letterforms is slightly different.

The heaviest strokes comprise the stems of letters. These are pulled downward using even pressure. Curved strokes that form round letters are made by shifting the brush down to the left before swinging back to the right as you approach the baseline. Horizontal cross-strokes, made from left to right, are usually a touch lighter than stems. Diagonal strokes can be pulled up- or downward, depending on your preference. These are typically the lightest strokes (though they still need some heft), which also helps to alleviate volume and provide contrast.

Keep the slope of brush caps modest; the greater the angle, the more difficult it will be to form the letters. Whether light or heavy, Brush Roman is usually spaced fairly tightly. It's not uncommon for letters to bump into one

COMPONENT STROKES FOR SANS BRUSH ROMAN CAPS

EFHILT!

VERTICAL AND HORIZONTAL STROKES

AKMNVWXYZ

DIAGONAL STROKES

JU CGOQ

CURVED STROKES

BDPR?

COMPOUND STROKES

the "PHILLY" SPECIAL

another, especially in bold versions, as long as the readability of the lettering is not impaired. The scale of letters can modulate, but not nearly as much as Brush Script.

You can enhance Brush Roman by revising brush-made forms, or redrawing them altogether. Both Roman and Script can also be emulated with other tools. Long-haired watercolor brushes were popular among twentieth-century lettering artists, as were filed-down ruling pens. A chisel-tip marker comes pretty close to mimicking a pointed tip, too. Experiment to see what works for you.

Brush Roman Serif

Brush Roman Sans

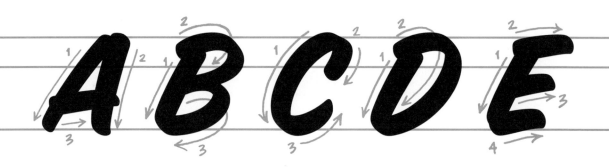

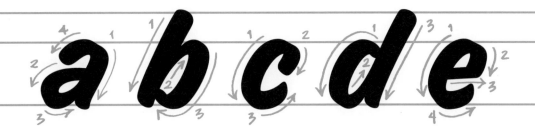

Models like these provide a solid foundation on which to apply what you've learned about lettering technique, while getting a handle on basic letter styles. Just remember that these represent only a fraction of the possibilities that exist across the design continuum. As you've seen, it doesn't take much to nudge any of these styles into new territory simply by tweaking a few general characteristics. So, have at it!

Before signing off, it's worth addressing a popular misconception among beginners: the notion that lettering must be inventive in order to be good. It's not uncommon for newcomers lacking know-how to feel the urge to introduce something novel in their work—an extra serif here, an unusual letter construction there. There is a mistaken belief that simple, well-made lettering isn't good enough.

The truth of the matter is that letterers don't have to invent anything new; they simply need to adapt existing letterforms to fulfill the demands that each new design opportunity presents. One of the reasons that I like drawing letters so much is because I'm lazy—most of my work has already been done for me. Besides, letterers can't truly make anything *original* when it comes to the alphabet itself. The forms of letters were decided long ago, and most people (consciously or unconsciously) have already made up their minds about what's acceptable and what's not when it concerns how those letters look and behave. That isn't to say that an artist's personality won't naturally come through in his or her work. Each person has a unique way of combining the various influences, techniques, and ideas that go into a piece of lettering.

Yet a letter won't resonate with viewers if it doesn't convey some sense of familiarity, no matter how imaginative or distinctive the letter may be. Lettering is visual storytelling, and the best stories are usually ones that are true. That's why lettering that is faithful to recognized styles is reliably more convincing than lettering that deliberately tries to appear original, avant-garde, or the dreaded "experimental." Don't get me wrong, I dig seeing heavily customized lettering, but the work that excels runs on logic and consistency under the hood, however souped-up it may appear from the outside. True innovation is adapting established forms to new ideas. This revelation shouldn't discourage the aspiring lettering artist. On the contrary, there's still loads of fun to be had— just in ways yet to be imagined.

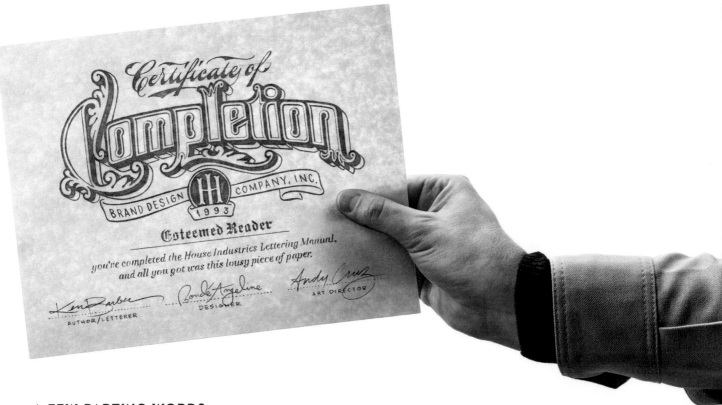

A FEW PARTING WORDS

Congratulations—you made it to the end of the book! By now, you should have plenty to chew on. It may take a while to digest everything, but don't sweat it—it'll all come together eventually. I've been at this for over half of my life, and I still manage to uncover tasty morsels here and there. In fact, it's what keeps me going. Besides, there's a lot of territory we didn't cover. (Sorry that I waited until now to break it to you). You're bound to come across techniques or letter styles that don't fit neatly into existing categories. The information provided in this manual is meant to serve as a general guide to keep you moving in the right direction, but it might just steer you toward exit ramps that send you down entirely new roads. (What's that adage about rules being made to be broken?)

Now that you've spent a little time pushing around a pencil, your appreciation for lettering (and especially for folks who are really good at it) has undoubtedly grown. And, you're likely to have a new perspective on the value of craftsmanship, patience, and attention to detail. I'm a dad, so naturally I'm into the history behind things. (Seriously, I will watch a documentary about anything. *Anything.*) Hopefully, boning up on the background of letterforms has also given you a clearer idea of why they look and behave the way they do. What's more, you've got a set of tools to help you recognize truly good typography and lettering, and an understanding of how best to apply them.

Even if you discover that your talents lie elsewhere, or you get fired up about some other endeavor, logging a few hours drawing is only going to do you good. When you abstract the basic principles of lettering—say 'em with me: volume, spacing, contrast, and proportion—they map surprisingly well on to other creative fields, whether you're into typography, illustration, photography, or whatever. As long as you continue to turn a critical eye toward your work while maintaining a positive outlook, you'll be in good shape.

So, wherever you wind up in your future creative exploits, it's my sincere hope that a few ideas in these pages get lodged in the back of your skull and serve you well. Thanks for reading, and good luck!

APERTURE: the opening of a partially enclosed counterform.

APEX: the peak of a letterform created by two conjoining diagonal strokes.

ARCH: a curved stroke that spans a letter, as in the n or u. Sometimes called a shoulder, especially when occurring along the x-height.

ARM: a stroke that branches diagonally or horizontally from the stem of a letterform, as in an E or the top stroke of a K.

ASCENDER: a stroke that extends above the body, or x-height, of a letterform.

AXIS: the imaginary vertical or sloped line that bisects a letter. The extent to which this imaginary line is inclined indicates the angle of the letter's stress. Sometimes axis and stress are used interchangeably.

BASELINE: the imaginary line on which a group of letters rest.

BEAK: a serif at the end of an arcing stroke, as found on the ends of a serifed C or S.

BIFURCATED: split or splayed, as in a serif typical of a Tuscan style letter.

BODY (OF A LETTERFORM): the primary portion of a lowercase letter situated between the baseline and x-height. In uppercase letters, the body is situated between the baseline and cap line.

BOWL: an enclosed or partly enclosed round stroke creating a counterform. A bowl that projects from a vertical stem is sometimes called a lobe.

BRACKET: the smooth transition between a letter's stem and serif in some styles. Also called a fillet.

BROAD-EDGED PEN: a writing instrument with a wide inflexible tip.

CAP LINE: the imaginary line defining the height of uppercase, or capital, letters.

CAPITAL: an uppercase letter.

CAPTION: the large primary text in an advertisement. In typography, it's used to describe a brief piece of supplementary or explanatory text.

CARTOUCHE: any device used to contain or frame lettering, most often used to refer to the decorative strokes that surround flourished Roundhand Script and Spencerian Lettering.

CENTERLINE: an imaginary line upon which letterforms, usually those of varying size, appear to be aligned.

CHARACTER: an alphanumeric form such as a numeral or letter.

CLOSE SHADE: a shade whose edges extend from the corner or edges of a letterform, giving it the appearance of thickness. Sometimes called a block shade or drop shadow.

COLOR: the visual texture of a piece of lettering created by its balance of positive and negative forms, which is one of the most important factors of lettering. The term can also refer to the overall apparent darkness or lightness of an individual letterform or piece of lettering.

COMPOSITION: the overall layout of a piece of lettering.

CONTOUR: the outline of a stroke or letterform.

CONTRAST: the variation in the thickness of a stroke.

COUNTERFORM: the enclosed or partially enclosed negative space inside or around a letter. Sometimes simplified as counter.

CROSS BAR: a horizontal stroke, usually in the center of a letterform, that connects to two vertical or diagonal strokes, as in the A or H. Sometimes simplified as bar.

CROSS STROKE: a horizontal stroke crossing a vertical stroke, as in the lowercase f or t.

CURSIVE: sloped letters that give the impression of flowing movement, usually used to describe connected script handwriting.

DESCENDER: a stroke that extends below the body, or x-height, of a letterform.

DISPLAY TYPE: a typeface designed to work at large sizes, as compared with text type, which is designed to be read in small sizes in running copy.

DROP SHADE: a shade that is distinctly separate from a letterform, usually offset to give the impression of a shadow.

DROP SHADOW: a term often used by graphic designers to refer to a closed shade.

DUCTUS: the direction and order of strokes that comprise a letter.

EAR: the small stroke often found in the upper-right area of a two-story lowercase g.

EMBELLISHMENT: any ornamentation or decorative treatment applied to a letterform.

ENTRY STROKE: the stroke beginning a letter, usually reserved to describe script and italic forms.

EXIT STROKE: the stroke ending a letter, usually reserved to describe script and italic forms.

EXTENDER: a stroke that extends above or below a lowercase letter; an ascender or descender.

EXTREMA: the outermost top, bottom, left, or right edge of a shape.

EYE: a small enclosed counterform, usually reserved to describe the upper counterform of a lowercase e.

FILLET: another word for bracket.

FINIAL: a curved exiting stroke of some letters, like the e or c.

FLOURISH: a decorative stroke that extends from letters or exists independently. Flourishes enclosing lettering creates a cartouche, and is typical of ornate Roundhand Script and Spencerian Lettering styles.

FRAMEWORK: the underlying architecture of a composition.

HALATION / IRRADIATION: a glowing effect created by scattered light, causing letterforms to appear larger when they are reversed out of a dark background.

HANDLE: a control point extending from the BCP of a curved vector line segment used to modify its shape.

HEADLINE: the heading of an article or editorial in a magazine or newspaper. Also referred to as a caption in advertising lettering.

HIERARCHY: the organization of a composition's elements according to their importance.

IDENTITY: the visual branding of a person, product, organization, or company, the cornerstone of which is typically its logo.

INLINE: an embellishment added to a letter in which a thin line is applied through the center of its strokes.

INTERLOCKING LETTERING: a technique in which sizes and shapes of letters are varied to fill negative spaces or to avoid colliding serifs.

LEG: a lower stroke that branches from the stem or bowl of a letterform, like the bottom right stroke in an R or K.

LETTER: a graphic representation of a sound in speech; a symbol belonging to an alphabet. The term can also describe a particular letter style or category; for example, "a Modern letter."

LETTERING: a process by which the primary parts of letterforms are built up by multiple strokes of a drawing tool.

LINE SEGMENT: a portion of a vector outline defined by a BCP at each end.

LINK: the stroke connecting the upper and lower bowls of a two-story g.

LOBE: another term for a bowl, usually one that projects from a vertical stem.

LOGO: a symbol or proprietary mark used to represent a person, product, company, organization, or brand; short for logotype.

LOOP: the lower bowl of a two-story g.

LOWERCASE: a small letter, as compared to a capital one.

MAJUSCULE: an uppercase letter.

MINUSCULE: a lowercase letter.

MONOGRAM: a graphic device comprised of two or more letters, which are usually initials interconnected to create a decorative motif.

MORGUE: an artist's collection of reference material.

OGEE: an S-shaped compound curve. Not to be confused with OG.

OPTICAL DIRECTION: the visual flow of a composition through which the viewer's eye is directed.

OSSATURE: the underlying skeletal framework of a letter. Also, a super cool word for an armature.

OUTLINE: a form of embellishment in which the perimeter of a letter is indicated by a thin line.

PARAPH: a stroke that usually extends from the final letter of a word to underline it.

PATH: a vector outline, or portion of an outline, defining a two-dimensional digital shape.

POINTED BRUSH: a round-ferrule watercolor brush, frequently made of sable hair, used to make Brush Roman and Brush Script lettering.

POINTED PEN: a writing instrument with a tapered flexible tip, usually made out of metal.

PROOFING: the process of evaluating the performance of a logo or wordmark before it is implemented.

PROPORTION: the comparative size of different letterforms and their various parts. The term can also be used to refer to the general width of a group of letters, or the relationship between their uppercase and lowercase forms.

RELIEF SHADE: a close or drop shade separated from the edges of the letterform.

ROMAN: the upright version of a letter, as opposed to its sloped italic form. Roman can also refer to Latin script, the alphabet used for many languages, including English.

SANS SERIF: without serif stroke endings; a letter style exhibiting such qualities.

SCRIPT: letterforms derived from cursive handwriting that suggest flowing movement from one letter to the next, usually connected by joining strokes. The same word is also used to refer to the alphabet used by a given language; for example, Latin script.

SEAL: a solitary letter, monogram, or symbol that acts as a stand-alone identifier.

SERIF: a secondary finishing stroke that terminates the ends of primary strokes in certain letter styles; a letter style with such stroke endings.

SHADE: any manner of embellishment added to the margins of a letterform, usually suggesting a three-dimensional or shadow-like effect. The terms "shading" or "shaded" may also refer to the swelling of flourishes or strokes, most evident in high-contrast letterforms.

SIGNATURE: a logo that includes a separate name and symbol treated as a single mark.

SKELETON: the underlying framework of a letterform.

SLOPE: the slant or angle of an oblique letter.

SPEED METAL: an aggressive genre of heavy metal typified by extremely fast tempos, rhythmic guitar riffs, and virtuosic solos. One of the greatest things to happen in the 1980s.

SPINE: the primary compound stroke that forms the center of the letter S.

SPUR: a small serif-like foot, like that found at the base of the vertical stroke of the G in some styles.

STEM: a main weighted stroke of a letter, usually vertical, but can be diagonal or curved.

STENCIL LETTER: a letter whose strokes are disconnected, as if produced by a stencil.

STROKE: any primary part of a letterform.

SWASH: a flourished embellishment that begins or ends a stroke.

TAIL: the curved exit stroke at the bottom of an a , t, or Q in some letter styles. The curved leg of an R is sometimes referred to as a tail, too.

TENSION: an effect created when elements of a letterform or composition deviate from normal standards or expectations.

TERMINAL: the end of a stroke.

TITTLE: the dot above a lowercase i or j.

TYPOGRAPHY: a procedure by which prefabricated letterforms are systematically composed and reproduced.

UNITY: the visual or conceptual means by which the various parts of a composition are harmonized.

UPPERCASE: a capital letter.

VECTORIZING / VECTORING: a digital process of creating two-dimensional forms by plotting a series of points that are connected by lines.

VINEWORK: a method of flourishing by which additional decorative strokes branch outward from other flourishes.

VISUAL CENTER: the area of a letterform slightly above its exact midpoint.

VERTEX: the bottom of a letterform created by two conjoining diagonal strokes.

VOLUME: the area occupied by a negative or positive form. "Volume" can also refer to the fullness of a stroke.

VOLUTE: a spiral-shaped stroke ending, common in flourishing.

WORDMARK: a general term referring to lettering that can function as a company's primary logo, sub-brand, property, or slogan. In a broader sense, the term can also be used to describe any distinctive word-based mark.

WRITING: a method of making letterforms by which their primary parts are made with a single pass of a writing instrument.

X-HEIGHT: the height of the body of a lowercase letter, not including ascenders or descenders.

RECOMMENDED READING

This list represents a handful of books by authors and artists who have influenced my personal outlook and approach to lettering. Some are basic primers, while others delve into history and technique more extensively. While you might not be thrilled by the idea of homework, these titles are loaded with juicy morsels that will help you improve your lettering.

The ABC of Custom Lettering: A Practical Guide to Drawing Letters, by Ivan Castro (*Korero Press, 2016*)
To my knowledge, this is one of the few recent publications that makes an effort to connect the principles of writing and lettering in one comprehensive instruction manual. (And, no, I don't get any kickbacks from sales because I wrote the foreword.)

Art and Visual Perception: A Psychology of the Creative Eye, by Rudolf Arnheim (*University of California Press, 1954*)
This is the book that opened my eyes to the essential role that tension plays in lettering. It's not a lettering guide, but rather an analysis of how visual effects, optical direction, and other important phenomena affect the way we perceive art and design.

Encyclopaedia of Type Faces, by W. Pincus Jaspert, W. Turner Berry, and A. F. Johnson (*Pitman, 1950; Fifth Revision: Seven Dials, 2001*)
I've included this handbook of metal type specimens principally as a reference for students to see the countless ways in which typeface designers have interpreted the various genres of letter styles.

Fonts & Logos: Font Analysis, Logotype Design, Typography, Type Comparison, by Doyald Young (*Delphi, 1999*)
In addition to offering a great overview of typographic styles and terminology, this tome is loaded with examples from one of the most versatile letterers of the recent past. A former student and colleague of Mortimer Leach, Young details his lettering approach, from sketch phase to final vector artwork. The book

might be a tad pricey these days, but it would be a crime not to mention it.

The History and Technique of Lettering, by Alexander Nesbitt (*Prentice-Hall, 1950; reprinted by Dover, 1998*)
While this gem isn't exactly an instructional primer, it is one of the rare books that attempts to chart the course of lettering in modern advertising. It also documents parallel handwriting, typography, and lettering trends over the past few centuries, and includes a series of design exercises.

House Industries: The Process Is the Inspiration, by Andy Cruz, Rich Roat, and Ken Barber (*Watson-Guptill, 2017*)
What kind of shameless huckster would I be if I didn't mention one of my other books? While it doesn't contain any instructional lessons, its binding of 400 pages is bursting with tons of specimens and case studies like the ones in this manual.

An Introduction to the History of Printing Types, by Geoffrey Dowding (*Wace, 1961; reprinted by Oak Knoll, 1998*)
Whenever I need a refresher on the essentials of a typographic genre, or a tidbit of historical info to help put things in context, I reach for this handy and extremely accessible reference book.

Letter Design in the Graphic Arts, by Mortimer Leach (*Reinhold, 1960, reprinted by Echo Point Books and Media, 2016*)
Leach's classic text covers the process of lettering by referring to typographic models, and is loaded with examples. The author's *Lettering for Advertising* (Reinhold, 1960) gets into the nitty-gritty of essential lettering models, but unfortunately is tougher to come by.

Love Letters, by Tony DiSpigna (*Thinstroke, 2017*)
This is the only book I know of that is dedicated to the distinctive style of Spencerian Lettering, which emerged during the late 1960s—and it's written by one of the innovators himself! Not much by way of instruction, but it is filled with page after page of luscious script lettering.

The Script Letter: Its Form, Construction, and Application, by Tommy Thompson (*Studio, 1939; reprinted by Dover, 1965*), and the more recent edition of the same book, Script Lettering for Artists (*reprinted by Dover, 2012*)
This is a foundational text on the topic of contemporary script lettering by one of my favorite letterers of the twentieth century. Thompson demonstrates the tools and methods used to create various script styles, and includes a short how-to section. The instruction isn't that comprehensive, but it remains an indispensable addition to your library.

The Stroke: Theory of Writing, by Gerrit Noordzij (*tr. Peter Enneson, Hyphen, 2005; reprinted by De Buitenkant, 2019*)
If you really want to roll up your sleeves and get into the influence of the broad-edged and pointed pen on the structure of letterforms, this is the book for you.

The Universal Penman, by George Bickham (*reprinted by Dover, 1941; BN Publishing, 2012*)
This eighteenth-century compendium is a treasury of engraved Roundhand Script, along with a smattering of other styles. The lettering that fills its pages will blow your mind.

THANKS

To my wife, Lynn, for your love, support, and invaluable input. To my kids, Līlā and Kanai, for hanging in there over the course of this project. To Mom and Dad, for your continued encouragement. To my earliest art advisers, my brothers, Eric, Steve, and Mike. To Rich Roat, for giving me the freedom to develop the ideas presented in these pages. To Andy Cruz, for being the right side of my left-sided brain; thanks for your friendship and trust, and for always pushing me to take my lettering further. To Bondé Angeline, for your cleverness, enthusiasm, and talents in designing this book. To my editor, Julie Bennett, for whipping the contents of this manual into shape. To Serena Sigona, Betsy Stromberg, and Mari Gill at Watson-Guptill, for helping to make this happen. To House's book agent, Katherine "Kitty" Cowles, for your patience. To Joe Schafer, Kris Sowersby, and Christoffer Leka for feedback on the manuscript. To Luong Nguyen, Adam Cruz, Jeremy Dean, Jess Collins, David Dodde, Lori Geonnotti, Jason Campbell, Yayoi Cannon, Jonathan Dupree, and the rest of the House Industries gang. To House alumni Allen Mercer, Chris Gardner, Tal Leming, and Ben Kiel. To Carlos Alejandro, Tom Bejgrowicz, BJ Betts, Christian Schwartz, Erik van Blokland, Kris Sowersby, Dave Foster, Ilya Ruderman, Hannes Famira, Mitja Miklavčič, Mark Borden, Brian Awitan, Erich Weiss, Kaisa Leka and the coterie of House co-conspirators. To the Roat and Cruz families, for putting up with House's capers. To House Industries' clients, customers, and fans. To my lettering mentors Ed Benguiat, Doyald Young, Ricardo Rousselot, Ruth Guzik, John Downer, Mark Oatis, and Carl Rohrs, for sharing your knowledge with me, and showing me tough love when I needed it. To Keith Morris and Tony DiSpigna, for your inspiring work. To Ivan Castro, Antero Nuutinen, Sergey Shapiro, James Edmondson, and my other talented colleagues, for reminding me what lettering can do. To Cara DiEdwardo and Ellen Lupton, for giving me a classroom to test my ideas and share my know-how. To my high school art instructor, Miriam Geddis, for keeping me out of trouble. To my professors at Tyler School of Art. To the design organizations, publications, and schools that hosted talks and workshops. And, to all of my students over the years— thanks for helping to shape me as a teacher and letterer.

PUBLISHED IN THE UNITED STATES BY WATSON-GUPTILL PUBLICATIONS, AN IMPRINT OF RANDOM HOUSE,
A DIVISION OF PENGUIN RANDOM HOUSE LLC, NEW YORK.
WWW.WATSONGUPTILL.COM

WATSON-GUPTILL AND THE HORSE HEAD COLOPHON ARE REGISTERED TRADEMARKS OF PENGUIN RANDOM HOUSE LLC.

LIBRARY OF CONGRESS CATALOGING-IN-PUBLICATION DATA
NAMES: BARBER, KEN, 1972- AUTHOR | HOUSE INDUSTRIES
TITLE: HOUSE INDUSTRIES LETTERING MANUAL | KEN BARBER
DESCRIPTION: CALIFORNIA: WATSON-GUPTILL PUBLICATIONS [2020] | INCLUDES INDEX
IDENTIFIERS: LCCN 2018054091 | ISBN 9781984859594 (TRADE PAPERBACK)
SUBJECTS: LCSH: LETTERING—TECHNIQUE | ALPHABETS
CLASSIFICATION: LCC NK3603 .B37 2019 | DDC 745.6/1—DC23 LC RECORD AVAILABLE AT HTTPS://LCCN.LOC.GOV/2018054091

TRADE PAPERBACK ISBN: 978-1-9848-5959-4

BOOK DESIGN, PHOTO STYLING, AND PRODUCTION: BONDÉ ANGELINE; CHIN STROKING: KEN BARBER AND ANDY CRUZ; LETTERING: KEN BARBER; PRODUCTION ASSISTANCE: ADAM CRUZ, JESS COLLINS, BEN KIEL; MODELS: LYNN, LĪLĀ, AND KANAI BARBER, BARRY KATZ SR., LORD REGINALD CLAMWELL IV; MENTORING: BARRY KATZ SR.; PITCH TYPEFACE FROM KLIM TYPE FOUNDRY COURTESY OF KRIS SOWERSBY. WATAIN LOGO BY ERIK DANIELSSON COURTESY OF WATAIN.

PRINTED IN CHINA

10 9 8 7 6 5 4

FIRST EDITION